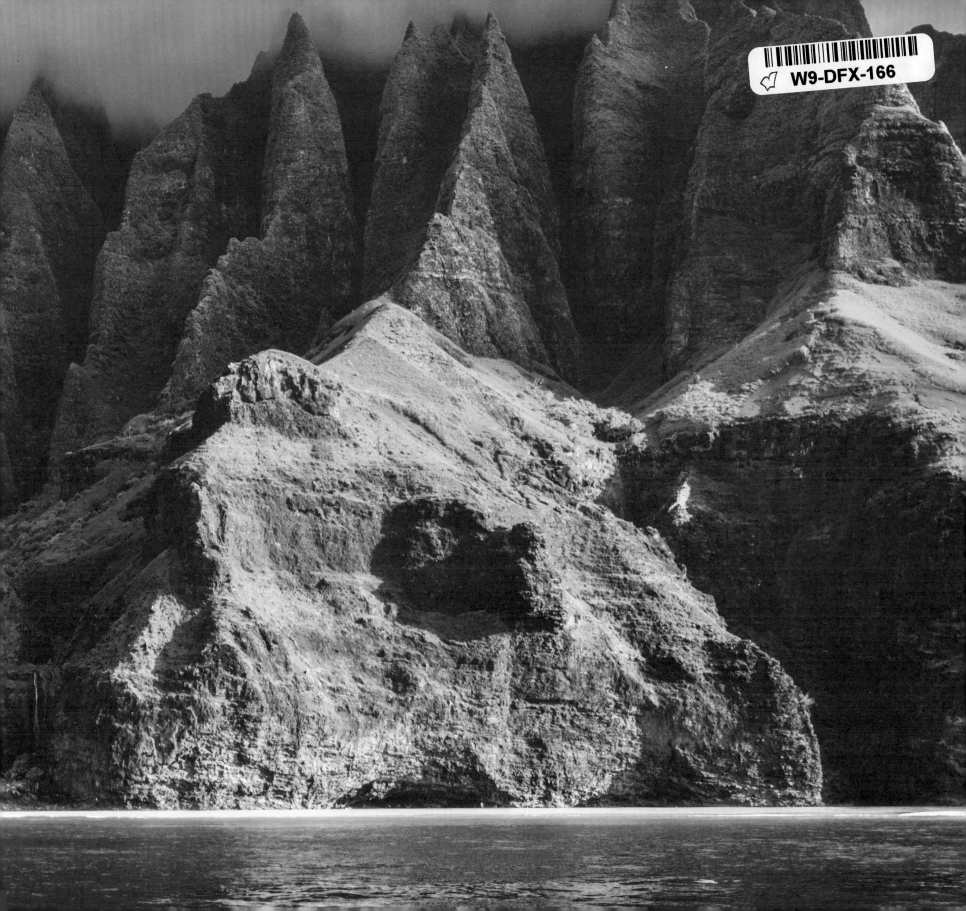

50 STATES
500 STATE PARKS

An essential guide to America's best places to visit

pil
Publications International, Ltd.

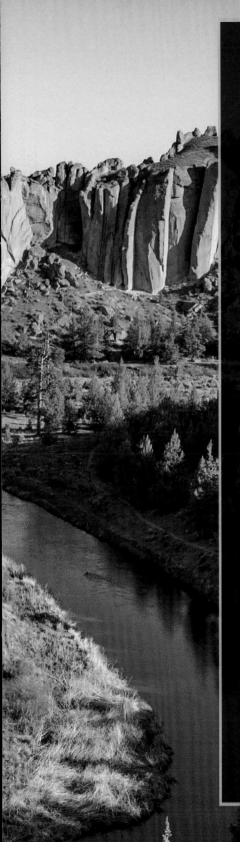

Table of Contents

ALABAMA

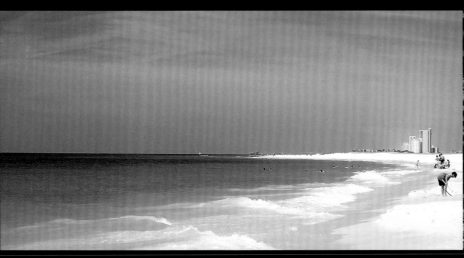

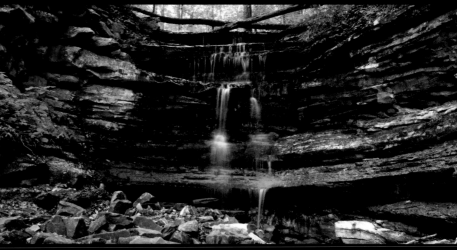

Gulf State Park

Its access to two miles of pristine beaches along the Gulf of Mexico makes Gulf State Park one of the top vacation destinations in Alabama. Its campground offers nearly 500 full-hookup sites and a handful of "primitive" sites as well. There are also cabins and lakeside cottages within walking distance of a golf course.

Monte Sano State Park

Located near Huntsville, Monte Sano State Park features 20 miles of hiking trails, 14 miles of biking trails, and plenty to see no matter which mode of transportation you choose. There are mineral springs to view, and native azaleas that bloom along the trails in the spring. Stone cabins built in the 1930s are still in use today.

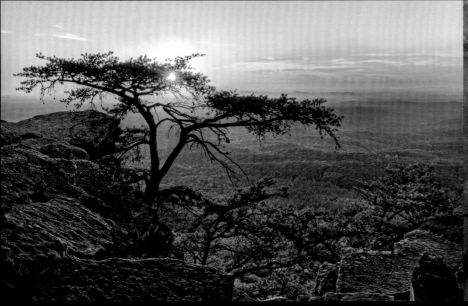

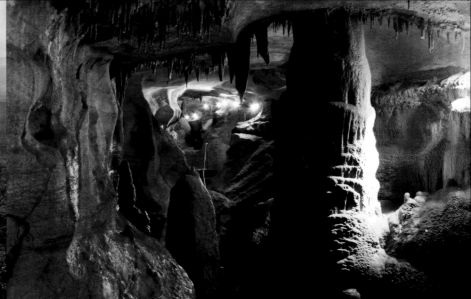

Cheaha State Park

The Indians named this "Chaha," meaning "high place." That's because Cheaha State Park in Clay and Cleburne counties boasts the highest spot in Alabama–2,407 feet above sea level. Surrounded by the Talladega National Forest, this Appalachian Mountain foothill offers camping, cabins, and some of the state's most spectacular views.

Rickwood Caverns State Park

Just north of Birmingham is one of Alabama's most unique spots to visit. Rickwood Caverns are especially attractive in the heat of the summer, as temperatures in this underground spectacle stay at an even 58–62 degrees year-round. A trip into the cave 175 feet below the earth's surface reveals 260-million-year-old formations created by water.

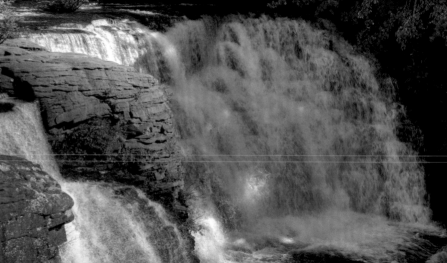

Oak Mountain State Park

Alabama's largest state park, at almost 10,000 acres, Oak Mountain State Park also offers a large variety of outdoor activities. Mountain biking, hiking, horseback riding, boating, fishing, basketball, and an 18-hole golf course are just a handful of the many options.

DeSoto State Park

DeSoto State Park, atop scenic Lookout Mountain in northeast Alabama, is renowned for its rushing waterfalls, sandstone beauty, and array of wildflowers. DeSoto Falls (pictured above) drop more than 100 feet.

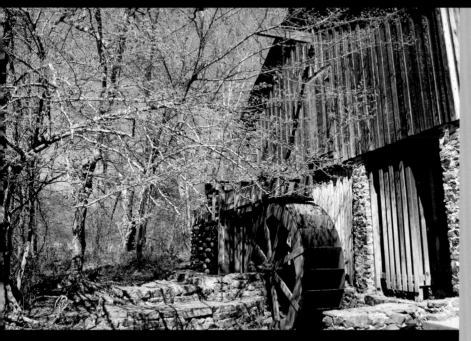

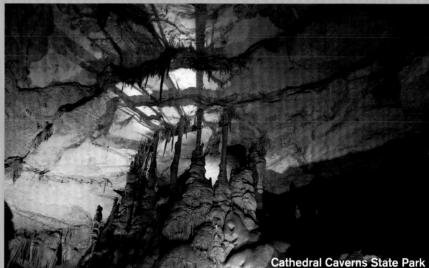

Cathedral Caverns State Park

Other Alabama State Parks

- Cathedral Caverns State Park (Woodville)
- Joe Wheeler State Park (near Rogersville)
- Chattahoochee State Park (southeastern Alabama)
- Lake Guntersville Resort State Park (Guntersville)
- Wind Creek State Park (near Alexander City)

Tannehill Ironworks Historical State Park

Listed on the National Register of Historic Places as the Tannehill Furnace, Tannehill Ironworks Historical State Park in Tuscaloosa County preserves much of Alabama's rich iron and steel history. The John Wesley Hall Grist Mill (pictured above) is one of the most photographed spots in the park.

Kachemak Bay State Park

Some 400,000 acres of ocean, glaciers, forest, and mountains greet visitors at Alaska's first state park, as do many wild animals. Among the ocean creatures here are whales, otters, seals, and porpoises. Moose, black bears, mountain goats, and wolves roam the land. There's no road access to the park, so visitors typically fly in or catch a boat from Homer. A few cabins and semi-developed campgrounds are among the places to stay. Park attractions include Grewingk Glacier, Poot Peak, China Poot Bay, Halibut Cove Lagoon, Humpy Creek, and China Poot (Leisure) Lake. Kayaking, fishing, boating, hiking, camping, and mountain sports are popular here.

Kachemak Bay State Park

Chugach State Park

At about a half-million acres, Chugach is the third-largest state park in the United States. The breathtaking jewel known as "Anchorage's playground" offers some of the most amazing and accessible wildlife viewing in the world. It is also a northern mecca for hikers, skiers, kayakers, and campers. The park offers year-round views of snow-capped mountains, and in the winter it's the scenic home to unparalleled snowmobiling and snowshoeing. A viewing platform at Glen Alps is a great spot to see moose, along with brown and black bears.

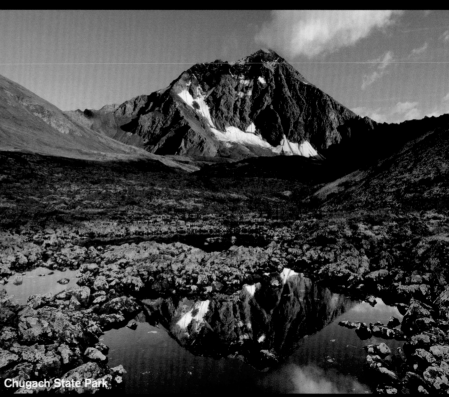

Chugach State Park

Denali State Park

The former Mount McKinley is now officially known as Denali, a Tanana Indian word meaning "the high one." At more than 20,000 feet, Denali's peak is the highest point in North America. The state park was established in 1970 and grew to its present size–325,240 acres–six years later. It sits about 100 air miles north of Anchorage, sharing its western boundary with the larger Denali National Park and Preserve (formerly Mt. McKinley National Park). Denali State Park maintains cabins offering spectacular mountain views along with several campgrounds, the perfect home base for outdoor adventurers and wildlife seekers.

Wood-Tikchik State Park

The nation's largest state park at 1.6 million acres, Wood-Tikchik was established in 1978 to protect the area's recreational activities and fish and wildlife breeding systems. It's named for its two connected, crystal-clear lakes, and prides itself on sustainability. "Leave no trace" is a way of life here, and a well-respected one among those who stay at its rustic facilities. Moose, caribou, and brown bears are far more plentiful than people at this Dillingham-headquartered spectacle.

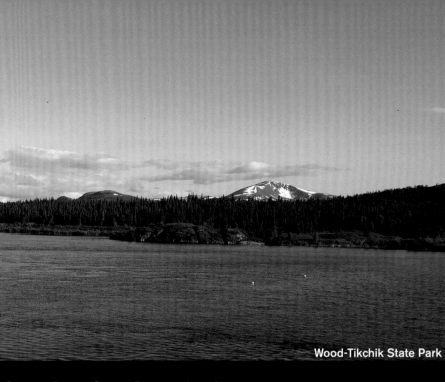

Wood-Tikchik State Park

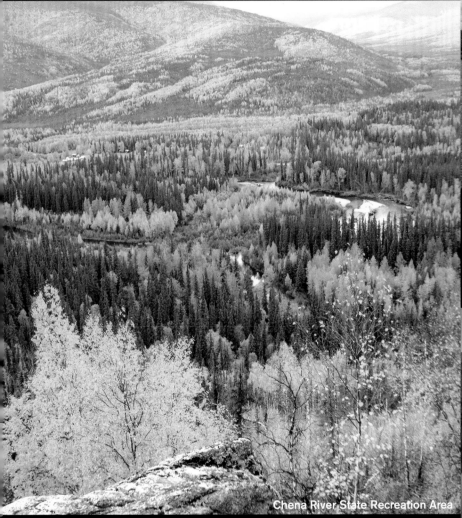

Chena River State Recreation Area

Chena River State Recreation Area

Chena River State Recreation Area encompasses 397 square miles of forests, rivers, and alpine tundra. You can hike, bike, dogsled, horseback ride, ski, snowmobile, or snowshoe on over 100 miles of maintained trails.

Tanana Valley State Forest

The sprawling 1.8-million-acre Tanana Valley State Forest in east-central Alaska offers camping, fishing, hunting, hiking, wildlife viewing, and berry picking.

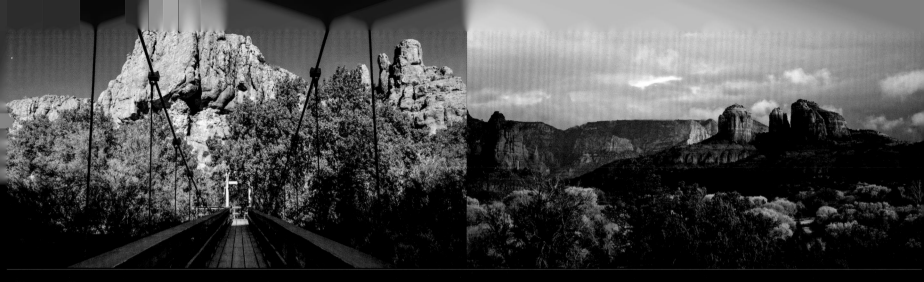

Boyce Thompson Arboretum State Park

Arizona's oldest and largest botanical garden was founded as a living museum in 1924. Almost 100 years later, the flowering oasis in the Sonoran Desert draws close to 100,000 visitors annually. The main trail that loops through the gardens is 1.5 miles long and offers up-close looks at palm and eucalyptus groves, a cactus garden, and exhibits showcasing plants of the world. The park is about an hour's drive east of Phoenix.

Red Rock State Park

Red Mountain, *Fort Massacre*, and *The Hallelujah Trail* are just a few of the films that have brought Yavapai's Red Rock State Park onto the big screen. It's no surprise, considering the park looks like a colorful film set. It features a red sandstone canyon just outside Sedona, a camera-friendly array of plant life and wildlife, and some of the best hiking and horseback riding trails you'll find.

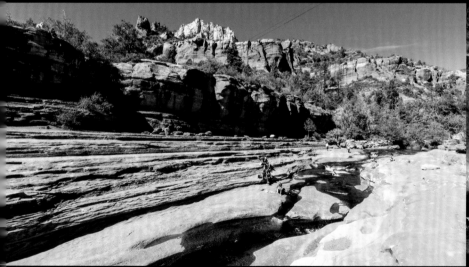

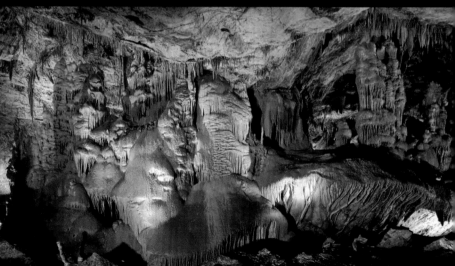

Slide Rock State Park

This beautiful spot in Sedona is best known for a unique natural waterslide formed by the slick bed of Oak Creek. Visitors can slide down the park's namesake slide into the glistening pool below. Expect company when visiting this popular site, which has been named one of America's top 10 swimming holes by the Travel Channel, *USA Today*, and others. The park, located in Coconino National Forest, also offers three short trails, fishing, wildlife viewing, and picnic shelters.

Kartchner Caverns State Park

Discovered in 1974 by local cave explorers, Kartchner Caverns State Park sits nine miles south of Benson and provides visitors some of the most unique views (and photos) to be found in scenic Arizona. There are two main rooms open to the public. The Throne Room contains a 21-foot stalactite and a 58-foot column named the Kubla Kahn. The Big Room (pictured above) has the world's largest formation of brushite moonmilk.

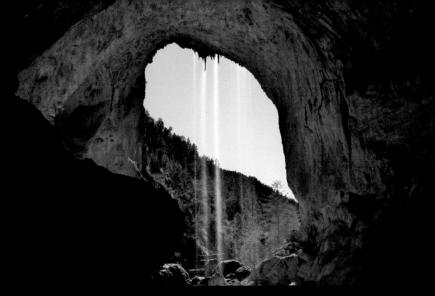

Tonto Natural Bridge State Park
Tonto Natural Bridge stretches over a 400-foot-long tunnel and is thought to be the largest natural travertine bridge in the world. Ten miles north of Payson, the bridge and the area surrounding it were established as Tonto Natural Bridge State Park in 1969.

Lost Dutchman State Park
Lost Dutchman State Park in Apache Junction is a great place to view native plants and animals. Depending on the year's rainfall, visitors might be greeted with a carpet of desert wildflowers in the spring.

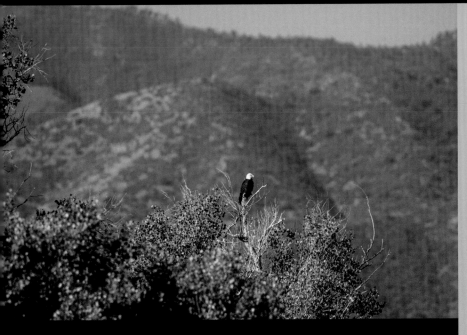

Dead Horse Ranch State Park
Otters, hawks, bald eagles, coyotes, and a variety of other wildlife are plentiful within the 423 acres of Dead Horse Ranch State Park in Cottonwood. Capturing the many aspects of historic life on the Verde River, the park offers camping, fishing, and hiking along several trails.

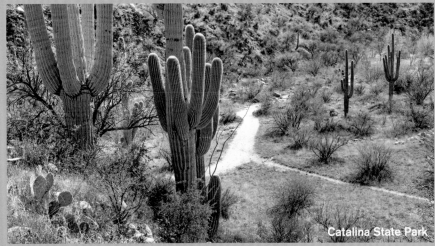

Catalina State Park

Other Arizona State Parks
- Catalina State Park (Oro Valley)
- Homolovi State Park (near Winslow)
- Patagonia Lake State Park (Santa Cruz)
- Picacho Peak State Park (between Casa Grande and Tucson)
- Yuma Territorial Prison State Historic Park (Yuma)

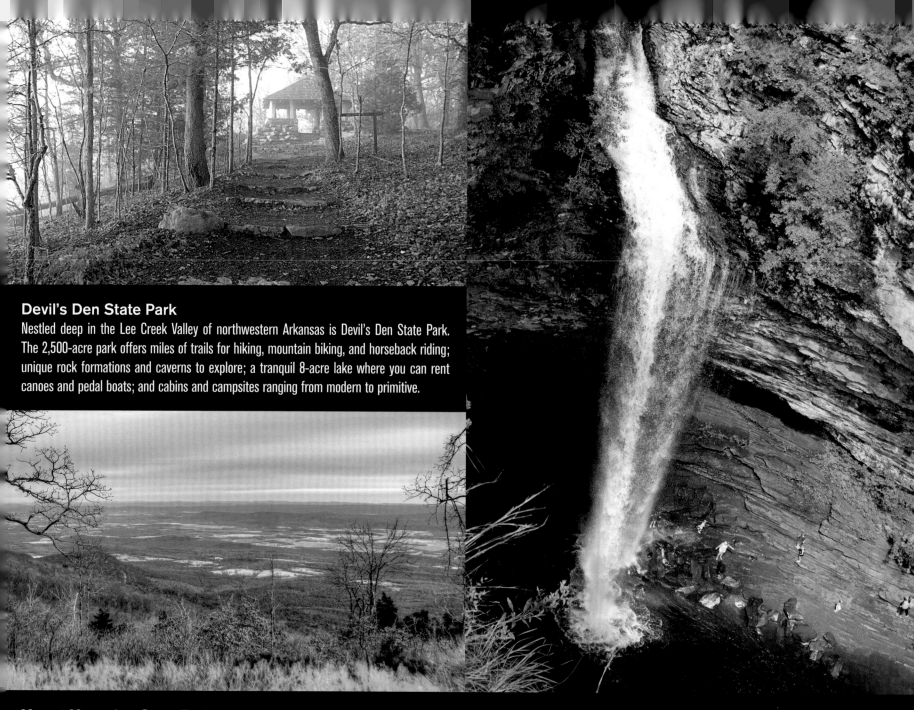

Devil's Den State Park

Nestled deep in the Lee Creek Valley of northwestern Arkansas is Devil's Den State Park. The 2,500-acre park offers miles of trails for hiking, mountain biking, and horseback riding; unique rock formations and caverns to explore; a tranquil 8-acre lake where you can rent canoes and pedal boats; and cabins and campsites ranging from modern to primitive.

Mount Magazine State Park

Mount Magazine State Park boasts the highest peak in Arkansas at 2,753 feet. The park offers breathtaking views as well as opportunities for hang gliding, mountain biking, ATV riding, hiking, and rock climbing.

Petit Jean State Park

Petit Jean State Park lies between the Ozark and Ouachita mountain ranges in west-central Arkansas. The park contains more than 3,000 acres of woods, ravines, streams, waterfalls, and surprising geological formations. The spectacular 95-foot Cedar Falls is pictured above.

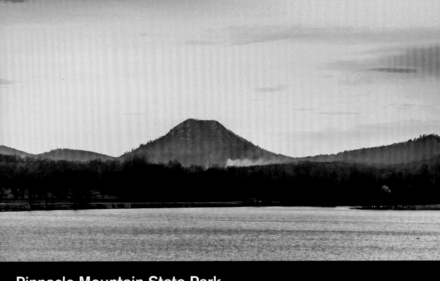

Mammoth Spring State Park

Mammoth Spring State Park preserves one of the world's largest natural springs, with approximately nine million gallons of water flowing hourly. The park also preserves a mill, hydroelectric plant, and a fully-restored 1886 train depot and museum.

Pinnacle Mountain State Park

Just west of Little Rock is Pinnacle Mountain State Park. This geographically diverse day-use park covers more than 2,000 acres that include upland forests and rocky peaks as well as wetlands and bottomlands along the Big and Little Maumelle rivers.

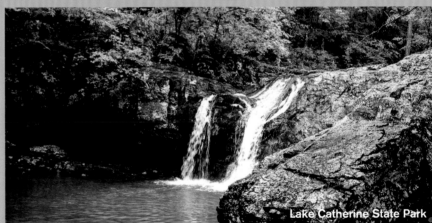

Lake Catherine State Park

Other Arkansas State Parks

- Lake Ouachita State Park (Mountain Pine)
- DeGray Lake Resort State Park (Bismarck)
- Bull Shoals-White River State Park (Bull Shoals)
- Toltec Mounds Archeological State Park (Scott)
- Ozark Folk Center State Park (Mountain View)
- Lake Catherine State Park (Hot Springs)
- Queen Wilhelmina State Park (Mena)

Crater of Diamonds State Park

Crater of Diamonds State Park in Murfreesboro, Arkansas, is billed as the "world's only diamond site where you can search and keep what you find." The 37-acre field is the eroded surface of an ancient, gem-bearing volcanic pipe.

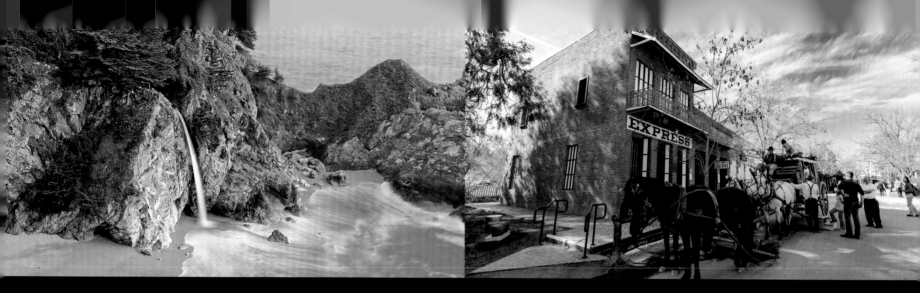

Julia Pfeiffer Burns State Park

Named after a well-known pioneer and rancher in the Big Sur area, Julia Pfeiffer Burns State Park is home to redwoods that reach 300 feet into the sky and are some 2,500 years old. The main draw is McWay Falls (above), which drops 80 feet into the Pacific Ocean. While the Overlook Trail leading to the falls was technically closed in 2019 and access prohibited, that does not stop adventurous visitors from finding their way to the beach and its views.

Columbia State Historic Park

The town of Columbia was the second-largest city in California at the time of the Gold Rush. Now, it's often visited for Columbia State Historic Park, a preservation of many of the great buildings and artifacts that served the tin-panners of that time. Costumed tours are given on the second Saturday of the month during peak season. Guests can ride an authentic stagecoach, but no cars are allowed!

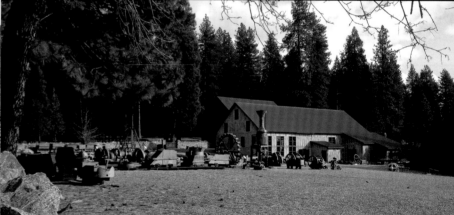

Anza-Borrego Desert State Park

The largest of California's state parks, Anza-Borrego is named after famed Spanish explorer Juan Bautista de Anza and "Borrego," the Spanish word for the area's native bighorn sheep. The park encompasses the entire southeast corner of the state (three counties), protecting more than 600,000 acres of badlands, palm oases, slot canyons, and hills peppered with cactus. Choose your dates carefully; the Colorado Desert region gets blazing hot in the summer months.

Empire Mine State Historic Park

A state-protected park and mine in the Sierra Nevada mountain range, Empire Mine holds a spot on the National Register of Historic Places. It's one of the oldest, largest, and richest gold mines in California, and a living tribute to the Rush that brought so many hopeful newcomers to the state. More than 5.6 million ounces of gold were extracted here before the mine shut down in 1956. Guided tours of the 60-mile-long site in Grass Valley, which includes

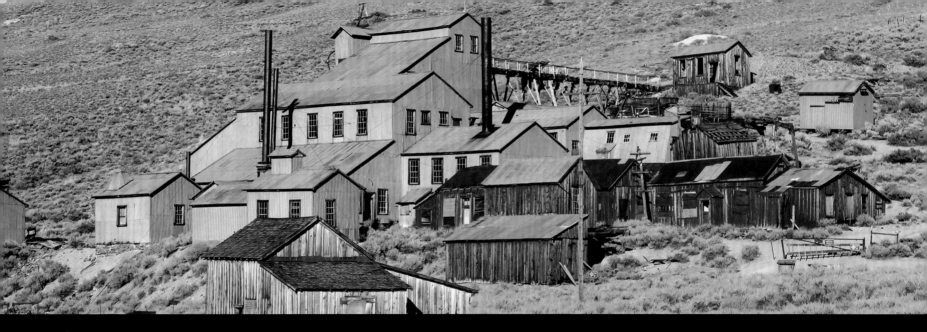

Bodie State Historic Park

Not far from Yosemite National Park is one of the most unique towns you will find anywhere in the country. Bodie is a true ghost town, sitting just as it did when the once-booming gold-mining community was abandoned by virtually every one of its 10,000 residents a half-century ago. Tattered stores, hotels, homes, old trucks, and gas pumps are among the remains that depict both the life and death of a remote town in the high desert. Bodie became a state historic park in 1962.

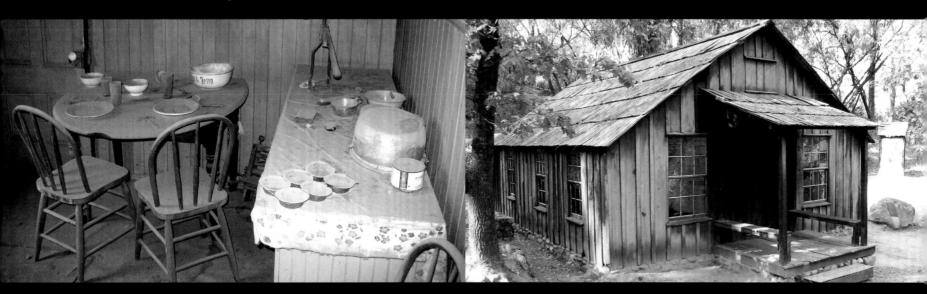

(Above) More than a century of horrid winters, a pair of major fires, and decades of ghosthood have destroyed about 95 percent of Bodie. Yet, the Bodie that remains is a real gem. About 150 weather-blasted buildings still stand. California State Parks preserves the surviving buildings in a state of "arrested decay." Interiors remain as they were left when they were abandoned.

Marshall Gold Discovery State Historic Park

The James Marshall Cabin in Coloma is among the many highlights of the Marshall Gold Discovery State Historic Park in the little town between Auburn and Placerville. A schoolhouse, general store, and tin-roofed post office are among the historic buildings protected in the park. There is also a Gold Discovery Museum, where visitors can try their hand at gold panning.

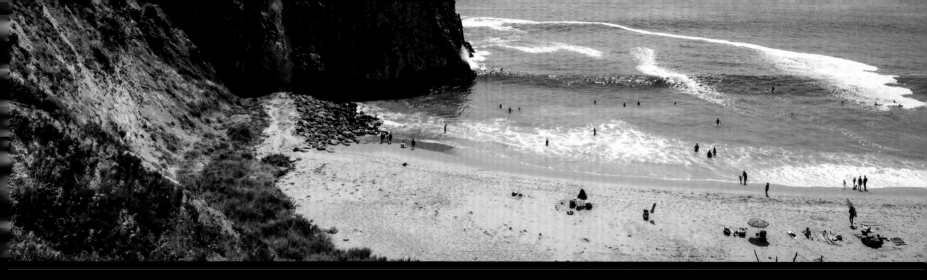

Crystal Cove State Park

Rocky coves, golden cliffs, perfect sunny weather, and crashing waves are the norm at Crystal Cove State Park. It's one of Orange County's largest remaining vestiges of open space and natural seashore, spanning more than three miles of beach, 2,400 acres of backcountry wilderness, and an offshore underwater area. The park also features 46 vintage rustic coastal cottages that were built to form a seaside colony around the mouth of Los Trancos Creek in the 1930s and 1940s. More than 20 restored cabins are available to rent, but they fill up quickly!

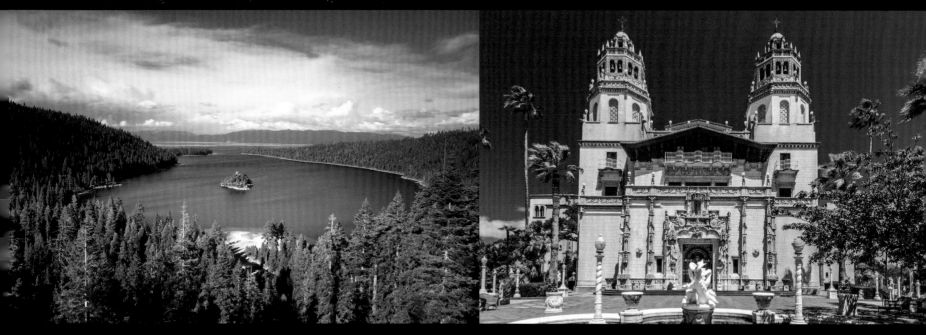

Emerald Bay State Park

Named for its brilliant green hues that accompany Lake Tahoe's turquoise and blue waters, blue skies, and stunning mountain views, Emerald Bay is considered by many to be the Tahoe area's crown jewel. Declared a National Natural Landmark in 1969, Emerald Bay also became a California state park in 1994—one of the first underwater parks in the state.

Hearst San Simeon State Park

A state historical monument, Hearst Castle (above) is a center of excess and opulence in San Simeon. California's first female architect, Julia Morgan, designed the mansion that was completed in 1947. It sits within the Hearst San Simeon State Park, one of the most visited state parks in California, and features pools, fountains, scenes from famous films, and 165 awe-inspiring rooms.

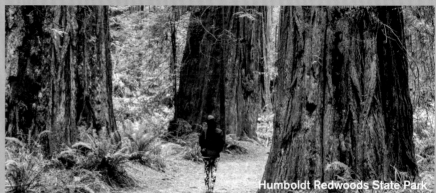
Humboldt Redwoods State Park

Big Basin Redwoods State Park
California's oldest state park is a popular spot for both tourists and the many locals that pack Silicon Valley. More than 80 miles of trails wind through the Santa Cruz mountains under towering redwoods and past waterfalls. Watch where you step, though, as you'll be sharing those trails with the area's colorful banana slugs. The Skyline to the Sea Trail is one of the most popular (and home to multiple trail races for runners), meandering from Saratoga Gap to the ocean at Waddell Beach.

Other Top State Parks for Redwoods

- Humboldt Redwoods State Park (near Rio Dell)
- Henry Cowell Redwoods State Park (near Felton)
- Armstrong Redwoods State Natural Reserve (near Guerneville)
- Navarro River Redwoods State Park (Mendocino County)
- Del Norte Coast Redwoods State Park (near Crescent City)
- Jedediah Smith Redwoods State Park (near Crescent City)

Prairie Creek Redwoods State Park
A sanctuary for ancient redwood trees in Humboldt County on California's north coast, Prairie Creek Redwoods State Park offers some 14,000 acres of treed canopy, rainforest, and soft hiking trails. It's also home to some fascinating wildlife, including Roosevelt elk in a meadow along the Newton B. Drury Scenic Parkway, the tailed frog, and several salmon species.

Limekiln State Park
This Big Sur gem features four kilns used in the late 1800s, when limestone was harvested from a nearby slope and fired up to extract pure lime—used in construction cement that was key to buildings in nearby Monterey and even all the way up in San Francisco. Exploring the remains of the kilns, checking out Limekiln Falls, and trying to capture photos of the

Grover Springs State Park

If swimming in pools fed by six underground hot springs sounds fun, a visit to Markleeville–about an hour's drive southeast of Lake Tahoe–ought to be on the bucket list. The pools pull water that's close to 150 degrees Fahrenheit, but it's cooled to an enjoyable (and safe) 103 degrees on its way to the Grove Springs State Park's two concrete swimming pools. Folks have been taking dips in the low-sulfur waters, some raving about their healing powers, since the 1850s.

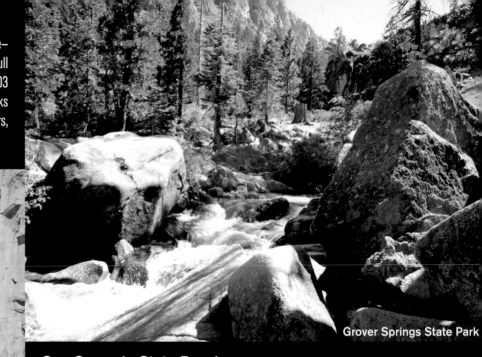

Grover Springs State Park

San Gregorio State Beach

Californiabeaches.com recently named this the best beach in the state. That's saying something. A short trek south from the surfing hub Half Moon Bay, San Gregorio State Beach sits just to the west of the State Route 1–State Route 84 intersection. Its appeal is many-faceted. There's a creek that widens into a lagoon behind a sand berm, and during the winter it sometimes cuts through the berm to the Pacific. There are bluffs, caves to explore north of the creek, and some of the best sand you'll find anywhere.

San Gregorio State Beach

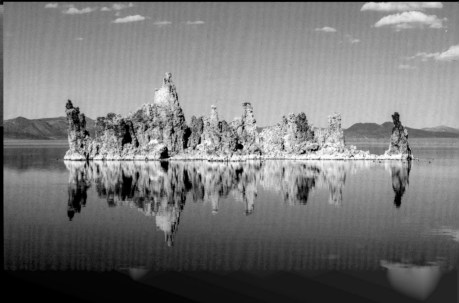

Mono Lake Tufa State Natural Reserve

Few places in the world look as otherworldly as this one. The tufa columns jutting out of Mono Lake toward the sky, on the eastern side of the Sierra Nevada mountain range, seem like they belong on another planet. The salty lake provides extra swimming buoyancy and is thought to be about a million years old, left over from an ancient inland sea. It's teeming with interesting seabirds to view while hiking, swimming, or kayaking. The reserve's visitor center is just off Highway 395, north of Lee Vining.

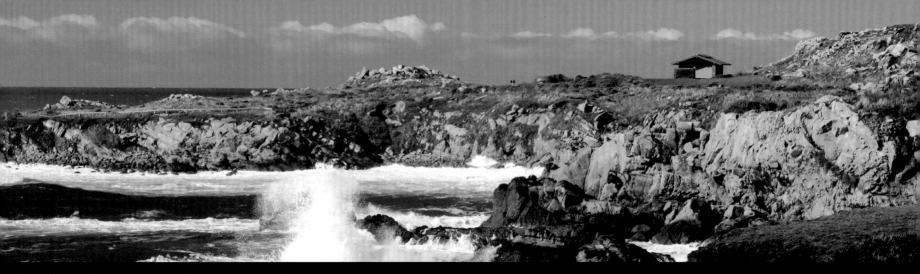

Salt Point State Marine Conservation Area

About 100 miles north of San Francisco on the Sonoma coast sits 6,000 inviting acres of headlands trails, tidepools, sandstone cliffs dropping to the Pacific Ocean, and beautiful, grassy terraces. Salt Point State Marine Conservation Area is protected as one of the first underwater parks in California. A spectacular stretch of Highway 1 winds through the park, which includes about 20 miles of scenic trails. Salt Point State Marine Conservation Area comprises the shoreline of Salt Point State Park and surrounding ocean, including Gerstle Cove (pictured above).

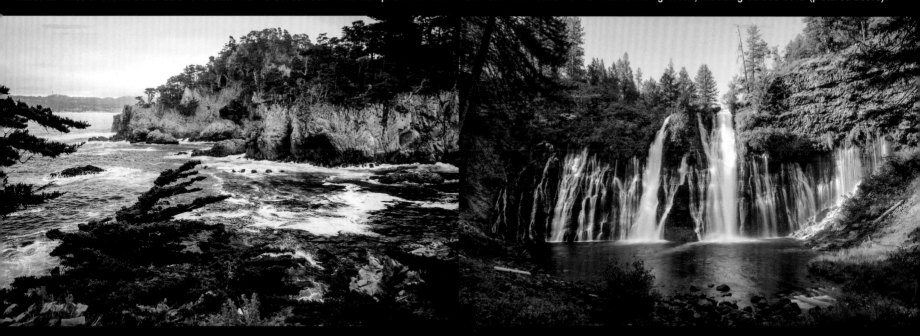

Point Lobos State Natural Reserve

It's been called the "crown jewel" of California's state park system, and nature lovers know exactly why. It's one of the richest marine habitats in the state—home to two marine protected areas. In addition to the vibrant sea life, the reserve boasts some of the best ocean and cliff views along the spectacular Big Sur coastline near Monterey and Carmel. Whaler's Cove is the largest of a number of coves that draw more than one million visitors annually.

McArthur-Burney Falls Memorial State Park

Scenes from Hollywood movies like *Stand by Me* and *Willow* were shot at California's second-oldest state park, and it's easy to see why. This gem about six miles north of Burney is renowned for its jaw-dropping views—particularly Burney Falls (above). Woodpeckers, deer, and an occasional black bear, among other wildlife, can be seen in the park, which can be enjoyed via the Pacific Crest Trail by hikers of all skill levels.

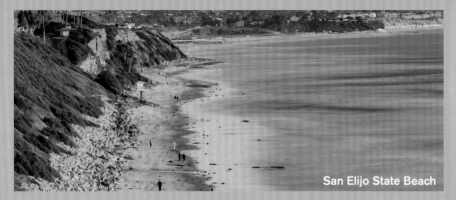
San Elijo State Beach

California's Huge State System
Among the close to 300 state lands in California are:

- 87 state parks
- 63 state beaches
- 51 state historic parks
- 32 state recreation areas
- 16 state natural reserves
- 8 state vehicular recreation areas

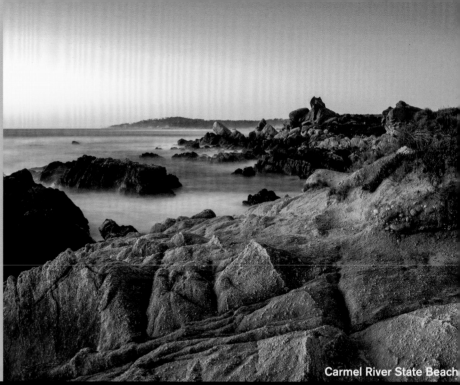
Carmel River State Beach

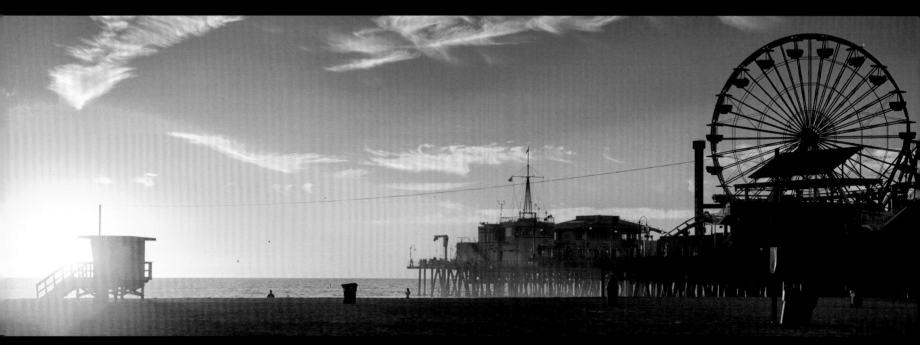

Santa Monica State Beach
Sunset at Santa Monica State Beach is not to be missed. Annually ranked among the best beaches in California, Santa Monica is a year-round attraction for its famous pier, plenty of nearby

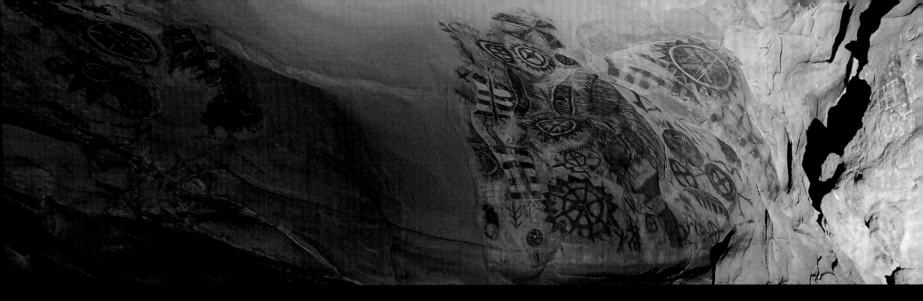

Chumash Painted Cave State Historic Park
The exquisite artwork of the Chumash Indians is on brilliant display at Chumash Painted Cave State Historic Park northwest of Santa Barbara. The state park system has preserved this small sandstone cave that holds a spot in the National Register of Historic Places. Some of the markings are thought to be perhaps 1,000 years old.

La Purísima Mission State Historic Park
This state park just outside Lompoc in Santa Barbara County contains La Purísima Mission, the 11th of the 21 California missions established by the Franciscans. La Purísima is considered the most completely restored of all the Spanish missions. Ten of its buildings are completely restored, giving visitors a truly realistic glimpse of what life was like there in the 1820s.

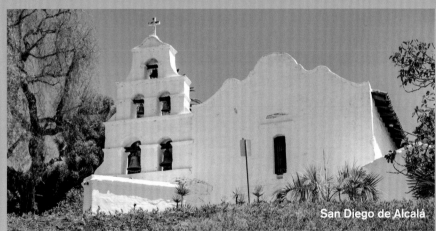

San Diego de Alcalá

Other Spanish Missions Worth a Visit

- San Diego de Alcalá (San Diego)
- San Luis Obispo de Tolosa (San Luis Obispo)
- San Juan Capistrano (San Juan Capistrano)
- San Buenaventura (Ventura)
- Santa Barbara (Santa Barbara)
- San Fernando Rey de España (Los Angeles)

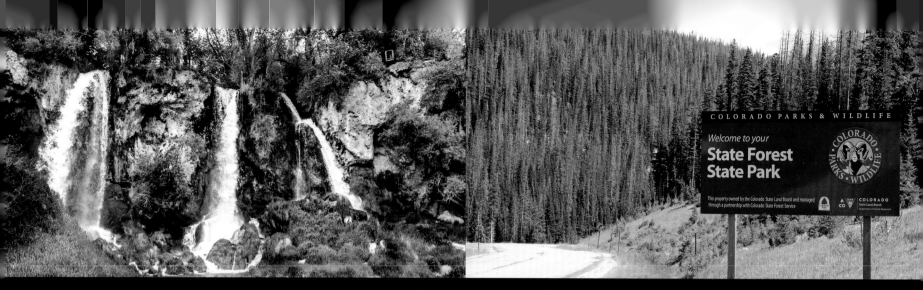

Rifle Falls State Park

A small park (48 acres) with a giant claim to fame, Rifle Falls State Park boasts one of the most eye-pleasing spectacles in Colorado—a triple, 70-foot waterfall spilling over a dam on East Rifle Creek. Three species of bats reside in small caves among the cliffs, and larger residents include elk and deer. It's an easy walk (50 yards) from the parking area to the falls at this park just northeast of Rifle.

State Forest State Park

Look no further than State Forest State Park near Walden for moose. The scenic park is known as the moose viewing capital of the state, with more than 600 roaming the grounds. With some 90 miles of hiking trails and 130 miles of biking trails, it's also a paradise for active outdoor enthusiasts.

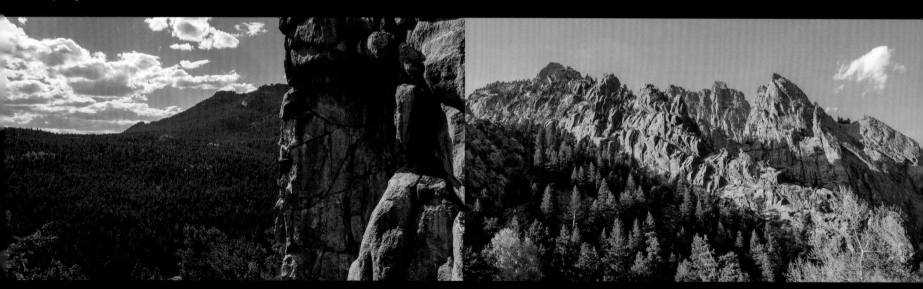

Golden Gate Canyon State Park

The fact it sits just 30 miles from Denver in the Golden area makes Golden Gate Canyon a favorite among locals. Its expansive view of the Continental Divide from Panorama Point Scenic Overlook, where on a clear day one can see up to 100 miles of mountains, stamps it a popular

Eldorado Canyon State Park

Climbers from all over the world flock to this Boulder-area park and head toward the skies. There are more than 500 technical climbing routes here, along with 11 miles of trails for hikers and bikers, and some fantastic fishing in South Boulder Creek.

Mueller State Park

West of Colorado Springs is 5,000-acre Mueller State Park, which is gorgeous year-round and downright spectacular when the leaves change each fall. There are 50 miles of trails, including areas where visitors can view elk herds. Some are open to bikes and horseback riders.

Barr Lake State Park

The southern half of Barr Lake State Park near Brighton, Colorado, is a wildlife refuge that contains a nature center. Numerous bald eagles spend the winter in its confines—one of the 350-plus species of birds that have been sighted here.

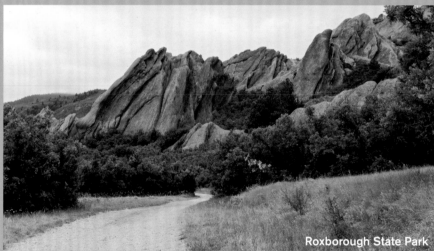

Roxborough State Park

Lory State Park

A 2,500-acre haven near Fort Collins, Lory State Park is a favorite among boaters, climbers, and campers. However, bikers might have it best here. There's a bike park that features dirt jumping, a pump track, and a skills area.

Other Colorado State Parks

- Cherry Creek State Park (Aurora)
- Eleven Mile State Park (near Lake George)
- Navajo State Park (near Arboles)
- Roxborough State Park (near Littleton)
- Vega State Park (Collbran)

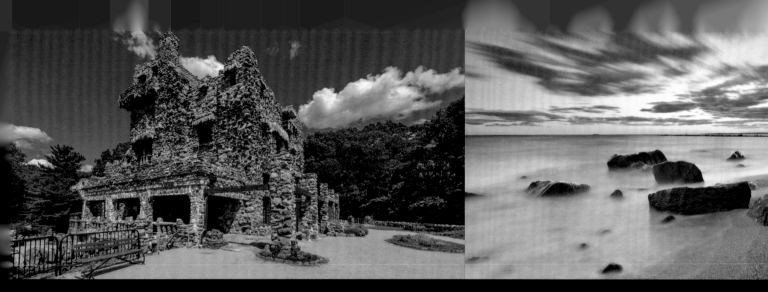

Gillette Castle State Park

What links Lyme, Connecticut, with the figure of Sherlock Holmes? They're joined in the figure of William Gillette (1853–1937), a Connecticut-born actor who played Sherlock Holmes on stage in England and America for more than three decades. Gillette also built an elaborate castle high up on a bluff overlooking the Connecticut River that was completed in 1919.

Gillette's will stipulated that his castle not fall into the hands of any "blithering sap-head who has no conception of where he is or with what surrounded." In 1943, the actor got his wish when the state of Connecticut took possession of the unique property and christened it Gillette Castle State Park. The park, which straddles the towns of Lyme and East Haddam, consists of the castle and its grounds. Visitors can picnic, hike, and tour the castle.

Hammonasset Beach State Park

Hammonasset Beach State Park in Madison offers two miles of beachfront on Long Island Sound. Visitors to the park can stroll the boardwalk, swim, fish, bike, picnic, hike, and camp. The new Meigs Point Nature Center opened at the park in 2016. The nature center offers hands-on learning experiences and exhibits and hosts a variety of native animals.

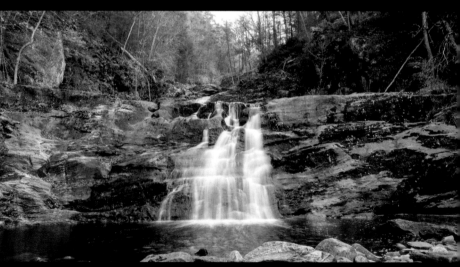

Dinosaur State Park

In 1966, some 2,000 dinosaur tracks were unearthed in Rocky Hill, Connecticut, during excavation for a new state building. Realizing the importance of the find, the Connecticut Department of Environmental Protection took action. The result is Dinosaur State Park, a dino-centric spot where 500 of these tracks are now enclosed within the exhibit center's geodesic dome. The exhibit center

Kent Falls State Park

Kent Falls State Park is home to a series of waterfalls on Falls Brook, a tributary of the Housatonic River. The Kent Falls Trail offers many scenic vantage points from which to view the falls. Visitors can hike the falls, cross a covered bridge, enjoy a picnic, or go fishing. Facilities at this day-use park include bathrooms, pedestal grills, and picnic tables.

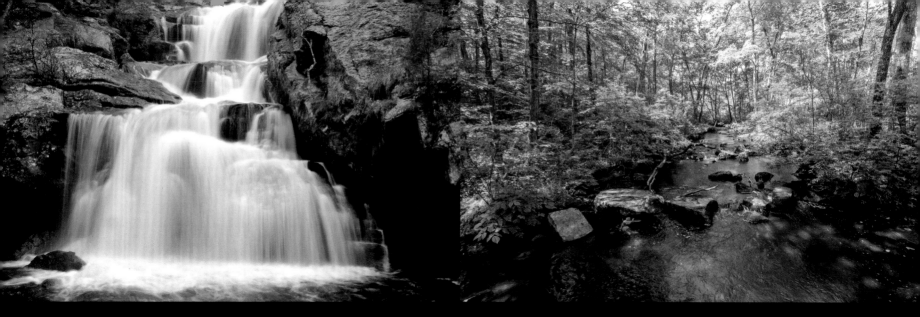

Devil's Hopyard State Park

At Devil's Hopyard State Park in East Haddam, Connecticut, activities include hiking, stream fishing, birding, camping, and picnicking. Chapman Falls is pictured above.

Gay City State Park

Gay City State Park in Hebron, Connecticut, offers more than 1,500 acres where you can swim, hike, bike, pond fish, picnic, and explore the ruins of a now-extinct mill-town.

Bigelow Hollow State Park

Bigelow Hollow State Park and the adjoining Nipmuck State Forest in eastern Connecticut offer more than 9,000 acres for enjoying nature. Activities include hiking, picnicking, boating, pond fishing, hunting, scuba diving, cross-country skiing, and snowmobiling.

Harkness Memorial State Park

Other Connecticut State Parks

- Burr Pond State Park (Torrington)
- Chatfield Hollow State Park (Killingworth)
- Harkness Memorial State Park (Waterford)
- Penwood State Park (Hartford County)
- Wadsworth Falls State Park (Middletown)

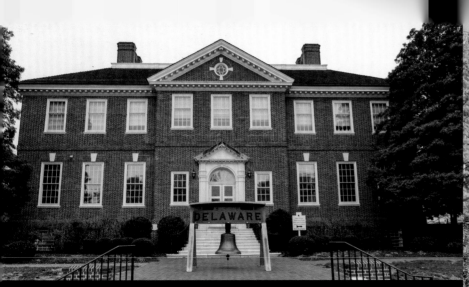

First State Heritage Park

An "urban park without boundaries," First State Heritage Park links historic and cultural sites in Delaware's capital city. Dover has been the state's government seat since 1777 but the state park designation came along in 2004. The park's name highlights Delaware's role as the first state to ratify the U.S. Constitution. Free programs and events are offered on the first Saturday of every month. The Welcome Center & Galleries (above) offers free parking, information for visitors, and a gallery of changing exhibits on Delaware history.

Wilmington State Parks

Situated along Brandywine Creek, Wilmington State Parks is actually a collection of three smaller parks–Brandywine (above), Rockford, and H. Fletcher Brown. Brandywine, which features a 12-acre zoo, is the oldest of the trio (claiming park status since 1886). Rockford's tower is one of Wilmington's most famous landmarks. The smallest of the three, H. Fletcher

Trap Pond State Park

Trap Pond State Park, near Laurel, is one of Delaware's oldest state parks, and owns the country's northernmost natural stand of bald cypress trees. Boating and fishing are popular on the pond, which was created in the 1700s to power a sawmill. Hiking and camping are also popular at this park.

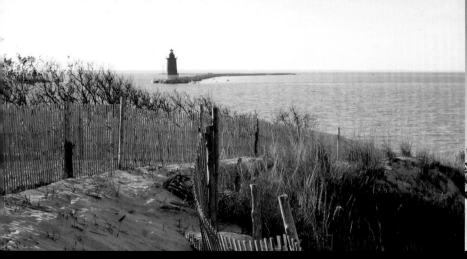

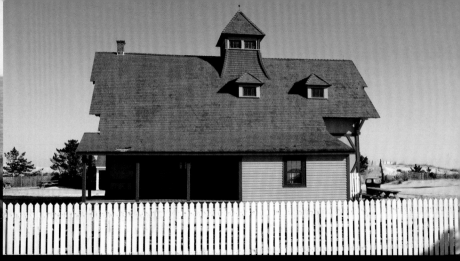

Cape Henlopen State Park

At more than 5,300 acres, Cape Henlopen State Park is Delaware's largest state park. Cape Henlopen was one of the first public lands established in the late 1600s. It includes the remains of Fort Miles (World War II) and offers views of two lighthouses in the National Harbor of Refuge and Delaware Breakwater Harbor.

Delaware Seashore State Park

Delaware Seashore State Park is a barrier island surrounded by the Atlantic Ocean, Rehoboth Bay, and Indian River Bay. Camping, swimming, and clambakes are popular here. The Indian River Life Saving Station (above), built in 1876, holds reenactments of 19th century ship-saving techniques.

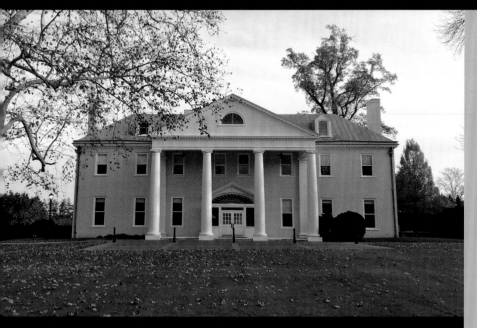

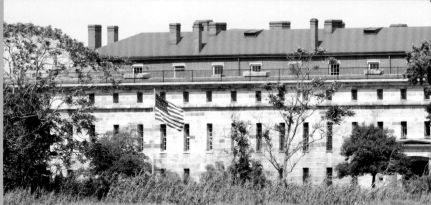

Fort Delaware State Park

Bellevue State Park

Bellevue State Park in suburban Wilmington was named for Bellevue Hall (shown here), the former mansion of William du Pont Jr. The grounds, acquired by the state in 1976, include walking trails, a stocked catch-and-release fishing pond, gardens, tennis courts, and equestrian stables.

Give Them the Gold

Delaware State Parks won the national gold medal for excellence in parks and recreation management from two national parks organizations in 2015. The award goes annually to the state park system that "address the needs of those they serve through the collective energies of citizens, staff and elected officials."

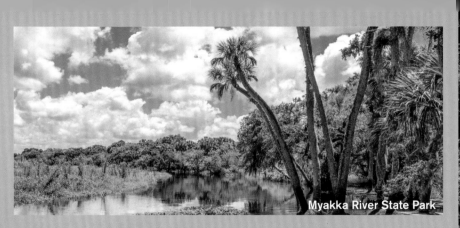
Myakka River State Park

Florida's State Parks System

Florida's state land system is made up of:

- 112 state parks
- 17 state historic sites
- 17 state preserves
- 4 state forests
- 1 state memorial

Myakka River State Park

Myakka River is one of the largest and oldest state parks in Florida. Established in 1941, it covers 37,000 acres in Manatee and Sarasota counties, and the river itself flows through 58 square miles of wetlands, prairies, hammocks, and pinelands. Five palm log cabins, built by the Civilian Conservation Corps in the 1930s, have been modernized for use.

Cayo Costa State Park

Nine gorgeous miles of Gulf Coast beaches await those who make it to Cayo Costa, which is accessible only by private boat or ferry from Pineland. Also found on this barrier island are nine forests, mangrove swamps, and a wide array of wildlife. It's not unusual to spot dolphins

Anastasia State Park

Just south of historic St. Augustine, which bills itself as the oldest continuously-inhabited city in the U.S., is a paradise on the water. Ponce de Leon landed near Anastasia's sand in 1513. Now, it's a magnet for sunbathing, swimming, camping, and boating, among other activities.

Weeki Wachee Springs State Park

Where else can you witness a mermaid show in a 400-seat submerged theater, enjoy a peaceful riverboat cruise, or hang out on the beach? Weeki Wachee Springs ("Little Spring" or "Winding River" to the Seminole tribe) is a unique destination near Florida's west coast.

(Above) Mermaids have been performing at Weeki Wachee Springs State Park since 1947. Manatees swim in the park's clear waters (pictured on top left).

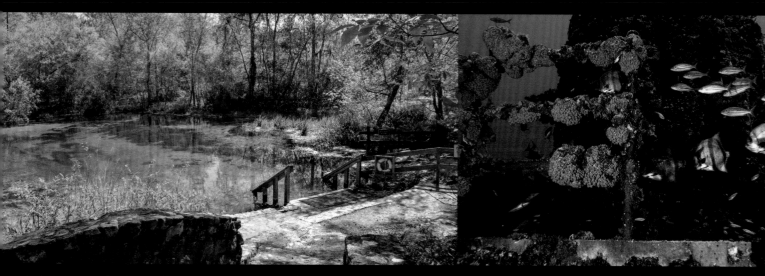

Ichetucknee Springs State Park

Northwest of Gainesville, this state park doubles as a National Natural Landmark. It gained that distinction in 1972, and one look at the Ichetucknee River's crystalline waters flowing through lush wetlands en route to the Santa Fe River is enough to see why. Tubing down the six-mile river is one of the area's most popular pastimes.

John Pennekamp Coral Reef State Park

Covering 70 nautical square miles off Key Largo, John Pennekamp was the first underwater park in the United States. It's a great spot to hang out on dry land, too, but the reefs, their colorful marine life, and the remains of an early Spanish shipwreck are among the underwater attractions that make this park a snorkeler's or scuba diver's paradise.

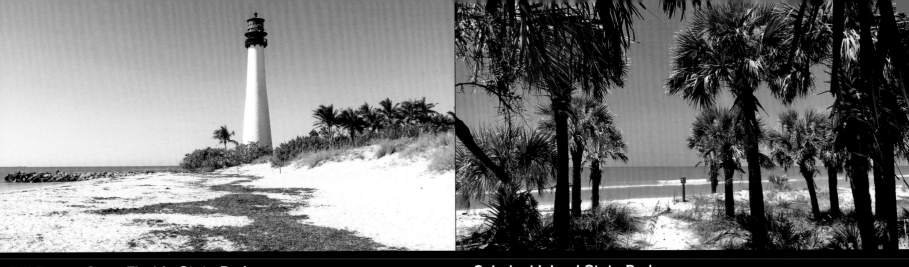

Bill Baggs Cape Florida State Park

The oldest-standing structure in Miami-Dade County—and one of its most popular landmarks—is the 109-step Cape Florida Light that brings visitors to this state park. It was built in 1825 and restored in 1846. Guided tours of the lighthouse and keeper's cottage are given twice daily Thursday through Monday. The beach here has also been ranked among the very best.

Caladesi Island State Park

The white sand beaches along the shores of Caladesi—one of the rare completely natural islands along the Florida coast—have consistently been ranked among the best in the country. Once arriving by ferry from Honeymoon Island State Park or private boat, visitors can walk a three-mile nature trail across the island or kayak that same distance through the mangroves.

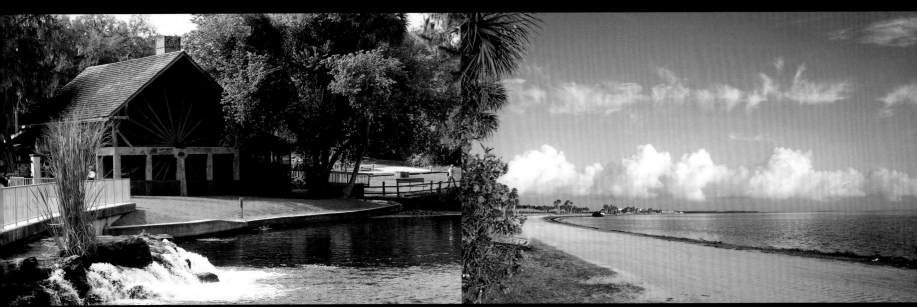

De Leon Springs State Park

Named for Spanish explorer Ponce de Leon, the spring waters here were once thought to be the "Fountain of Youth" he was seeking. Though no one has gained immortality from them, the park outside Orlando, Florida, is worth a visit not only for a dip in the 68-degree (year-round) water but also a boat tour, the Old Spanish Sugar Mill, and some delightful

Honeymoon Island State Park

A break from the hotel- and shop-lined beaches of the Tampa–St. Pete area, Honeymoon Island State Park is a short drive across the Dunedin Causeway to inviting sand, mangrove swamps, and bird observation areas. It was originally called Hog Island but renamed in 1939 when 50 thatched bungalows were built to entice honeymooners.

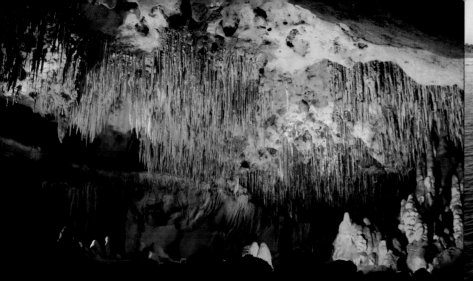

Florida Caverns State Park

Florida's low elevation profile precludes most homes from having basements, so the existence of caves with fascinating stalagmites, stalactites, soda straws, and flowstones is a true treat in the Panhandle. The only Florida state park with air-filled caves open to the public, Florida Caverns offers year-round guided cave tours along with an audiovisual program.

Sebastian Inlet State Park

One of the most visited state parks in Florida, Sebastian Inlet owes a large chunk of its popularity to its fish—or, rather, its fishing. Surrounded by water at the tip of two barrier islands, it yields snook, redfish, bluefish, and Spanish mackerel, among others. It's considered the best saltwater fishing destination on Florida's east coast.

Rainbow Springs State Park

Near Ocala, Florida's "horse country," flows a spring that evidence suggests has been around for some 10,000 years. The water comes from several vents, rather than one large spring. The resulting Rainbow River is a delight on a hot day for swimmers and snorkelers and also accommodates many a kayak. Camping is popular here.

Collier-Seminole State Park

Camping, boating, and canoe rentals are popular at this scenic Naples-area state park, but history buffs will also be captivated. The Bay City Walking Dredge, used to construct the Tamiami Trail (Highway 41) from Tampa to Miami through the Florida Everglades, is a National Historic Mechanical Engineering Landmark.

Lovers Key State Park

One of four barrier islands that make up Lovers Key State Park, Lovers Key was once accessible only by boat. Having merged with a county park in 1996, its two miles of Gulf Coast beaches can now be reached by boardwalk or tram. Canoes, kayaks, and bikes are available for rent.

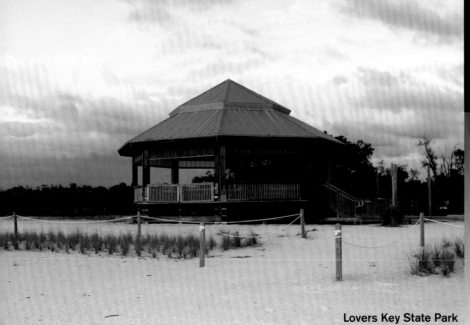

Lovers Key State Park

Big Talbot Island State Park

Photographers and nature lovers adore Big Talbot Island State Park, a peaceful Jacksonville gem that can trace its history of human occupancy to 4000 B.C. The endangered wood stork, egrets, herons, ibis, and ospreys can occasionally be spotted in its marshes. Boneyard Beach (pictured on right) is famous for its unique oak and cedar "skeletons."

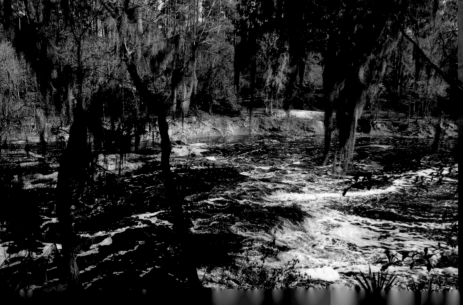

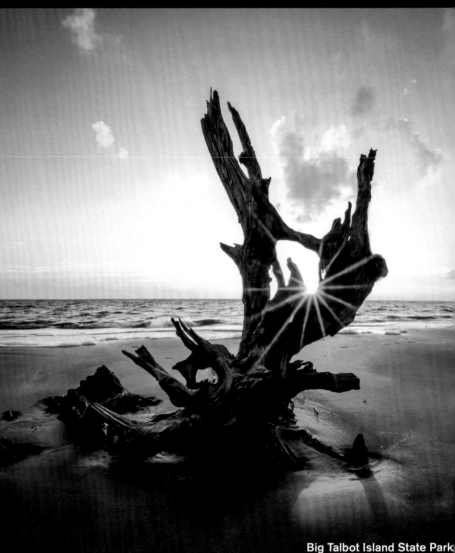

Big Talbot Island State Park

Big Shoals State Park

Big Shoals State Park, just outside White Springs in the northern part of the state, boasts Florida's largest whitewater rapids. The Class III rapids on the Suwanee River are a popular destination for canoers, kayakers, and thrill-seekers. The park also has more than 28 miles

Hillsborough River State Park

One of Florida's first state parks, Hillsborough River State Park opened in 1938. Canoeing and kayaking, sometimes among the gators, is a popular activity on this Tampa-area river. The park also has a swimming pool and a replica of a fort from the Second Seminole War.

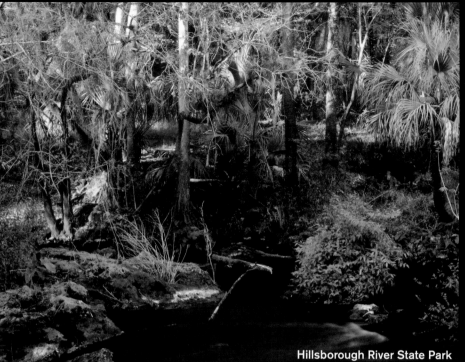

Hillsborough River State Park

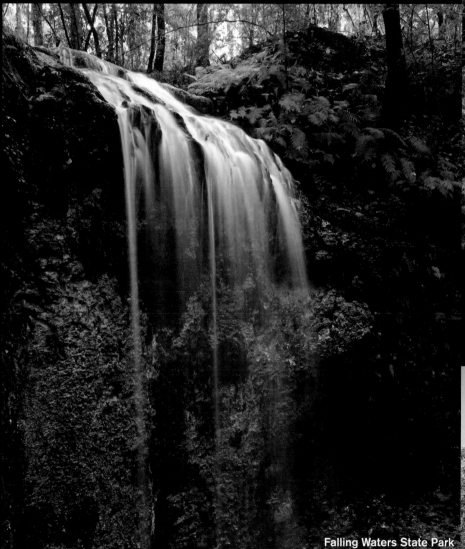

Falling Waters State Park

The centerpiece of Falling Waters State Park in the Florida Panhandle is the state's tallest waterfall. Tumbling more than 70 feet, Falling Waters Falls (left) is the action hero in an otherwise serene oasis just south of Interstate 10. Hiking trails and camping are popular.

Falling Waters State Park

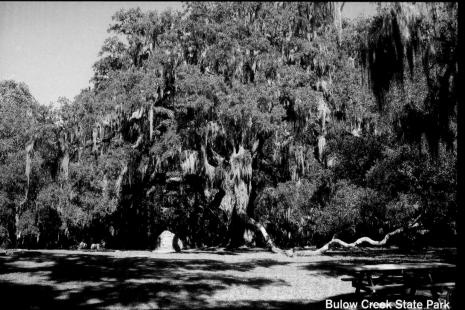

Bulow Creek State Park

Bulow Creek State Park protects one of the largest remaining stands of southern live oak on Florida's east coast. The Fairchild Oak (pictured on right) is several hundred years old and a popular photo subject. A seven-mile trail leads hikers to Bulow Plantation Ruins Historic State Park.

Bulow Creek State Park

Blue Springs State Park

Gold Times Three

The National Recreation and Park Association and the American Academy for Park and Recreation Administration annually award one gold medal for excellence in the management of state park systems. In 2013, Florida became the first three-time winner of the award. The Sunshine State also took gold in 1999 and 2005.

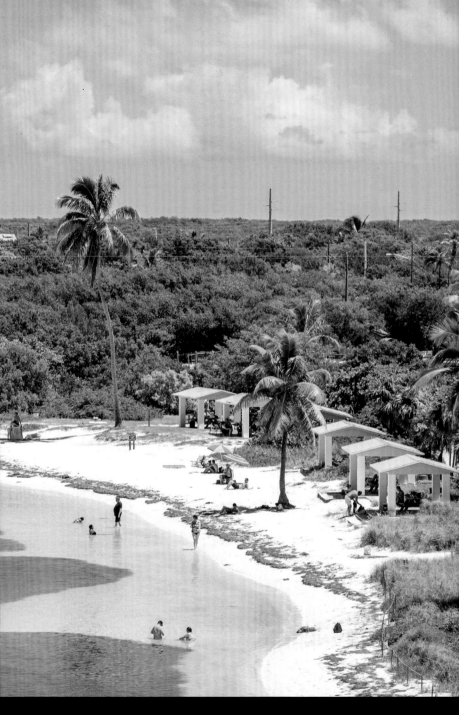

Crystal River Preserve State Park
Crystal River Preserve State Park borders 20 miles of the northern Gulf Coast between Yankeetown and Homosassa. Bald eagles, wood storks, and manatees are among the animal life visitors might see while enjoying the river, marshes, or wide variety of hiking trails.

Bahia Honda State Park
The bright blue waters of Bahia Honda State Park in the Florida Keys became hugely popular in the early 1900s when tycoon Henry Flagler ran his railroad through the area on its way to Key West. The snorkeling and sunsets in this beautiful beach park are second to none.

John D. MacArthur Beach State Park

Kayaking is just one of many options in Palm Beach County's John D. MacArthur Beach State Park. Sea turtles nest along the park's shores, and visitors enjoy a wide array of plant and animal life.

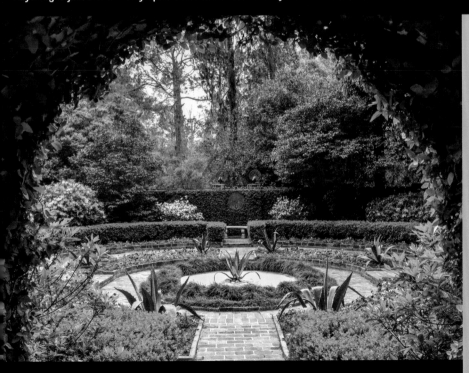

Alfred B. Maclay Gardens State Park

This state park in Tallahassee features a secret garden, a walled garden, a reflecting pool, and hundreds of camellias and azaleas.

Wekiwa Springs State Park

Other Florida State Parks

- Blue Spring State Park (Orange City)
- Fakahatchee Strand Preserve State Park (Naples)
- Grayton Beach State Park (Santa Rosa Beach)
- Little Manatee River State Park (near Tampa)
- Wekiwa Springs State Park (Apopka)

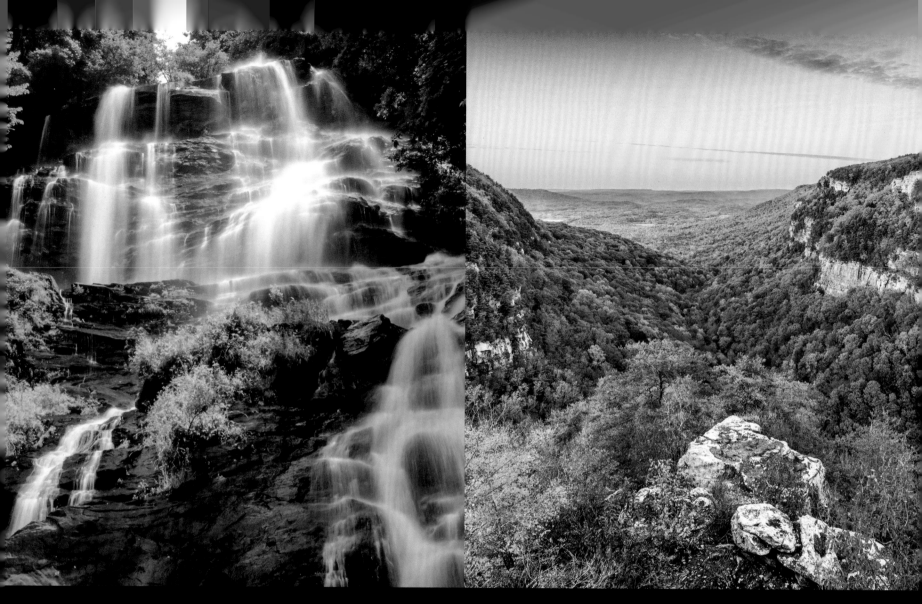

Amicalola Falls State Park

A hiker's paradise unfolds at Amicalola Falls State Park in northern Georgia. Twelve miles of trails weave through the picturesque Appalachian Mountains and lead to the Amicalola Watershed and Amicalola Falls. At 729 feet, Amicalola Falls (above) is the tallest waterfall in Georgia and one of the tallest east of the Mississippi River. Its name means "Tumbling Waters" in Cherokee.

Visitors can stay at the modern lodge near the falls, which has 57 rooms. Travelers can also stay at the remote Len Foote Hike Inn, accessible by a five-mile hike along the Hike Inn Trail. The secluded inn's 20 rooms are arranged around a two-story lobby. The rustic inn provides many gorgeous panoramas of oak and hickory forests with mountain laurel and rhododendron

Cloudland Canyon State Park

Located on the western edge of Lookout Mountain, Cloudland Canyon State Park is one of Georgia's most scenic and rugged parks. The park straddles a deep gorge cut into the mountain by Sitton Gulch Creek, and is home to 1,000-foot deep canyons, waterfalls, wild caves, dense woodland, and abundant wildlife. The park offers exceptional hiking, mountain biking, and horseback riding trails; caving trips; a disc golf course; a fishing pond; picnicking grounds; and interpretive programs. Overnight visitors can choose from comfy cottages, quirky yurts, or a range of campsites.

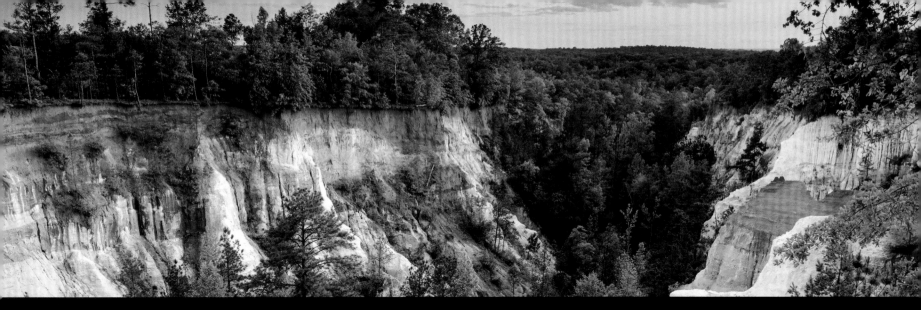

Providence Canyon State Outdoor Recreation Area

Providence Canyon has been dubbed Georgia's "Little Grand Canyon"–and for good reason. Peering up at its walls from the valley floor, visitors are treated to a striking array of orange, red, pink, and purple hues, similar to those found at the famous Arizona canyon. The 150-foot-deep canyon encompasses more than 1,100 acres. It was formed by erosion after settlers clear-cut the land in the 1800s. In the 1930s, the Civilian Conservation Corps planted trees and plants in an effort to slow the process. In 1971, the unique area became a state park. Despite its unlikely roots, Providence Canyon State Outdoor Recreation Area provides breathtaking vistas, numerous hiking trails, fossilized areas, and a chance to commune with nature.

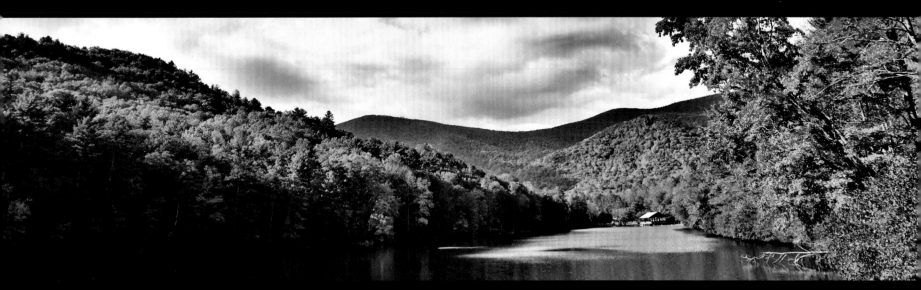

Vogel State Park

Vogel State Park, nestled in Chattahoochee National Forest, is one of Georgia's oldest and most popular state parks. Many park facilities were built by the Civilian Conservation Corps during the Great Depression. The park's Vogel Museum tells the story of the Civilian Conservation Corps' activities in Georgia. Hikers can choose from a variety of trails, including the popular 4.1-mile Bear Hair Gap Trail, the easy 1-mile loop around Lake Trahlyta (above), and the challenging 12.9-mile Coosa Backcountry Trail. Overnight accommodations include cottages and tent, trailer, and RV campsites.

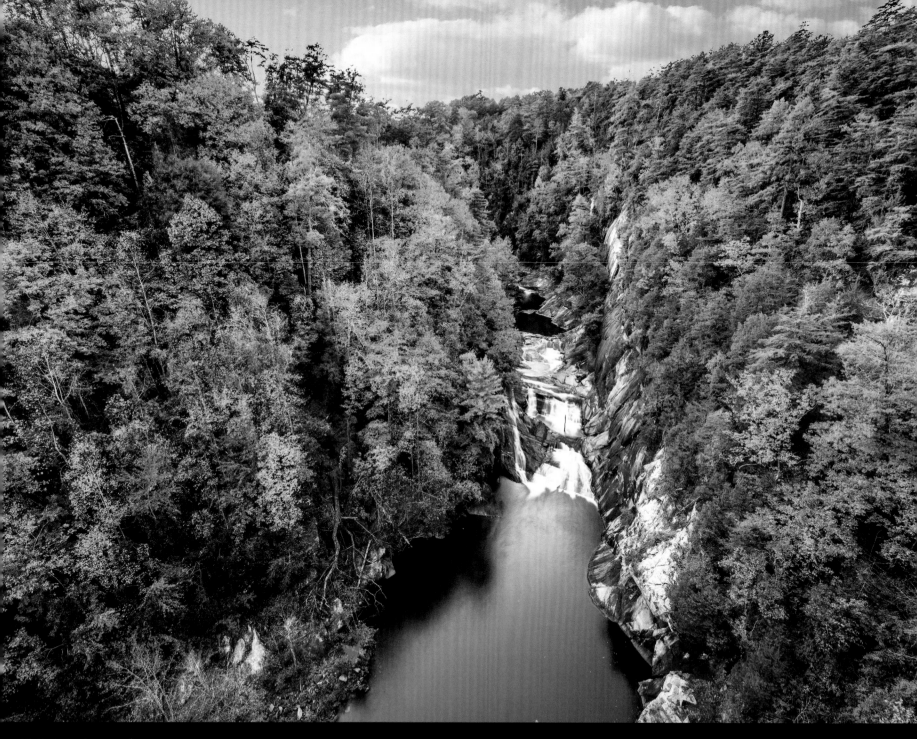

Tallulah Gorge State Park

Tallulah Gorge State Park offers stunning views of the nearly 1,000-foot canyon, thundering waterfalls, and a swaying suspension bridge crossing the Tallulah River. The gorge is one of the Seven Natural Wonders of Georgia (the others being Okefenokee Swamp, Stone Mountain, Providence Canyon, Amicalola Falls, Warm Springs, and Radium Springs).

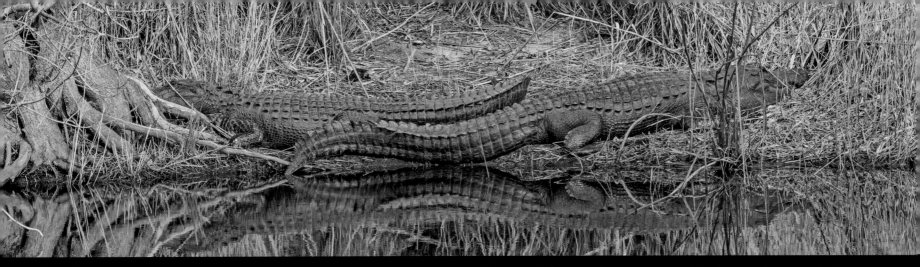

(Above) American Alligators on the bank of the Okefenokee Swamp in Stephen C. Foster State Park. The swamp is home to alligators, raccoons, black bears, and numerous bird species.

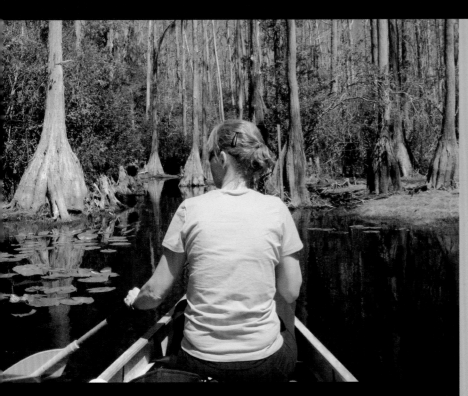

Fort Mountain State Park

Best Georgia State Parks for Hiking

- Amicalola State Park
- Black Rock Mountain State Park
- Cloudland Canyon State Park
- F.D. Roosevelt State Park
- Fort Mountain State Park
- Providence Canyon State Park
- Tallulah Gorge State Park
- Skidaway Island State Park
- Sweetwater Creek State Park
- Unicoi State Park
- Vogel State Park

Stephen C. Foster State Park

Visit the Stephen C. Foster State Park in southern Georgia to explore the Okefenokee Swamp, another one of Georgia's Seven Natural Wonders. The park offers canoe, kayak, and fishing boat rentals as well as guided boat tours.

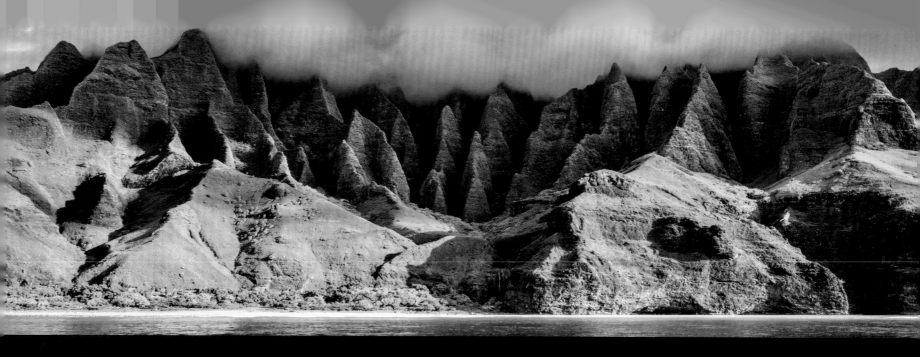

Napali Coast State Wilderness Park

The Napali Coast on the island of Kauai is one of the most beautiful coastlines in the world. The *pali*, or cliffs, extend as much as 4,000 feet above the Pacific's blue waters. The Kalalau Trail (pictured on right) provides the only land access along the remote and rugged coast. Napali Coast State Wilderness Park is inaccessible to vehicles. The best way to view the entire Napali Coast is from the air or sea. Local companies offer helicopter and boat tours.

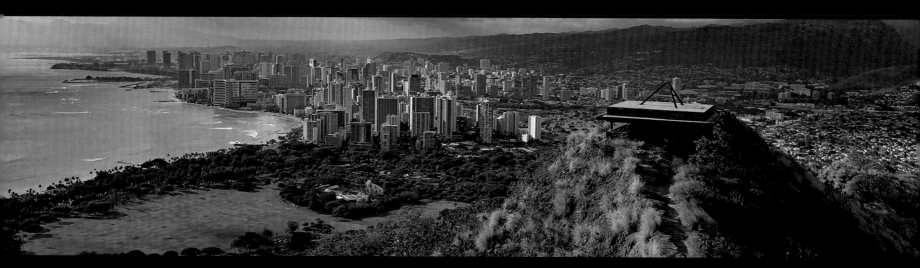

Diamond Head State Monument

Diamond Head (Lēʻahi) is one of Hawaii's most iconic geological features and a National Natural Landmark. The large, saucer-shaped crater was formed by a volcanic eruption some 300,000 years ago. The 0.8-mile hike to the summit is steep and strenuous. Once you reach the top, you'll be treated to a panoramic view of Honolulu and Waikiki. Allow 1.5–2 hours round-trip for

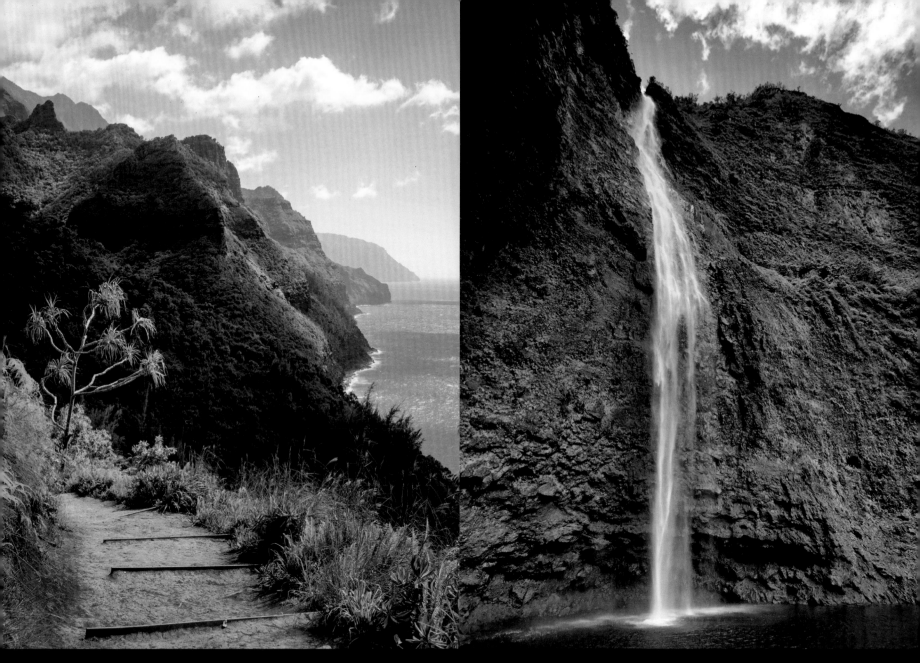

Kalalau Trail

The Kalalau Trail traverses five valleys before ending at Kalalau Beach where it is blocked by sheer, fluted cliffs. The 11-mile trail takes about a day to traverse (one-way). The first two miles, from Haʻena State Park to Hanakapiʻai Beach, make a popular day hike. From there, you can take a 1.8-mile trek inland to view the spectacular Hanakapiʻai Falls, adding another four hours hike time. Completing the entire Kalalau Trail is only recommended for experienced hikers. To hike beyond Hanakapiʻai valley, you must have a valid overnight camping permit.

Hanakapiʻai Falls

Named for a Hawaiian princess, Hanakapiʻai Falls are a popular destination for experienced hikers on the Kalalau Trail, located within Napali Coast State Wilderness Park. The beautiful, 300-foot ribbon of water cascades down a rugged volcanic wall, tumbling into an idyllic pool.

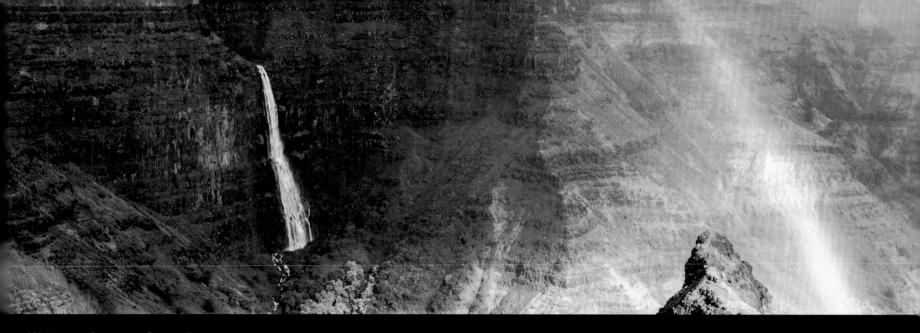

Waimea Canyon State Park

Dubbed "The Grand Canyon of the Pacific" by Mark Twain, Waimea Canyon's sharply eroded cliffs reveal layers of vivid colors that seem to change in the sun. Unlike the Grand Canyon, plentiful rainfall keeps this canyon and its surrounding area thick with vegetation, and visitors are frequently treated to the sight of vivid rainbows. At ten miles long, one mile wide, and more than 3,500 feet deep, Waimea Canyon (on the Hawaiian island of Kauai) is the largest canyon in the Pacific.

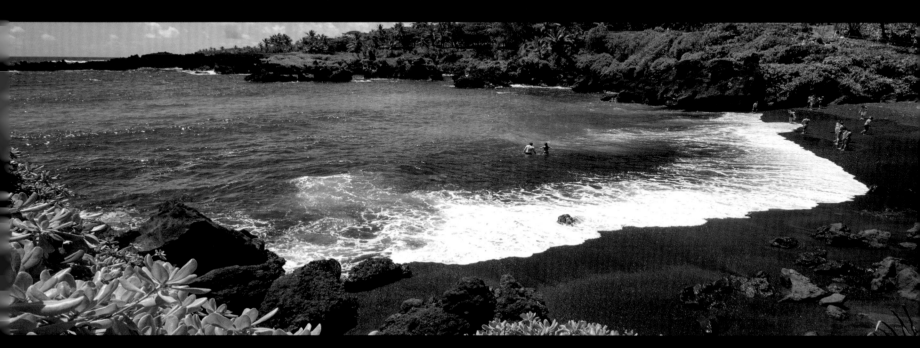

Waianapanapa State Park

For a unique beach experience, visit Waianapanapa State Park in Hana, Maui. The black sand beach is framed by lava cliffs and backed by bright green naupaka bushes.

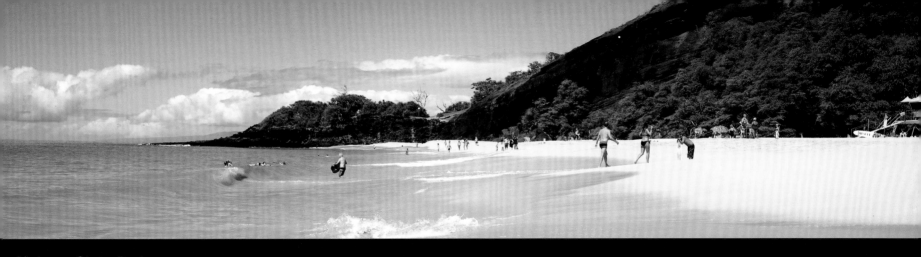

Makena State Park

Makena State Park on Maui is a great place to swim, snorkel, and body surf. Makena covers 165 acres and includes two beaches and Pu'u Olai, a 360-foot-tall dormant cinder cone at the center of the park.

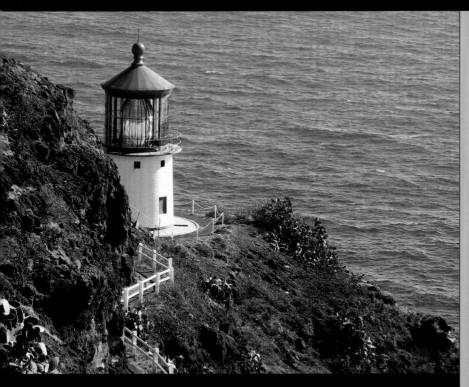

Akaka Falls State Park

Kaiwi State Scenic Shoreline

Kaiwi State Scenic Shoreline offers stunning views of the Oahu coastline and the Makapuu Lighthouse (above), which is closed to the public. Those who hike the Makapuu Lighthouse Trail (two miles round-trip) are treated to panoramic views of the Pacific. Groups of migratory whales are often spotted in winter.

Other Hawaii State Parks

- Akaka Falls State Park (eastern Hawaii Island)
- Wa'ahila Ridge State Recreation Area (Honolulu)
- Ka'ena Point State Park (westernmost Oahu)
- Wailua River State Park (eastern Kauai)
- Kōke'e State Park (northwestern Kauai)

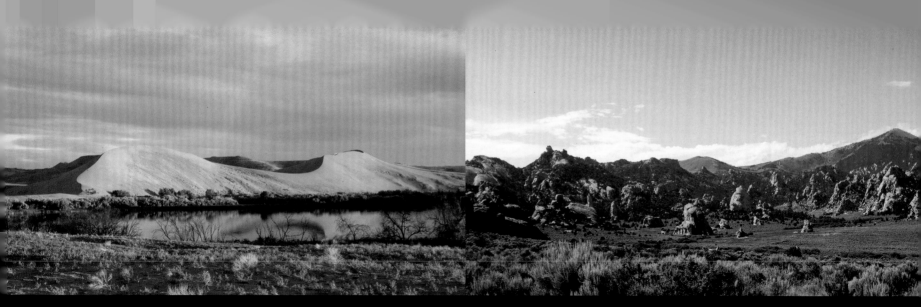

Bruneau Dunes State Park

Sand dunes are the main attraction here, including the tallest single-structured dune in North America (470 feet). Hikers, campers, and nature lovers in this park near Boise will also soak up prairie, lake, and marsh habitat, and the stargazers among them will love the Bruneau Dunes Observatory.

City of Rocks State Park

This state park is also a U.S. national reserve, and a spectacular one at that. Just two miles north of the Utah border, the area is a favorite among rock climbers. Expert climbers refer to it as "The City." Some of the rocks still show the ruts of wagon wheels that rolled over the area along the California Trail.

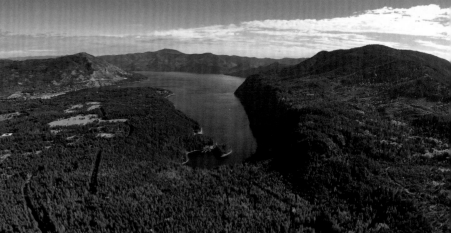

Old Mission State Park

Built in the mid-19th century, Mission of the Sacred Heart (above) is the oldest standing building in Idaho. This Jesuit mission to the Native American Coeur d'Alene people is the centerpiece of this North Idaho park, which also includes the parish house, two cemeteries, a nature trail, and

Farragut State Park

At the southern tip of Lake Pend Oreille is Farragut State Park, a recreation area that once served as a naval training station. Nearly 300,000 sailors were trained here during a 30-month stretch during World War II. A museum commemorates that era, although hiking,

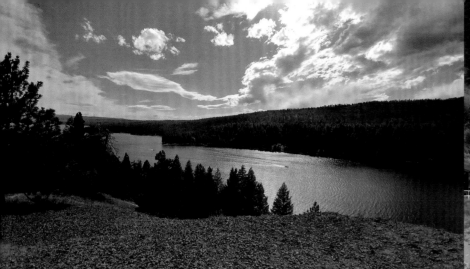

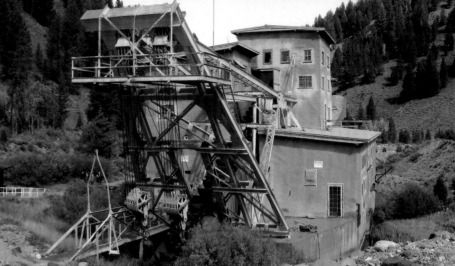

Ponderosa State Park

Near McCall, Ponderosa State Park occupies a peninsula that juts into Payette Lake. Besides scenic overlooks of the lake, the park has boating, swimming, hiking, biking, camping, and winter skiing amid ponderosa pines and Douglas firs.

Land of the Yankee Fork State Park

Idaho's mining history comes to life in Land of the Yankee Fork State Park near Challis. Within the park's 521 acres are three ghost towns: Bayhorse, Bonanza, and Custer. The U.S. Forest Service helps operate this throwback park. The Yankee Fork Gold Dredge is pictured above.

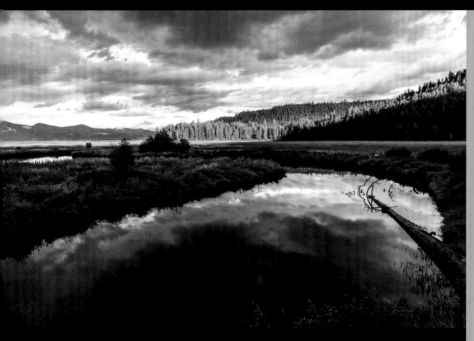

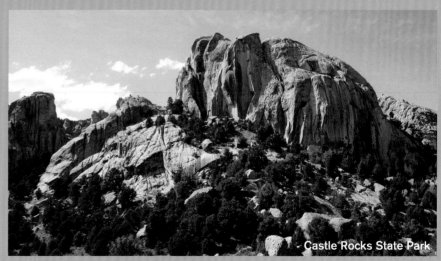

Castle Rocks State Park

Other Idaho State Parks

- Bear Lake State Park (near St. Charles)
- Castle Rocks State Park (near Burley)
- Dworshak State Park (near Orofino)
- Hells Gate State Park (near Lewiston)
- Priest Lake State Park (Priest River)

Heyburn State Park

Heyburn State Park, established in 1908, is the oldest state park in the Pacific Northwest. The Civilian Conservation Corps constructed many of its buildings in the 1930s. Visitors can choose from the many cottages, cabins, and campsites offered.

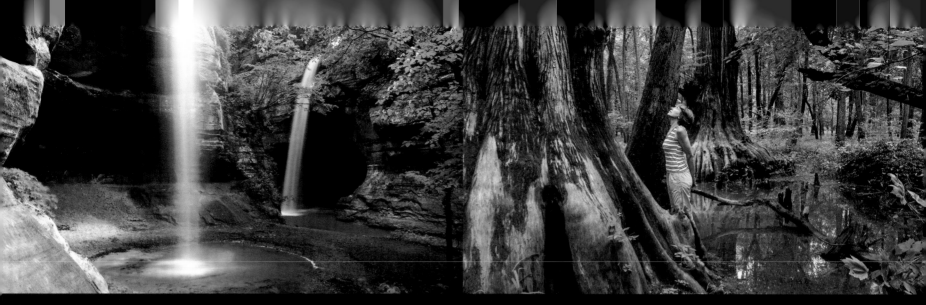

Starved Rock State Park

Starved Rock State Park is one of the top attractions in Illinois, welcoming over two million visitors annually. The park is located along the bank of the Illinois River in LaSalle County, less than 100 miles southwest of Chicago. Starved Rock offers 13 miles of trails, spectacular waterfalls, canyon views, camping, cross-country skiing, fishing, canoeing, and paddleboat cruises.

Cache State River Natural Area

Located in the southern tip of Illinois, Cache State River Natural Area features ancient cypress trees, some at least a millennium old. Canoeing and fishing are popular activities in this tranquil park. Visitors can also see—and hear—any number of waterfowl and shorebirds. The United Nations designated this rare wetland ecosystem as a Wetlands of International Importance.

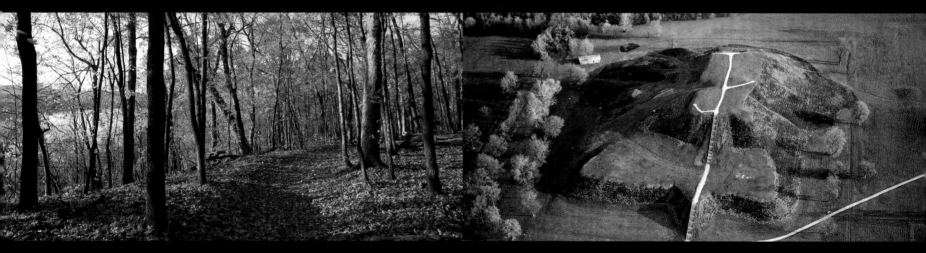

Pere Marquette State Park

At 8,000 acres, Pere Marquette State Park is the largest state park in Illinois. It is nestled along the banks of the Illinois River near Grafton. Outdoor enthusiasts will enjoy the park's nature trails, prehistoric sites, horseback riding, camping, fishing, boating, and hiking. The park also has a wonderful lodge built in the 1930s by the Civilian Conservation Corps. The fireplace alone soars 50 feet into the grand hall, and the great room is rich with massive timber beams and stone.

Cahokia Mounds State Historic Site

Cahokia Mounds State Historic Site near Collinsville has been designated as a United Nations World Heritage Site. It preserves the remains of a pre-Columbian Native American city. Among the most fascinating of the archaeological structures is Monk's Mound (above), a 100-foot-tall, four-tiered platform that covers 14 acres. West of Monk's Mound is a large circle of wooden posts known as Woodhenge. The Interpretive Center provides more information on the site and

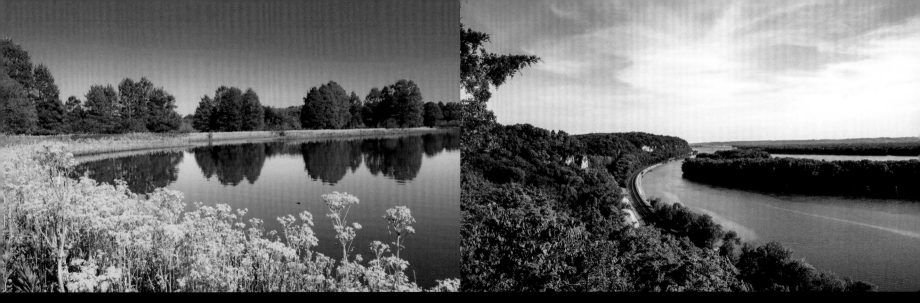

Eldon Hazlet State Park

Eldon Hazlet State Park in Clinton County has some of the state's best camping. The park is located on the western shore of Carlyle Lake (above), the largest man-made lake in Illinois. Visitors can camp, boat, fish, hunt waterfowl, bird-watch, sail, hike, and picnic.

Mississippi Palisades State Park

Mississippi Palisades State Park in northwestern Illinois offers phenomenal views to and from the bluffs (palisades) along the Mississippi River. The facilities for tent and trailer camping, fishing, cross-country skiing, and ice fishing are top-notch.

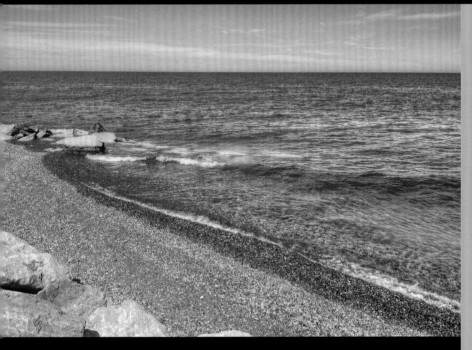

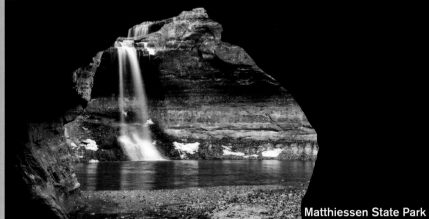

Matthiessen State Park

Illinois Beach State Park

Spanning 6.5 miles along Lake Michigan, Illinois Beach State Park in Zion provides a relaxing retreat just an hour's drive north of Chicago.

Other Illinois State Parks

- Cave-in-Rock State Park (Hardin County)
- Silver Springs State Park (Yorkville)
- Giant City State Park (Makanda)
- Fort Massac State Park (Metropolis)
- Lincoln Trail State Park (Clark County)
- Matthiessen State Park (LaSalle County)

Brown County State Park

Brown County State Park, located in southern Indiana, boasts numerous hiking, mountain biking, and horseback riding trails. You can bring your own horse or enjoy guided trail rides and pony rides at the Saddle Barn. Visitors can go fishing (or ice fishing) on the park's two lakes, visit the Nature Center, climb the 90-foot Fire Tower, picnic, or swim in an Olympic-size pool. Overnight accommodations range from primitive campsites to the Abe Martin Lodge, which offers motel rooms and cabins, banquet and conference rooms, a restaurant, and an indoor water park.

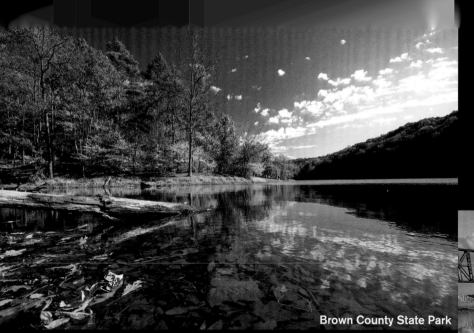

Brown County State Park

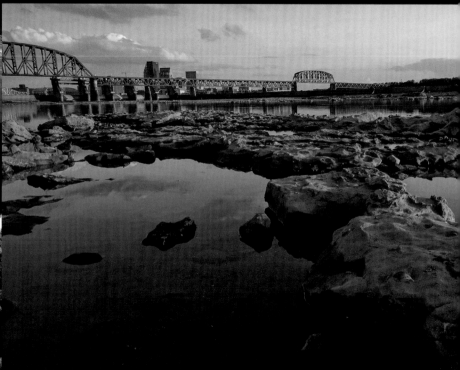

Falls of the Ohio State Park

Falls of the Ohio State Park

Falls of the Ohio State Park in Clarksville offers many nature hikes where you can look at fossil beds and various aquatic habitats. There are also picnic areas and a museum.

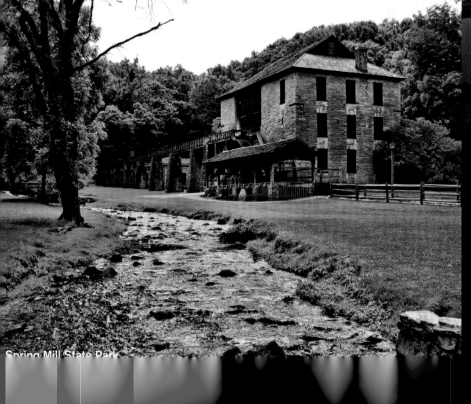

Spring Mill State Park

Spring Mill State Park

Spring Mill State Park includes four interpretive facilities—the Pioneer Village, Nature Center, Grissom Memorial, and Twin Caves Boat Tour—that help visitors understand the link between the environment and the people who shape it. Pioneer entrepreneurs founded an industrial village here in the early 1800s, harnessing the constant water flow from several cave springs to power mills. More than 20 buildings at the park's Pioneer Village show what life was like in the early 1800s, including a sawmill, a tavern, a weaver's shop, and a blacksmith shop. The mill (pictured on left) dates to 1817.

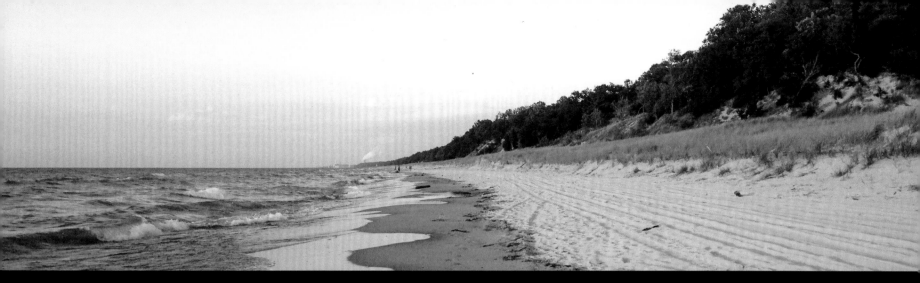

Indiana Dunes State Park

Indiana Dunes State Park has more to offer than its three-mile beach along Lake Michigan. Visitors can climb the towering sand dunes, check out the nature center, hike, swim, bird-watch, picnic, or camp at the 2,182-acre park.

White River State Park

White River State Park is an urban park in Indianapolis. The park is a unique blend of green space and cultural attractions, including the Indianapolis Zoo, Indiana State Museum, Eiteljorg Museum of American Indians and Western Art, NCAA Hall of Champions, White River Gardens, and a premier outdoor concert venue. Tour the park by foot, bike, boat, or Segway.

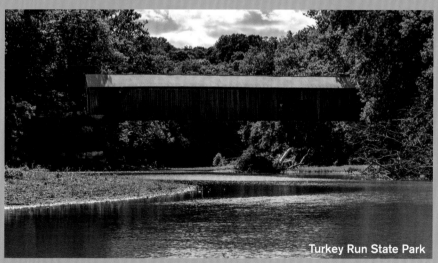

Turkey Run State Park

Other Indiana State Parks

- Turkey Run State Park (Marshall)
- Clifty Falls State Park (Madison)
- McCormick's Creek State Park (Spencer)
- Tippecanoe River State Park (Pulaski County)
- O'Bannon Woods State Park (Harrison County)
- Harmonie State Park (Posey County)

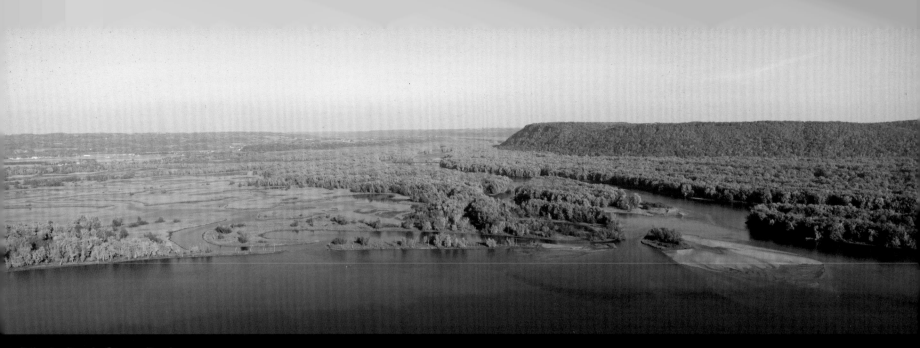

Pike's Peak State Park

If there's a more photogenic spot in Iowa, we're not sure what it might be. Pike's Peak State Park sits at the confluence of the Mississippi and Wisconsin rivers and features a bluff 500 feet above the water. Whatever one decides to do here—camping, hiking, and picnicking are among the favorite activities—the view is sure to be spectacular.

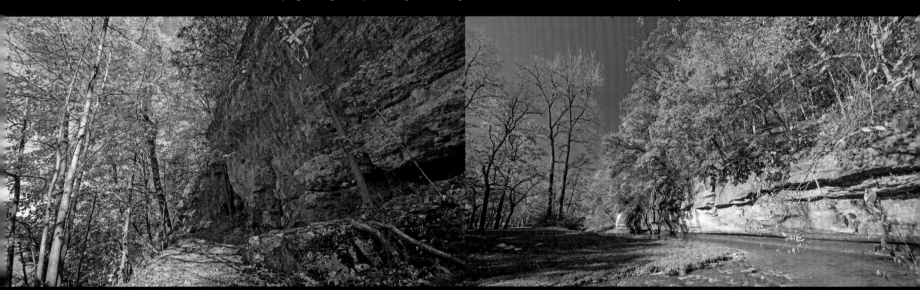

Backbone State Park

Originally named "Devil's Backbone" for its high, steep, and narrow rock ridge carved over centuries by the Maquoketa River, Backbone—Iowa's first state park—offers some of the best hiking, rock climbing, rappelling, trout fishing, and camping in the state. The Devil's Staircase is a challenging hike in this Dundee park that leads to one of the highest spots in northeast Iowa.

Ledges State Park

A stone bridge and Pea's Creek Canyon, a 100-foot gorge, are the masterpieces of this park four miles south of Boone in central Iowa. The former was built by the Civilian Conservation Corps; the latter by millions of years of glacial water. Named for the rock walls above the creek bed, Ledges is among the oldest (1924) and most visited state parks in Iowa.

Palisades-Kepler State Park

Palisades-Kepler State Park, just a few miles outside of Cedar Rapids, is where you'll find many student and professional photographers snapping photos among the fall colors. Its water access, selection of hiking trails, convenient location, and sheer beauty make it one of Iowa's most visited state parks.

Waubonsie State Park

Unique topography in the form of the Loess Hills helps Waubonsie State Park in Iowa's southwest corner stand out among the state's parks. The terrain along the Missouri River is more like that found in drier areas of the country. In addition to hiking for humans, this spot along the Lewis and Clark National Historic Trail also has equestrian trails.

Lacey-Keosauqua State Park

Lacey-Keosauqua State Park, Iowa's largest at 1,653 acres, is located along the Mormon Pioneer Trail and named after Civil War Major John Lacey—the father of the state's park system. Cliffs and valleys along the Des Moines River make for beautiful hiking trails. There's also a lake beach, cottages, and plenty of serene camping.

Fort Defiance State Park

Other Iowa State Parks

- Beeds Lake State Park (Hampton)
- Clear Lake State Park (Clear Lake)
- Fort Defiance State Park (Estherville)
- Lewis and Clark State Park (Onawa)
- Maquoketa Caves State Park (Maquoketa)

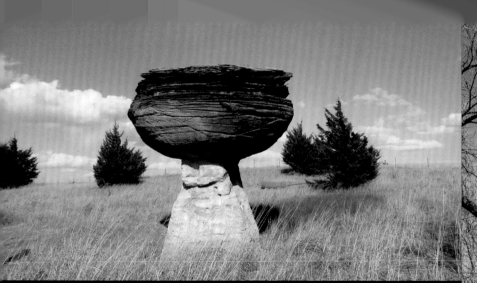

Mushroom Rock State Park

This little 5-acre park in Marquette, Kansas, owes its existence to a process that occurs naturally when sandstone and sedimentary rock meet. Mix in a little calcium carbonate, and you've got a natural cement that holds the formation together. Prairie winds and natural erosion do the rest. The word for this kind of rock formation is *hoodoo*. There are two mushroom hoodoos and several other rock formations in the park.

Just don't expect a pristine display of Mother Nature's sculpting skills. The softer portions of the rocks have been covered in chiseled graffiti. People have been cooling their heels in the shade of these natural umbrellas for centuries. The rocks served as landmarks for Indians as well as for later American pioneers like Kit Carson (he reputedly called the area his "favorite little place").

El Dorado State Park

The largest state park in the Kansas system, El Dorado State Park consists of four primary campgrounds covering 4,000 acres. The park offers trails for hiking, biking, and horseback riding; picnic shelters; swimming beaches; wildlife viewing; and nearly 1,100 campsites that

Cross Timbers State Park

Cross Timbers State Park is located at Toronto Lake in southeastern Kansas. Here, forested flood plains are surrounded by open prairie and hills of oak savanna. Popular pursuits at the park include camping, hiking, mountain biking, swimming, picnicking, boating, and fishing.

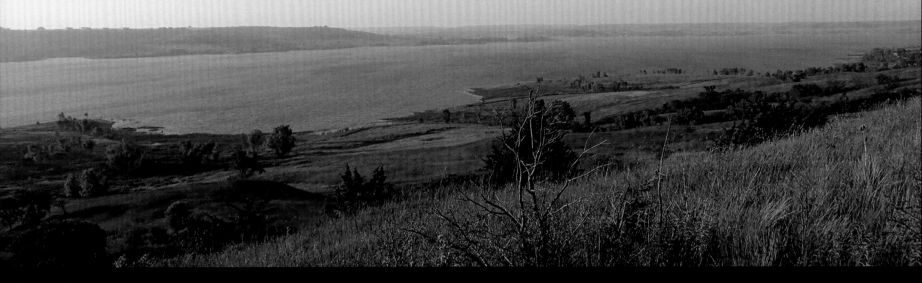

Wilson State Park

Many consider this park in central Kansas to be the most beautiful in the state. The park is located on the southeastern edge of the 9,000-acre Wilson Lake and is a premier recreation destination. The park and surrounding wildlife area offer opportunities for hiking, biking, fishing, boating, waterskiing, swimming, hunting (in the wildlife area), camping, and viewing wildlife.

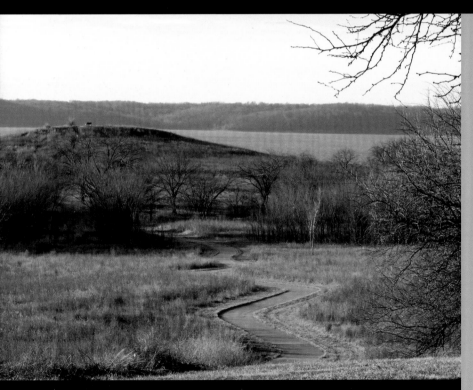

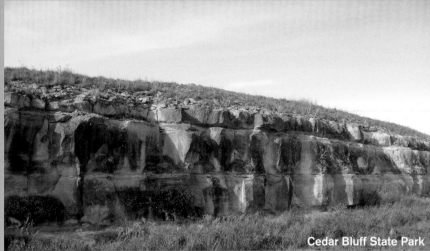
Cedar Bluff State Park

Clinton State Park

Located near Lawrence in eastern Kansas, Clinton State Park is well-known for its system of trails. The park lies along the edge of Clinton Lake and lures nature lovers of all sorts.

Other Kansas State Parks

- Cedar Bluff State Park (near Ellis)
- Crawford State Park (near Farlington)
- Historic Lake Scott State Park (western Kansas)
- Eisenhower State Park (near Osage City)
- Prairie Dog State Park (Norton)
- Hillsdale State Park (Miami County)

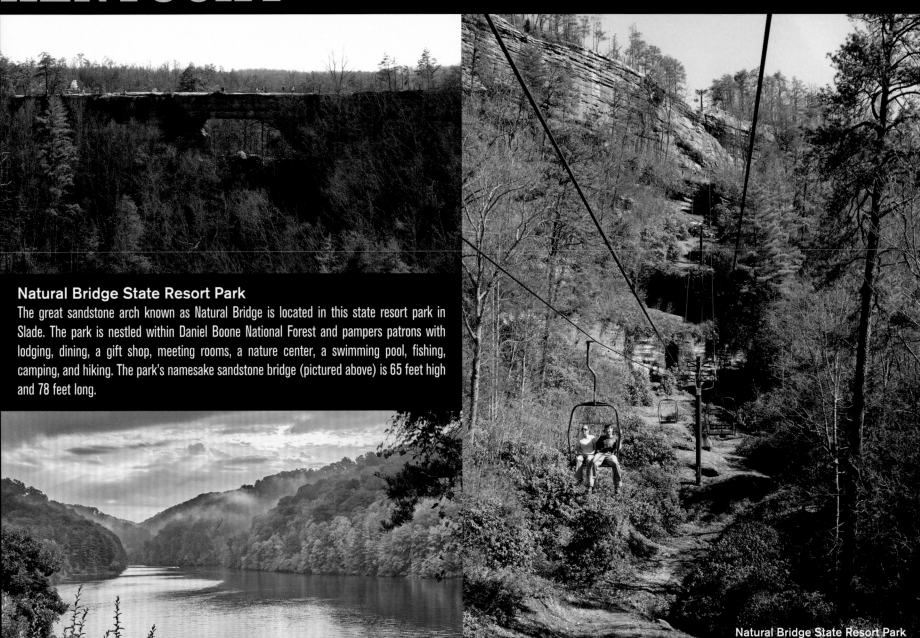

KENTUCKY

Natural Bridge State Resort Park

The great sandstone arch known as Natural Bridge is located in this state resort park in Slade. The park is nestled within Daniel Boone National Forest and pampers patrons with lodging, dining, a gift shop, meeting rooms, a nature center, a swimming pool, fishing, camping, and hiking. The park's namesake sandstone bridge (pictured above) is 65 feet high and 78 feet long.

Natural Bridge State Resort Park

Jenny Wiley State Resort Park

Jenny Wiley State Resort Park is the premier state park in eastern Kentucky. The park is situated on Dewey Lake in the heart of the Appalachian Mountains and was once an area of coal mining. The park offers three mountain biking trails, over 10 miles of hiking trails, outdoor theater performances, a nature center, bird-watching, camping, fishing, and boating on Dewey Lake (pictured above).

(Above) For a different view of the Natural Bridge and some spectacular Kentucky scenery, try the Sky Lift at Natural Bridge State Resort Park. The 22-minute ride carries passengers to within 600 feet of the giant sandstone formation.

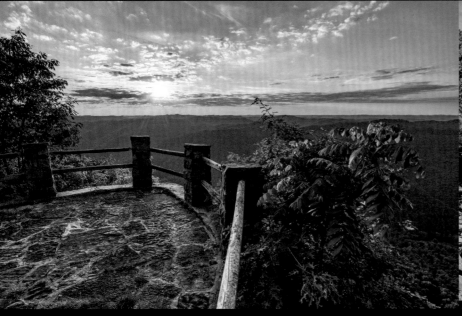

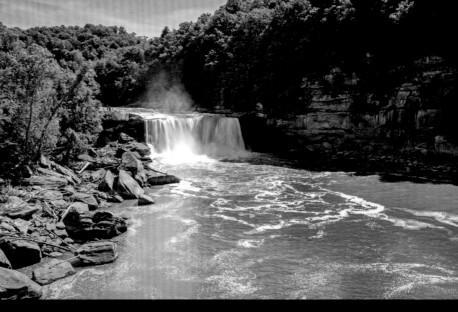

Kingdom Come State Park

At 2,700 feet, Kingdom Come State Park near Cumberland is Kentucky's highest state park. Visitors can admire the views from one of eight scenic overlooks, hike one of the 14 trails, or go fishing for bass, crappie, and trout.

Cumberland Falls State Resort Park

Cumberland Falls State Resort Park is nestled in Daniel Boone National Forest. Cumberland Falls (pictured above) is the park's main attraction and is known as the "Niagara of the South." The falls form a 125-foot-wide curtain of water.

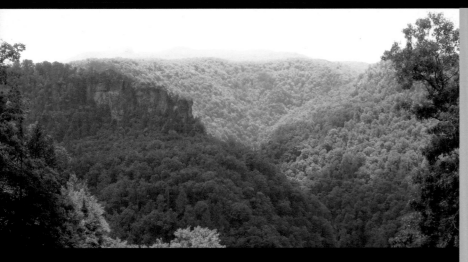

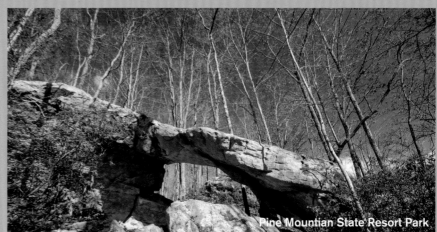

Pine Mountain State Resort Park

Breaks Interstate Park

Breaks Interstate Park straddles the border between southeastern Kentucky and southwestern Virginia. Comprising 4,500 acres of lush mountain scenery and 13 miles of hiking trails, this park is also home to the deepest gorge east of the Mississippi River. The chasm was formed by the rushing waters of the Russell Fork of the Big Sandy River. Visitors can enjoy fishing, paddleboating, guided tours, spelunking, horseback riding, and the driving and biking trails. Accommodations include woodland cottages, campsites, log cabins, and lodge rooms.

Other Kentucky State Parks

- Columbus Belmont State Park (Columbus)
- Dale Hollow Lake State Resort (Burkesville)
- E.P. Tom Sawyer State Park (Louisville)
- Levi Jackson Wilderness Road State Park (London)
- Pine Mountain State Resort Park (Pineville)

LOUISIANA

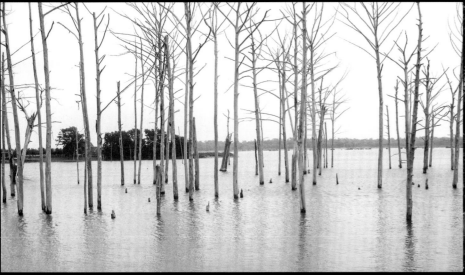

Poverty Point Reservoir State Park

Don't let the name fool you. This park is rich with activities for everyone in the family. The fact that bear-proof containers are available for trash is nod to at least one of the many wildlife varieties in this northern Louisiana treasure. Bird-watching, hiking, camping, and fishing from a stocked lake are among the top activities. There's also a rare, 72-foot Native American mound with a UNESCO World Heritage designation.

North Toledo Bend State Park

Covering one-third of Louisiana's western border, the Toledo Bend Reservoir is the largest man-made lake in the South and a bucket-list destination for those who love to fish. It's been named the best bass fishing lake in the country. Plenty of other activities are available, too, including a pool and playground.

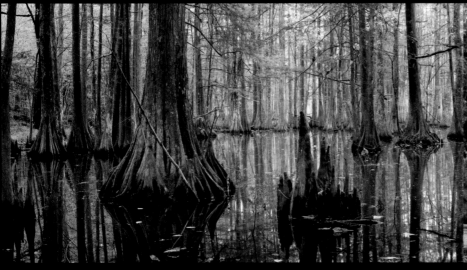

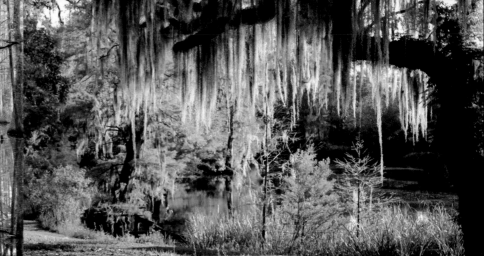

Chicot State Park

In the center of the state, near Ville Platte, is a nature lover's paradise. Chicot is the largest of Louisiana's state parks at 6,400 acres, and it also offers some of the most stunning scenery. It's home to the Louisiana State Arboretum, along with canoeing and kayaking among the cypress trunks peppered around Lake Chicot.

Fontainebleau State Park

On the northern shore of Lake Pontchartrain sits Fontainebleau State Park, on the site of a former sugarcane plantation. Visitors can enjoy the area's rich history at the welcome center or simply soak up the park's scenery and serenity. Live oak dripping with Spanish moss and the occasional gator are among the "photo ops" here.

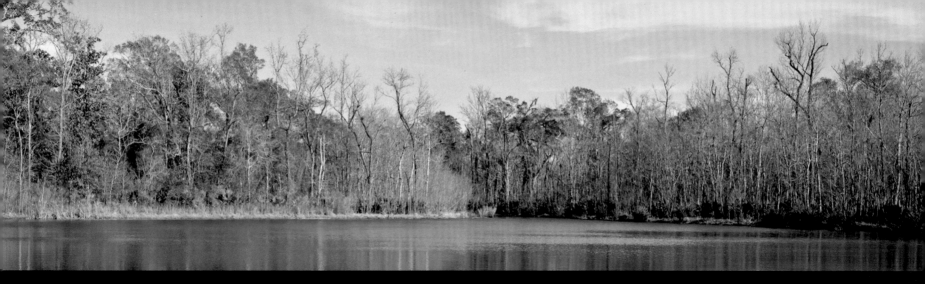

Palmetto Island State Park

Opened to the public in 2010, Palmetto Island State Park has quickly become a favorite among nature lovers. About six miles south of Abbeville in the southern part of Louisiana, it features towering cypress trees, dwarf palmettos, and hidden channels and lagoons perfect for a peaceful canoe or kayak trip. There's also a water playground for the little ones.

Lake Claiborne State Park

Lake Claiborne State Park is a 643-acre park overlooking a man-made lake, its namesake, that's 10 times that size. Cabins, a large beach, boat launch, hiking and biking trails, and a nature center are among the many reasons visitors flock to this popular park near Homer.

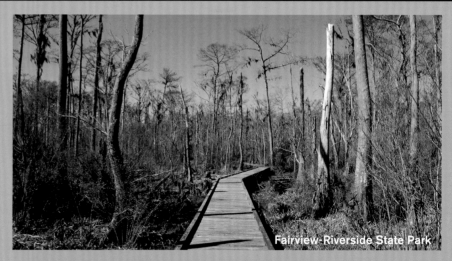

Fairview-Riverside State Park

Other Louisiana State Parks

- Bayou Segnette State Park (Westwego)
- Fairview-Riverside State Park (near Madisonville)
- Grand Isle State Park (Jefferson Parish)
- Lake Bruin State Park (near St. Joseph)
- Sam Houston Jones State Park (near Lake Charles)
- Jimmie Davis State Park (near Chatham)
- Bogue Chitto State Park (near Franklinton)

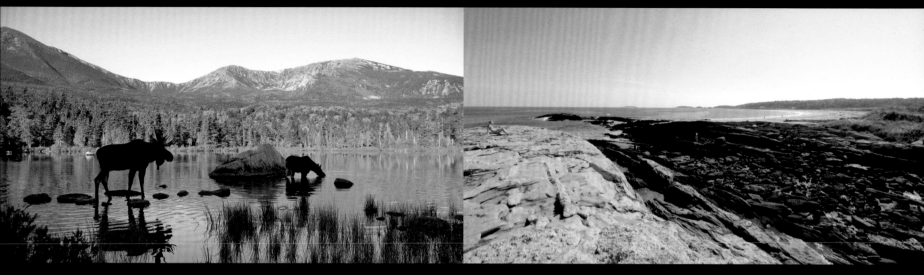

Baxter State Park

Born into wealth, Percival Baxter—who served as Maine's governor for four years in the 1920s—made a project of purchasing and donating land to the state to form Baxter State Park. Today, the park in north-central Maine includes more than 200,000 acres of wilderness. In keeping with Governor Baxter's "forever wild" philosophy, the park offers few creature comforts. Facilities are primitive and services are minimal. There is no electricity, running water, or paved roads. Activities include hiking the park's 215 miles of trails, fishing, hunting, canoeing, kayaking, camping, and viewing the abundant wildlife.

Reid State Park

Reid State Park is located on Georgetown Island, about an hour north of Portland, Maine. Businessman and Georgetown resident Walter E. Reid donated land to the state to preserve in 1946, and Reid State Park became a reality a few years later. The park is known for its sandy beaches and large sand dunes—both of which rare in Maine. The beaches are essential nesting grounds for endangered least terns and piping plovers. Swimming, surfing, bird-watching, fishing, and hiking are popular pursuits here.

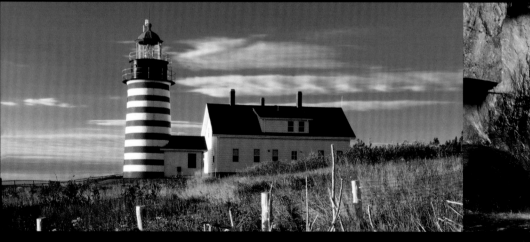

Quoddy Head State Park

Quoddy Head State Park is located at the easternmost point in the continental United States. The park encompasses over 540 acres with diverse plant and animal life, breathtaking views, picnic sites, and hiking trails. But the candy-striped West Quoddy Head Light is the park's most famous feature. First built in 1808, the present tower and house date back to 1858.

Grafton Notch State Park

Grafton Notch State Park is located along Route 26, nestled among the Mahoosuc Range in western Maine. A walking path from Route 26 leads to the 23-foot Screw Auger Falls (pictured above). Both short and longer hikes extend through the 3,000-acre park.

Camden Hills State Park

Visitors who climb Mount Battie at Camden Hills State Park are rewarded with scenic views of Camden, Penobscot Bay, and surrounding islands. The park also offers camping and other hiking opportunities.

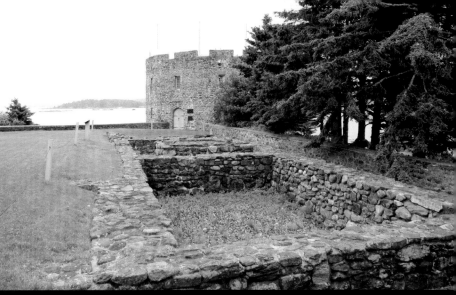

Colonial Pemaquid State Historic Site

Colonial Pemaquid State Historic Site near Bristol, Maine, includes a reconstructed Fort William Henry, the archaeological remains of 17th- and 18th-century village buildings and fortifications, and a museum.

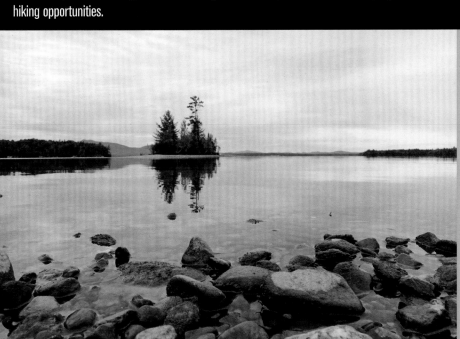

Lily Bay State Park

Located on crystal-clear Moosehead Lake, Lily Bay State Park offers 90 well-spaced campsites (many along the shore), boating, fishing, swimming, and cross-country skiing. An easy two-mile trail along the shoreline provides lovely views of Maine's largest lake.

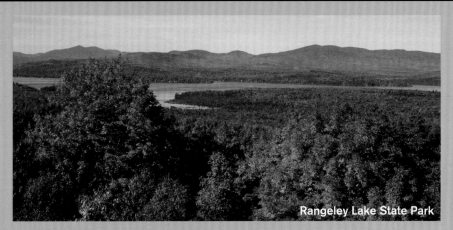

Rangeley Lake State Park

Other Maine State Parks

- Aroostook State Park (Presque Isle)
- Two Lights State Park (Cape Elizabeth)
- Moose Point State Park (Searsport)
- Rangeley Lake State Park (on Rangeley Lake)
- Peaks-Kenny State Park (Dover-Foxcroft)
- Cobscook Bay State Park (Dennysville)
- Lake St. George State Park (Liberty)

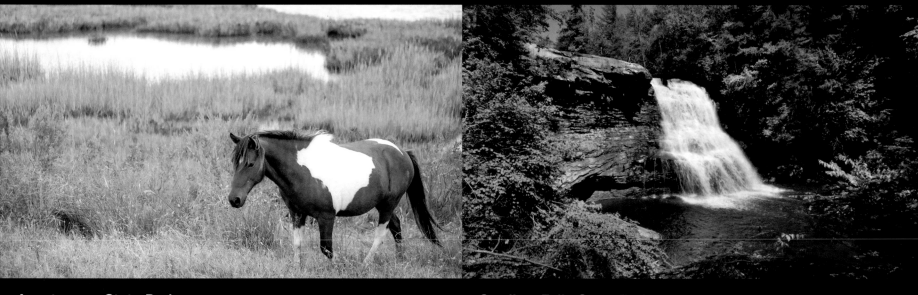

Assateague State Park

Assateague State Park is Maryland's only oceanfront park. The park is located on Assateague Island, a 37-mile-long barrier island bordered by the Atlantic Ocean and Sinepuxent Bay. The park's two miles of sandy ocean beaches are great for swimming, beachcombing, sunbathing, surfing, and fishing. The bayside contains secluded coves to explore in a canoe or kayak. The marsh areas are a bird-watcher's paradise. The park has 342 campsites, some with electric hookups.

Swallow Falls State Park

Swallow Falls State Park offers some of western Maryland's most stunning scenery. The park is home to Muddy Creek Falls (above), Maryland's highest free-falling waterfall at 53 feet. It also contains a stand of virgin hemlock and white pine trees that is over 300 years old. Swallow Falls State Park has 65 campsites, a picnic area with a pavilion and playground, and opportunities for hiking, mountain biking, and fishing.

(Above) Assateague State Park is home to an enormous diversity of birds. Tree swallows stop on Assateague Island to feed on bayberries during their southward migrations.

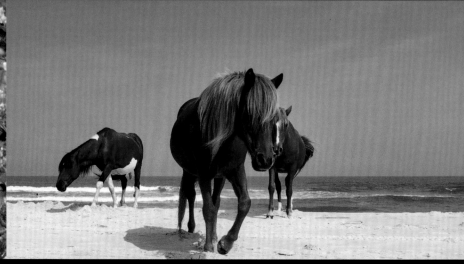

(Above) Visitors to Assateague State Park will likely encounter some of the island's most famous inhabitants—the wild horses. Assateague Island's horses descend from domesticated that reverted back to the wild.

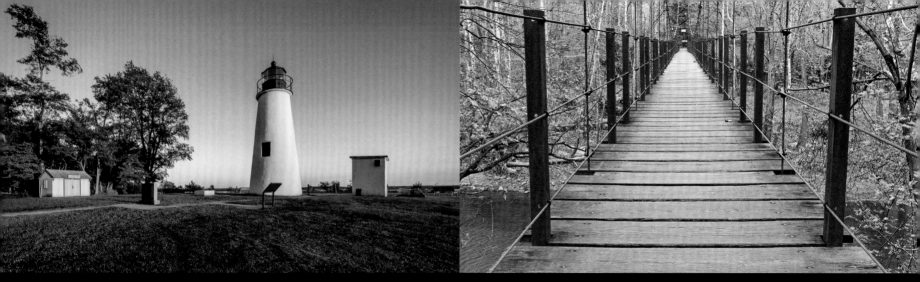

Elk Neck State Park

The varied landscape of Elk Neck State Park includes sandy beaches, marshlands, white clay cliffs, and heavily wooded areas. Located at the southern tip of the Elk Neck Peninsula, Turkey Point Lighthouse (above) offers views of Chesapeake Bay and the North East and Elk rivers.

Patapsco Valley State Park

Patapsco Valley State Park extends along 32 miles of the Patapsco River and encompasses over 16,000 acres. The park is popular for hiking, fishing, camping, canoeing, horseback riding, mountain biking, and picnicking.

Calvert Cliffs State Park

The massive cliffs after which Calvert Cliffs State Park is named dominate 25 miles of Chesapeake Bay shoreline. The cliffs contain a treasure trove of fossils, including prehistoric sharks, whales, rays, and seabirds. Visitors to this day-use park can hunt for fossils at the beach, enjoy a picnic, hike 13 miles of trails, or fish in the pond.

Deep Creek Lake State Park

Other Maryland State Parks

- Hart-Miller Island State Park (Essex)
- Seneca Creek State Park (Montgomery County)
- Susquehanna State Park (Harford County)
- Deep Creek Lake State Park (Garrett County)
- Janes Island State Park (Somerset County)
- Cunningham Falls State Park (near Thurmont)
- Point Lookout State Park (Scotland)

MASSACHUSETTS

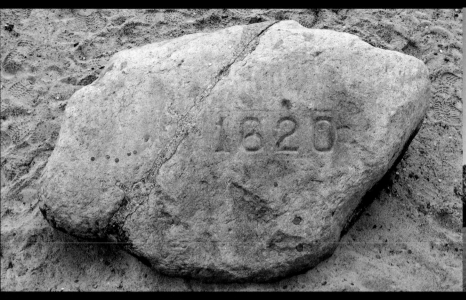

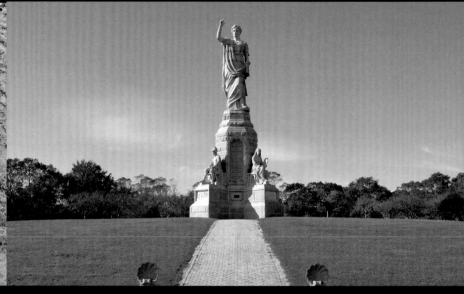

Pilgrim Memorial State Park

In 1620, the *Mayflower* Pilgrims landed in what became Massachusetts. Plymouth Rock marks their traditional landing site. Whether the rock was there at that point is an open question; contemporary documents do not refer to it. Throughout the years, the rock itself has been relocated multiple times. It's also become smaller, as pieces have been chipped off for souvenirs. Plymouth Rock (pictured above) is now housed in a portico at Pilgrim Memorial State Park in Plymouth, Massachusetts. Nearly one million people come to Pilgrim Memorial State Park each year for a dose of history and the pretty views of Plymouth harbor.

(Above) Another monument in Pilgrim Memorial State Park is the National Monument to the Forefathers. The names of the *Mayflower* Pilgrims are inscribed on the monument. The figures shown on the monument are not those of the Pilgrims, but allegorical figures: Faith, which brought the Pilgrims on their journey, stands on the main pedestal. She is surrounded by Morality, Law, Education, and Liberty. The National Monument to the Forefathers in Pilgrim Memorial State Park was dedicated in 1889.

Halibut Point State Park

Visitors to Halibut Point State Park in Rockport can explore the trails and tide pools, picnic on the rocky ledges, and learn about the region's granite quarrying history. The park also offers great bird-watching and beautiful ocean views.

Nickerson State Park

Nickerson State Park is in the inland pine woods of Cape Cod. The 1,900-acre park has several freshwater ponds, miles of trails, and more than 400 campsites. Swimming, fishing, hiking, biking, and paddling are popular here.

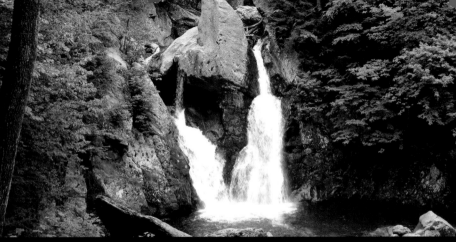

Walden Pond State Reservation

Henry David Thoreau moved to Walden Pond in Concord to get a little peace and quiet and to write. He wrote an account of his time there called *Walden; or, Life in the Woods*. Today, Walden Pond is part of Massachusetts's Walden Pond State Reservation, which includes the 61-acre pond plus another 2,680 acres known as "Walden Woods." Visitors can go swimming, boating, hiking, check out the replica of Thoreau's single-room cabin, and enjoy the landscape that inspired his most famous work.

Bash Bish Falls State Park

Located in southwestern Massachusetts, Bash Bish Falls State Park is great for hiking, fishing, and picnicking. The park is named for the state's highest waterfall, Bash Bish Falls. A boulder splits the falls into two parallel streams. From the Upper Falls parking lot, it's a steep hike down to the base of the falls. Visitors to Bash Bish Falls can also explore the neighboring Mount Washington State Forest or cross the border into New York's Taconic State Park.

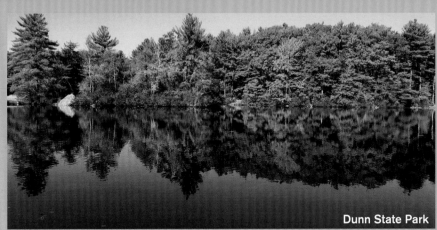

Dunn State Park

Other Massachusetts State Parks

- Dunn State Park (Gardner)
- Wells State Park (near Sturbridge)
- Skinner State Park (Hadley & South Hadley)
- Boston Harbor Islands State Park (Boston Harbor)
- Borderland State Park (Easton & Sharon)
- Maudslay State Park (Newburyport)

Mohawk Trail State Forest

Mohawk Trail State Forest is one of the state's most scenic woodland areas. It covers more than 6,000 acres of mountain ridges, gorges, and old-growth forests. Mohawk Trail State Forest offers hiking trails, trout fishing, swimming, canoeing, kayaking, and year-round camping.

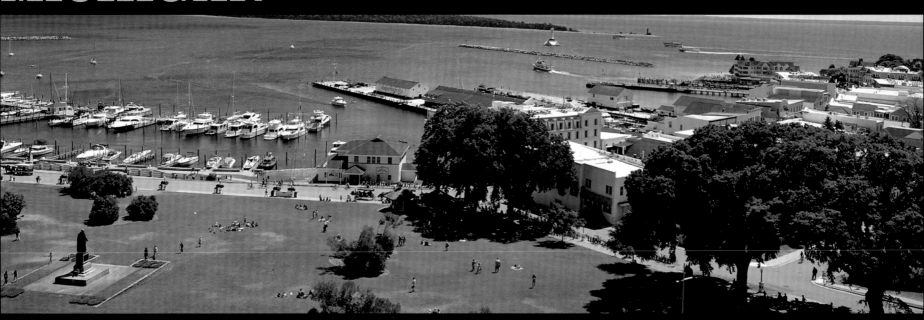

Mackinac Island and Fort Mackinac Historic Park

Mackinac Island is truly a trip back in time. Michigan's first state park (1895, preceding the formation of the state's parks commission), there are no cars allowed, a virtually endless supply of options when it comes to the isle's famous fudge, and a unique appeal that attracts visitors from all over the world. Fort Mackinac is a big draw in the charming downtown area, but hop on a bicycle or horse carriage and explore. Oh, and it's pronounced "MACK-in-aw."

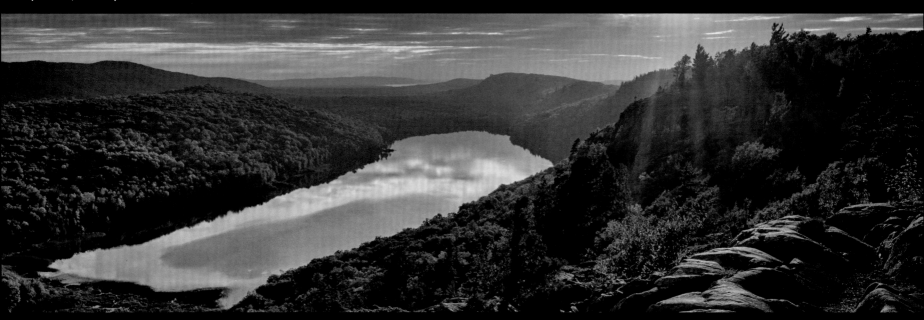

Porcupine Mountains Wilderness State Park

The "Porkies" offer hikers mile after mile of mountain forests untouched by human development. The Ojibwa people named the mountains for their silhouette, which is shaped like a crouching porcupine. The almost 60,000-acre wilderness on the far western side of the Upper Peninsula, touching Lake Superior near Wisconsin, has been a state park since 1944.

Silver Lake State Park

Located in Oceana County, Silver Lake State Park encompasses 3,000 acres along the Lake Michigan shoreline. The park is home to a swimming beach, campgrounds, hiking trails, a mature forest, and nearly 2,000 acres of sand dunes. Perhaps the biggest draw is the park's 450-acre off-road vehicle area. Check out Silver Lake State Park's website for special rules and restrictions about riding ORVs and ATVs at the park.

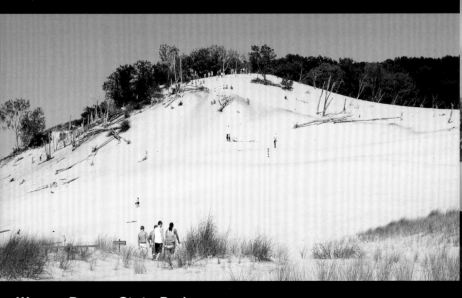

Warren Dunes State Park

Along the eastern shore of Lake Michigan is an almost 2,000-acre park with sand dunes, beaches, two campgrounds, and endless summer fun. Its proximity to Chicago, Indiana, and several good-sized Michigan cities helps Warren Dunes attract more than a million visitors every year. Tower Hill, the largest dune in the park, stands 240 feet above Lake Michigan.

Tawas Point State Park

One look at the lighthouse on the shores of Lake Huron is enough to understand why some call Tawas Point the "Cape Cod of the Midwest." Tawas Point Light (above), built in the mid-1850s, is open seasonally for tours and climbing. The park is also popular with bird-watchers and features a campground with swimming in Tawas Bay.

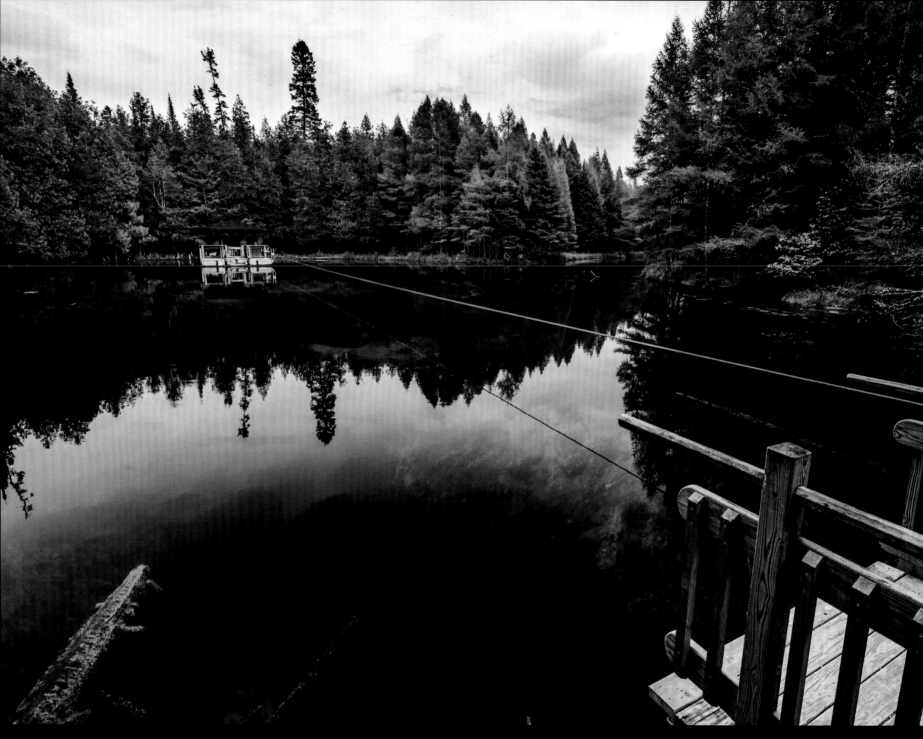

Palms Brook State Park

Palms Brook State Park in the southern part of the Upper Peninsula is filled with fascinating Native American tales and legends, but the greatest claim to fame is Kitch-iti-kipi (The Big Spring). Michigan's largest freshwater spring, it covers 200 feet and is fed by year-round 45-degree water that flows from 40 feet beneath the earth's surface.

Belle Isle State Park

For years, a trip across the bridge to Belle Isle has provided Detroiters a slice of serenity, away from the bustle of city life. In 2014, the popular respite area became an official state park. Top attractions include Detroit's only public beach and swimming area, Belle Isle Conservatory, a lighthouse, aquarium, zoo, and golf course.

Hartwick Pines State Park

Hartwick Pines State Park, near Grayling, is one of the Lower Peninsula's largest parks with more than 15 square miles. In addition to its stunning scenery, particularly when the leaves change color, the park is known for its tributes to Michigan's once-booming logging industry at the visitor center and the Hartwick Pines Logging Museum (open May–October).

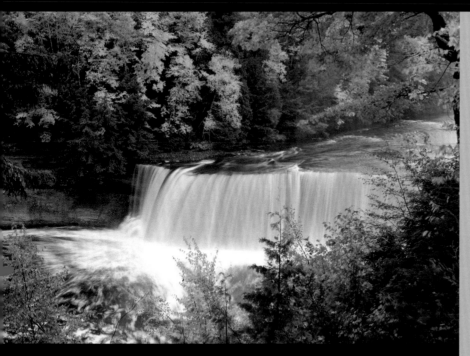

Tahquamenon Falls State Park

A waterfall so beautiful it seems surreal is the centerpiece of Tahquamenon Falls State Park, where the Tahquamenon River flows into Lake Superior's Whitefish Bay atop Michigan's Upper Peninsula. In late spring, more than 50,000 gallons of water per second rush over the falls–second only to Niagara Falls among vertical waterfalls east of the Mississippi River.

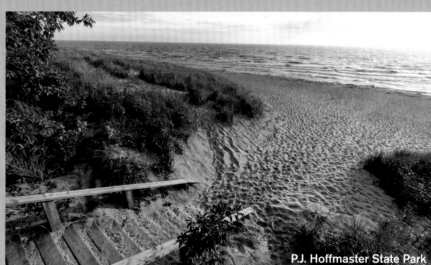

P.J. Hoffmaster State Park

Other Michigan State Parks

- Bay City State Park (Bay City)
- Grand Haven State Park (Grand Haven)
- Ludington State Park (Ludington)
- Petoskey State Park (Petoskey)
- Saugatuck Dunes State Park (Saugatuck)
- P.J. Hoffmaster State Park (near Muskegon)

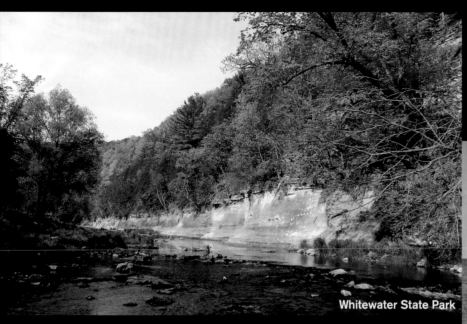

Whitewater State Park

Whitewater State Park

Whitewater State Park offers rapids, bluffs, trails, and overlooks similar to ones you might find in Minnesota's northern outposts, but without as many mosquitoes! The park's prime location just east of Rochester and an easy drive from the Twin Cities also contributes to making it one of the state's most popular spots for outdoor recreation.

Great River Bluffs State Park

The great river, of course, is the mighty Mississippi. From this southeastern Minnesota park in Winona, first-time visitors might gasp at the views of the river from the King's Bluff Nature Trail. There's also a self-guided tour that provides insight on the wooded and prairie landscapes. Bird-watchers can spot at least 100 different species here.

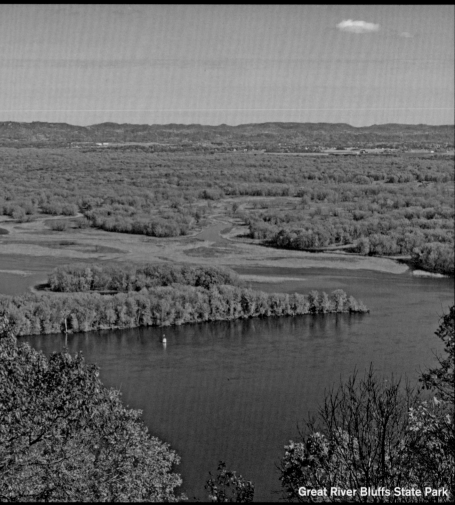

Great River Bluffs State Park

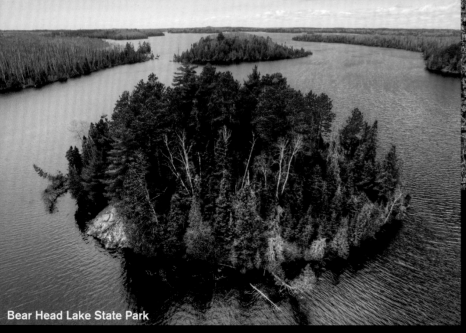

Bear Head Lake State Park

Bear Head Lake State Park

With spectacular scenery similar to the Boundary Waters Canoe Area Wilderness combined with more convenient access, modern facilities, and an allowance for motorboats, Bear Head Lake State Park is the best of both worlds for many visitors. Bear Head Lake is one of four fishing lakes in this park near Ely, where wildlife viewing is plentiful.

Jay Cooke State Park

The St. Louis River, which feeds into Lake Superior, can best be viewed from this state park about 10 miles south of Duluth. Whitewater rapids, fishing, camping, and more than 50 miles of hiking trails (some connecting with the North Country National Scenic Trail) lure many outdoor lovers.

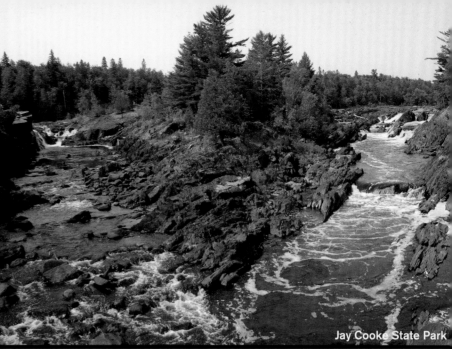

Jay Cooke State Park

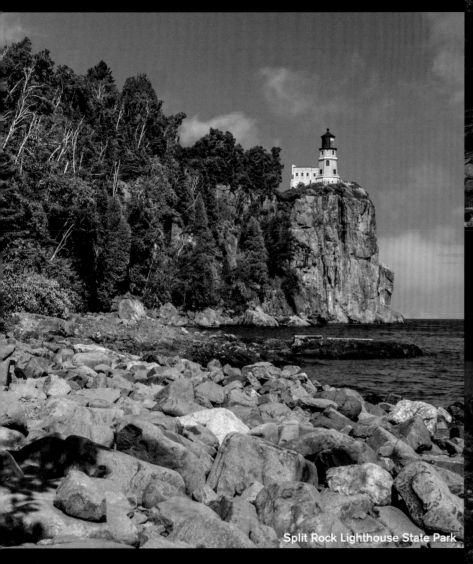

Split Rock Lighthouse State Park

Split Rock Lighthouse State Park

On the rugged north coast of Lake Superior stands a majestic sight: the historic Split Rock Lighthouse (left). Built in 1910, it's one of the country's most photographed lighthouses and part of a museum run by the Minnesota Historical Society in this Two Harbors park. The number of sailors kept safe by its light in the early 20th century is countless.

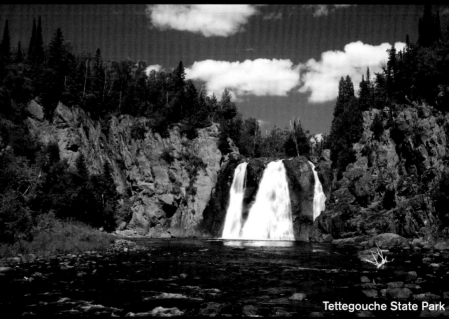

Tettegouche State Park

Tettegouche State Park

It's not unusual to see a black bear, moose, timber wolf, or peregrine falcon in this eye-popping state park on Lake Superior. Other favorite photo subjects include waterfalls, bridges, 9,000 acres of forest, and six inland lakes. The fishing is out of this world, and Tettegouche is rare among Minnesota state parks in allowing rock climbing.

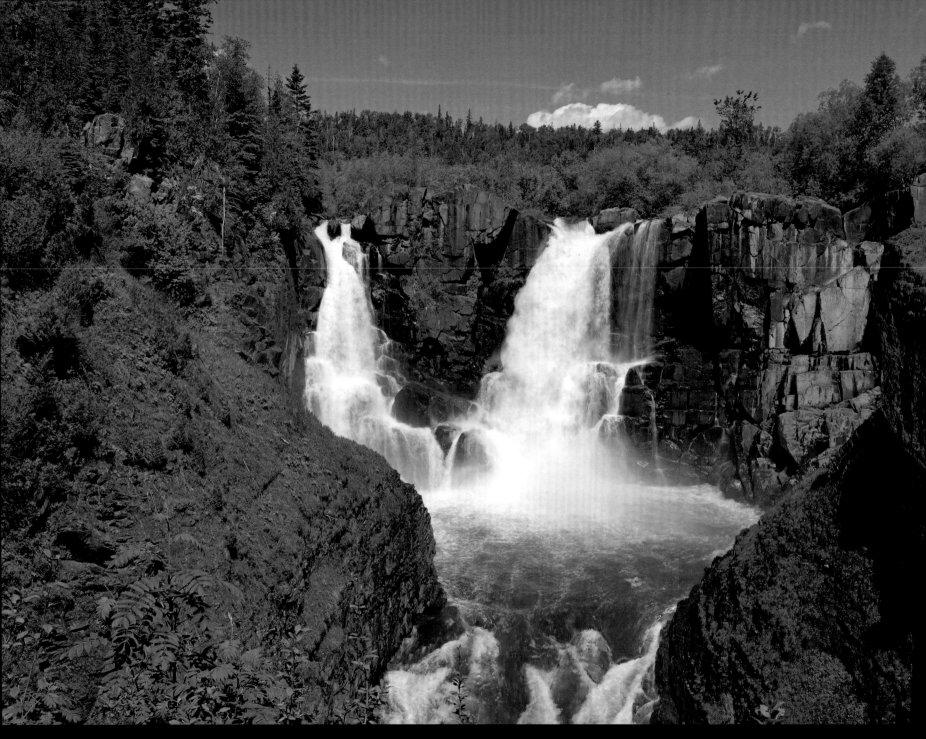

Grand Portage State Park

A 120-foot waterfall in Grand Portage State Park is the highest in the state (though part of it is actually in Canada). It's not the only claim to fame for this scenic gem on the northeastern tip of Minnesota. It's Grand Portage Indian Reservation land, making it the only American state park co-managed by a state and a Native American group.

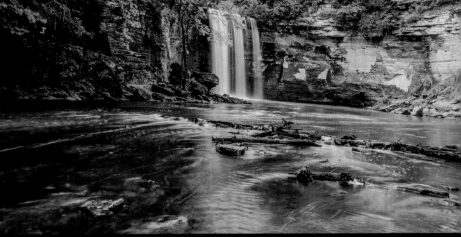

Lake Vermilion-Soudan Underground Mine State Park

Red quartzite and grey iron ore are among the wonders of Lake Vermilion-Soudan Underground Mine State Park. Minnesota's Iron Range is world famous, but at this park on the south shore of Lake Vermilion visitors can tour the state's oldest, deepest, and richest mine.

Minneopa State Park

There are at least two great reasons to visit Minneopa State Park, near Mankato in southern Minnesota. One is a unique, two-tiered waterfall. The other is an American bison herd that was reintroduced to the area.

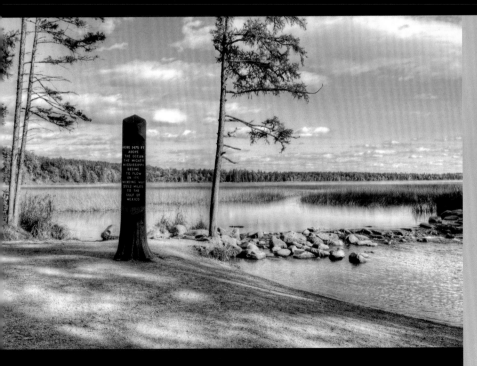

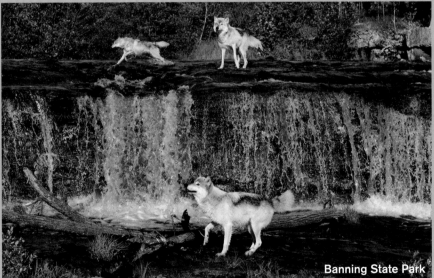

Banning State Park

Itasca State Park

Itasca State Park, some 20 miles north of Park Rapids, is a celebrity among Minnesota attractions. That's because it's the source of the country's grandest river, the Mississippi. It's the oldest state park in Minnesota, a distinction it earned in 1891, and holds a spot on the National Register of Historic Places.

Other Minnesota State Parks

- Banning State Park (near Sandstone)
- Blue Rocks State Park (near Luverne)
- Charles A. Lindbergh State Park (Little Falls)
- Lac Qui Parle State Park (near Watson)
- William O'Brien State Park (near Marine on St. Croix)

MISSISSIPPI

Lake Lincoln State Park

Lake Lincoln is the 550-acre centerpiece of this southern Mississippi state park, about five miles east of Wesson. Waterskiing, swimming, boating, or just spending a day on the beach are among the popular pastimes here. There's also a disc golf course if you're feeling competitive.

Tishomingo State Park

This northeast Mississippi gem, about 45 miles from Tupelo in the Appalachian Mountains, is rich in history. It's thought that Paleo-Indians lived here as early as 7000 B.C. The park also sits on the famed scenic Natchez Trace Parkway. Rock climbing is allowed with a helmet and permit, and there are several hiking trails.

Percy Quin State Park

One of the first Mississippi state parks constructed by the Civilian Conservation Corps in the 1930s, Percy Quin offers fishing, boating, and swimming thanks to its Lake Tangipahoa. Located just southwest of McComb, it also has a game room and an 18-hole golf course.

Roosevelt State Park

The 600-seat Livingston Performing Arts & Media Center, disc golf, tennis courts, and a waterslide give Roosevelt State Park, located between Meridian and Jackson, plenty of options. For overnighters, the choices range from a motel to campsites to dormitory-style cabins.

Leroy Percy State Park

Mississippi's first state park, Leroy Percy sits along Highway 12 about five miles west of Hollandale. It's named after a former U.S. Senator from Mississippi and known for Alligator Lake, where gators can be viewed from two observation towers.

Wall Doxey State Park

A 60-acre, spring-fed lake is the centerpiece of Wall Doxey State Park seven miles south of Holly Springs in northern Mississippi. Originally known as Spring Lake and built in the 1930s, it was one of Mississippi's first state parks.

Trace Lake Park

The one-time home of pioneer Davy Crockett and located just minutes from Tupelo, Trace Lake Park is named for the nearby Natchez Trace Trail. The park surrounds a 565-acre lake and includes campsites, cabins, and cottages, along with two 18-hole disc golf courses.

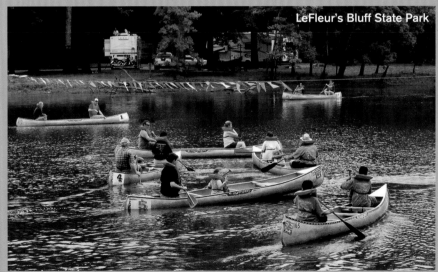

LeFleur's Bluff State Park

Other Mississippi State Parks

- J.P. Coleman State Park (near Iuka)
- John W. Kyle State Park (near Sardis)
- LeFleur's Bluff State Park (Jackson)
- Paul B. Johnson State Park (Hattiesburg)

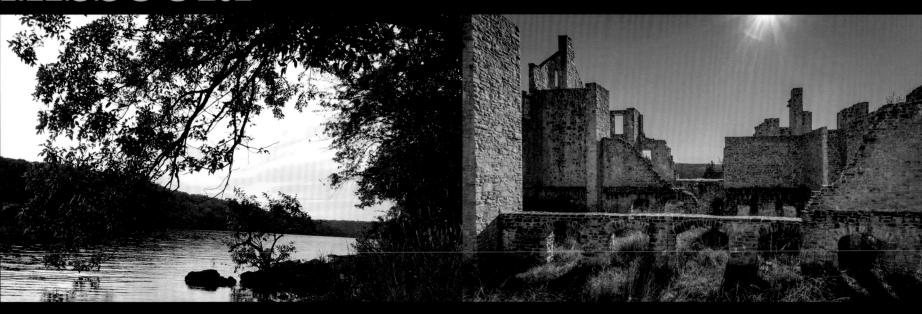

Lake of the Ozarks State Park

Missouri's largest state park spans more than 17,500 acres. Over 2.5 million people visited the park in 2017, drawn by the hiking, camping, beaches, boating, and tours of the Ozark Caverns. And for those who like camping but want a twist, there are log cabins and even a yurt available for rent.

Ha Ha Tonka State Park

Ha Ha Tonka State Park is a geologic wonderland featuring sinkholes, caves, a huge natural bridge, sheer bluffs, and Missouri's 12th largest spring. The park has 15 miles of hiking trails, as well as opportunities for boating, fishing, and swimming. The ruins of an early 20th century stone castle (above) offer impressive views of the Lake of the Ozarks and Ha Ha Tonka Spring.

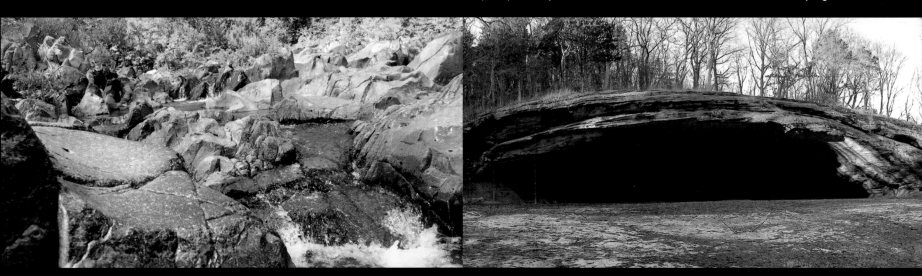

Johnson's Shut-Ins State Park

Johnson's Shut-Ins State Park in Reynolds County, Missouri, covers over 8,700 acres. This park contains the best-known example of shut-ins, which are formed when river water cascades over and around smooth-worn igneous rock, creating a natural water park. Activities at this park include camping, hiking, picnicking, and splashing in the shut-ins.

Graham Cave State Park

Graham Cave State Park spans 386 acres in Montgomery County. The park includes the 82-acre Graham Cave Glades Natural Area, which protects an area of sandstone and dolomite glades with a rich diversity of glade species. Artifacts uncovered in Graham Cave (above) reveal that people occupied the cave 8,000 to 10,000 years ago.

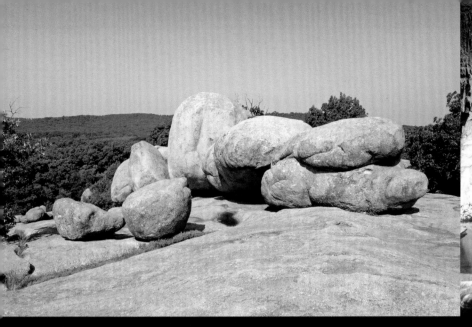

Elephant Rocks State Park
Elephant Rocks State Park, near Belleview, Missouri, is named for the string of large granite boulders that resemble a train of circus elephants.

Onondaga Cave State Park
The towering stalagmites and dripping stalactites at Onondaga Cave State Park illustrate why Missouri is often called "The Cave State."

St. Francois State Park

Other Missouri State Parks

- Montauk State Park (Salem)
- Table Rock State Park (Branson)
- Castlewood State Park (Ballwin)
- Hawn State Park (Sainte Genevieve)
- Trail of Tears State Park (Jackson)
- St. Francois State Park (Bonne Terre)

Thousand Hills State Park
Forest Lake (above) is the centerpiece of Thousand Hills State Park located in northern Missouri.

Makoshika State Park

Some 65 million years ago, the plains in eastern Montana were vast, lush, and green. After the last ice age 11,000 years ago, the ancient glacial marks left here were buried under layers of silt. But wind and weather wore the silt away, revealing layers of red sandstone atop layers of gray mudstone atop layers of dark shale; hoodoos, caprocks, and other geological anomalies; and an otherworldly badlands landscape the Lakota dubbed Makoshika, or "bad earth."

Besides exposing Makoshika's rugged beauty, erosion also helped unearth fossils hundreds of millions of years old, including a remarkable triceratops skull, excavated in 1991. It is now on display in the park's visitor center along with other fossils discovered here. There is also an exhibit on one prehistoric area resident that didn't go the way of the dinosaur: the paddlefish, which still swims in the depths of the nearby Yellowstone River.

Giant Springs State Park

Giant Springs State Park is the most visited state park in Montana, attracting over 300,000 visitors annually. The giant spring that gives the park its name is one of the largest freshwater springs in the country. Its waters stay at 54 degrees year-round. The Great Falls-area park offers fishing, hunting, hiking, biking, bird-watching, and even has a fish hatchery within its borders.

Yellow Bay State Park

Yellow Bay State Park is in the heart of Montana's famous sweet cherry orchards. In the summer, cherries can be picked at U-pick orchards or purchased at roadside stands. The park includes Yellow Bay Creek and a wide, gravelly beach. Boating, trout fishing, camping, swimming, scuba diving, and wildlife viewing are popular pursuits here.

Pictograph Cave State Park
Visit Pictograph Cave State Park to see rock paintings done by prehistoric hunters some 2,000 years ago. Bring your binoculars for the best views of the rock art and the area's wildlife.

Bannack State Park
Bannack State Park is a well-preserved ghost town and the site of Montana's first major gold discovery in July 1862. The park offers fishing, camping, biking, hiking, and interpretive programs.

Rosebud Battlefield State Park
Rosebud Battlefield State Park preserves the site of the Battle of the Rosebud, fought on June 17, 1876 during the Great Sioux War. The park offers hiking, picnicking, and wildlife viewing.

Lewis and Clark Caverns State Park

Other Montana State Parks
- Lone Pine State Park (Kalispell)
- Lewis and Clark Caverns State Park (Three Forks)
- Flathead Lake State Park (Kalispell)
- Lake Elmo State Park (Billings)
- Black Sandy State Park (Helena)
- Placid Lake State Park (Seeley Lake)

NEBRASKA

Niobrara State Park
Though Nebraska is a relatively flat state, the high hills of this northeastern state park provide some of the best views of the Missouri and Niobrara rivers. In addition to the usual state park activities, this one hosts cowboy storytellers and a buffalo cookout on summer Saturdays.

Chadron State Park
Established in 1921 in the northwest corner of the state, Chadron is the oldest state park in Nebraska. A swimming pool, paddleboard rentals, horseback riding, and disc golf are among the options in this beautiful spot, which includes the Pine Ridge escarpment and Chadron Creek.

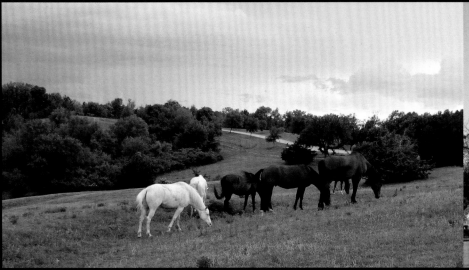

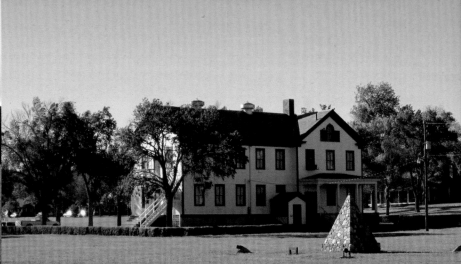

Platte River State Park
The rolling—even sometimes steep—hills of this eastern Nebraska park provide some of the best hiking in the state. The looping structure of the trails make it easy to cover any distance you'd like. There are also observation towers for panoramic views and a variety of camping options.

Fort Robinson State Park
Just west of Crawford in northwest Nebraska, Fort Robinson State Park recounts the history of a former U.S. military outpost built in the 1870s. The fort is a National Historic Landmark. There's also a museum and refurbished soldiers' quarters for visiting history buffs, surrounded by a plethora of recreation opportunities.

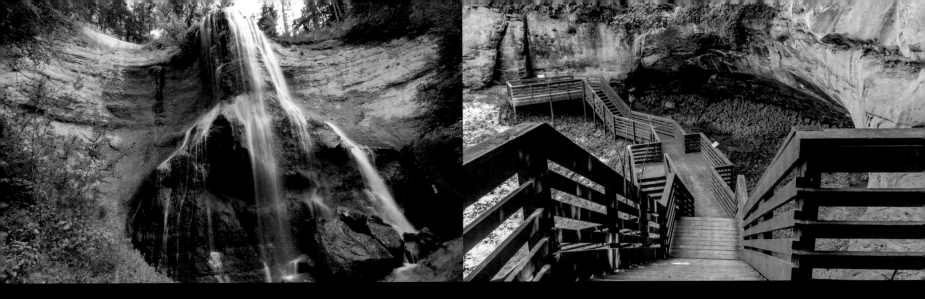

Smith Falls State Park

Canoe, kayak, and float trips up the Niobrara River on Nebraska's northern border beg for a stop at Smith Falls State Park, home of the highest waterfall in the state at 63 feet. It can also be accessed via a footbridge over the river in this popular state park.

Indian Cave State Park

Beckoning visitors near the Missouri River, Indian Cave State Park features a sandstone cave whose walls showcase what are thought to be prehistoric Native American petroglyphs. There's also a restored general store and schoolhouse from an old river town.

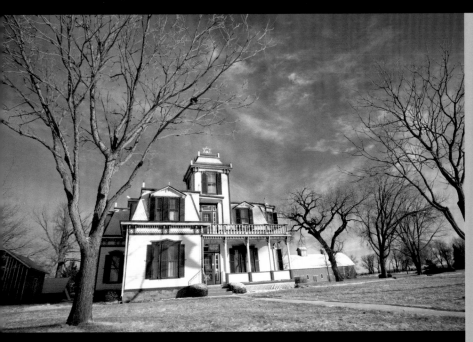

Buffalo Bill Ranch State Historical Park

The restored house and barn of famous Wild West showman Buffalo Bill Cody are on display just west of North Platte at Buffalo Bill Ranch State Historical Park. There's a museum that brings the Old West to life in this park that owns a spot on the National Register of Historic Places.

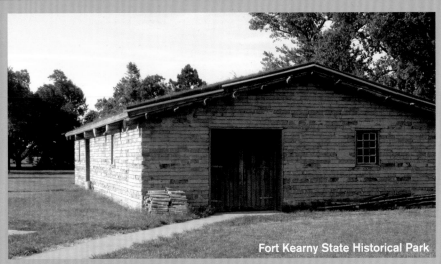

Fort Kearny State Historical Park

Other Nebraska State Parks

- Ash Hollow State Historical Park (near Lewellen)
- Fort Atkinson State Historical Park (near Fort Calhoun)
- Fort Kearny State Historical Park (near Newark)
- Mahoney State Park (near Ashland)
- Ponca State Park (near Ponca)

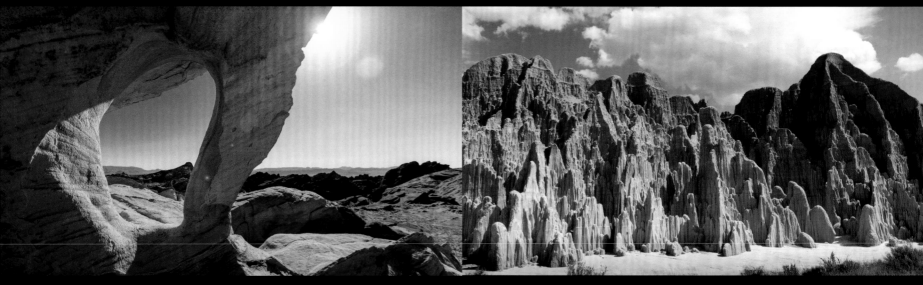

Valley of Fire State Park

Nevada's first state park–dedicated in 1935–offers both incredible views and glimpses of history. Visitors can see both lovely Aztec sandstone formations and petroglyphs carved by Ancestral Puebloans. And once a year, they can participate in an Atlatl competition, trying their hand at throwing a spear like the ones used in prehistoric days.

Cathedral Gorge State Park

Cathedral Gorge State Park is located in a long, narrow valley in southeastern Nevada where erosion has carved dramatic and unique patterns in the soft bentonite clay. The park sits at an elevation of 4,800 feet and is a great place for hiking, biking, and bird-watching.

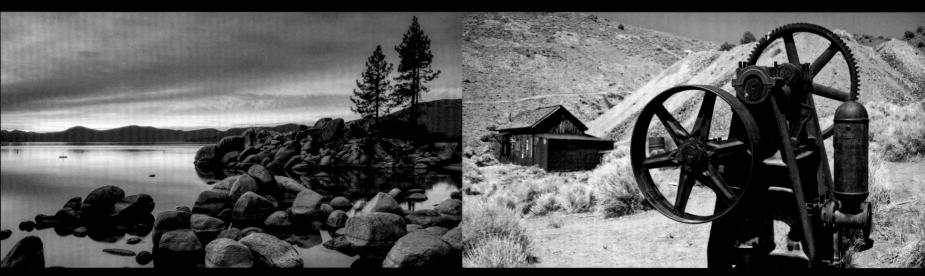

Lake Tahoe State Park

Lake Tahoe State Park is comprised of multiple entities and covers over 14,000 acres. Sand Harbor (pictured above) features gently sloping beaches and intriguing rock formations providing for excellent swimming, scuba diving, and kayaking. Cave Rock's steep shoreline makes for a terrific place to fish and includes a boat launch. And Spooner Lake and Backcountry offers 50 miles of hiking, horseback riding, and mountain biking trails.

Berlin-Ichthyosaur State Park

Berlin-Ichthyosaur State Park displays the ghost town of Berlin that was once a vibrant mining town. The park also has a fossil house that preserves the largest known remains of the Ichthyosaur, an ancient marine reptile that swam in central Nevada 225 million years ago.

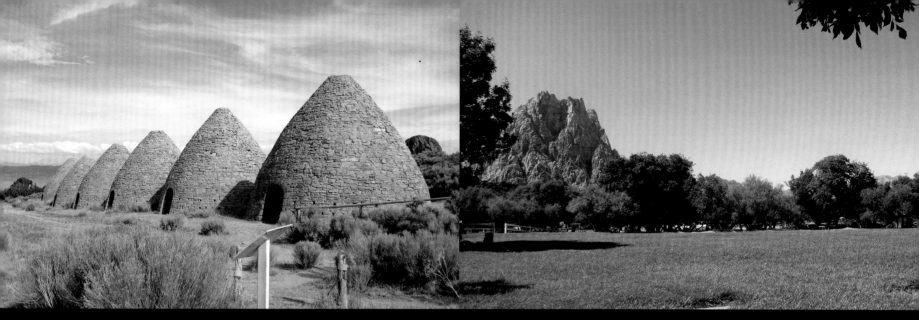

Ward Charcoal Ovens State Park

Six 30-foot charcoal ovens are the centerpiece of Ward Charcoal Ovens State Park. The ovens were used from 1876–1879 to produce fuel for smelting silver ore and are open today for touring.

Spring Mountain Ranch State Park

Spring Mountain Ranch State Park sits at the base of the magnificent Wilson Cliffs. There are hiking trails throughout the park, in addition to tree-shaded picnic sites with tables and grills.

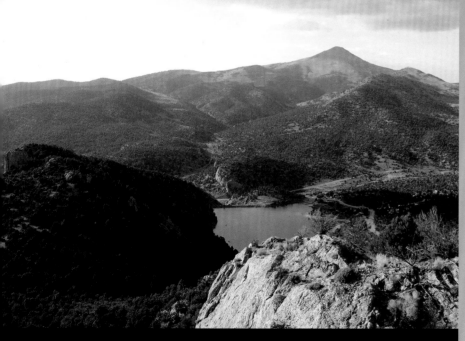

Cave Lake State Park

Cave Lake State Park near Ely, Nevada, provides opportunities for brown and rainbow trout fishing, crawdadding, boating, swimming, hiking, and camping.

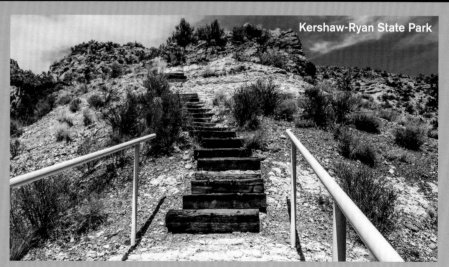

Kershaw-Ryan State Park

Other Nevada State Parks

- Washoe Lake State Park (Carson City)
- Dayton State Park (Dayton)
- Beaver Dam State Park (Caliente)
- Kershaw-Ryan State Park (Caliente)
- Ice Age Fossils State Park (North Las Vegas)

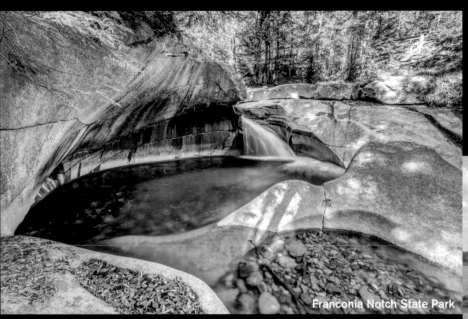

Franconia Notch State Park

Franconia Notch State Park

Franconia Notch State Park is home of Old Man of the Mountain Historic Site, Cannon Mountain, New England Ski Museum, and Flume Gorge. Also in the park are recreation trails, the Basin (left), Lafayette Place Campground, and the Cannon Mountain Aerial Tram, which takes visitors to the 4,180-foot summit of the mountain. Be sure to stop by the visitor's center at Flume Gorge for a 15-minute film, maps, and interpretive exhibits.

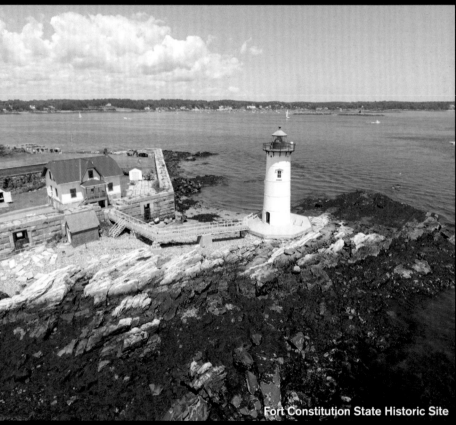

Fort Constitution State Historic Site

Fort Constitution State Historic Site

Fort Constitution State Historic Site is found on a peninsula on New Castle Island, overlooking both the Piscataqua River and the Atlantic Ocean. The site includes the ruins of the fort and the Portsmouth Lighthouse. The station was first established in 1771. During the Revolutionary War, the lighthouse helped guide local New England privateers who raided British shipping and harassed the king's navy vessels. Local history also states that folk hero Paul Revere and local militiamen captured the fort in Portsmouth Harbor with the help of the lighthouse keeper. The current tower (right) was built in 1878.

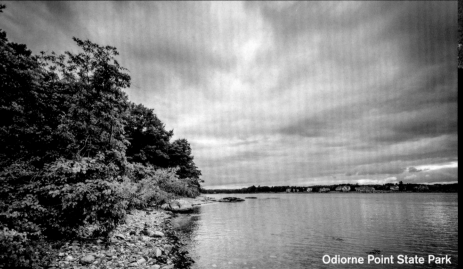

Odiorne Point State Park

Odiorne Point State Park

This state park includes Odiorne Point, the largest undeveloped stretch of shore on New Hampshire's 18-mile coast. Its spectacular oceanfront is backed by marshes, sand dunes, and dense vegetation. An extensive network of trails, including a paved bike path, winds through the park. There are also picnic areas, a boat launch, and a playground.

Kids will love visiting Odiorne's Seacoast Science Center to learn about the many creatures they're likely to spot in the tide pools. All kinds of sea urchins, starfish, mollusks, and crabs inhabit the shoreline's intertidal zone, and when the tide is low, there are many opportunities to see them.

Wellington State Park

Wellington State Park boasts the largest freshwater swimming beach in New Hampshire's state parks system. This is the view from the beach looking out at the expansive Newfound Lake. Boaters have free access to Newfound Lake via a developed boat launch adjoined to Wellington State Park.

Mollidgewock State Park

Mollidgewock State Park lies along the shore of the Androscoggin River. The Androscoggin offers great canoeing and kayaking opportunities for both novice and expert paddlers. The area is a favorite of fishing enthusiasts and is popular for watching moose and other wildlife.

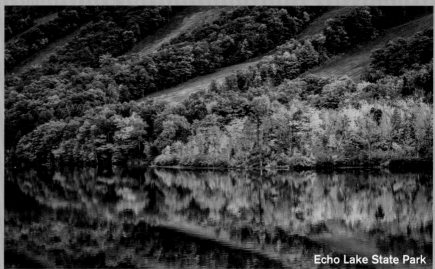

Echo Lake State Park

Mount Washington State Park

Mount Washington State Park is a 60.3-acre parcel perched on the summit of the Northeast's highest peak, Mount Washington. On a clear day, views from the 6,288-foot summit extend beyond New Hampshire as far as 130 miles to Vermont, New York, Massachusetts, Maine, Quebec, and the Atlantic Ocean. Mount Washington State Park can be accessed via the Mount Washington Cog Railway. Completed in 1869, it is the first mountain-climbing and second steepest cog railway in the world.

Other New Hampshire State Parks

- Clough State Park (Weare)
- Miller State Park (Peterborough)
- Lake Francis State Park (Pittsburg)
- Bear Brook State Park (Allenstown)
- Echo Lake State Park (North Conway)
- Kingston State Park (Kingston)

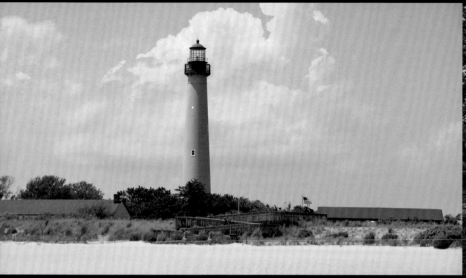

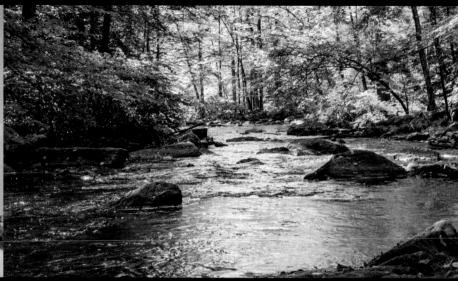

Cape May Point State Park

Located at the southern tip of New Jersey, Cape May Point State Park is one of the best places in North America to view the fall bird migration. The park consists of various pond, coastal dune, marsh, and forest habitats that are great for viewing wildlife. Park vistors who climb the 199 stairs to the top of the Cape May Lighthouse (above) are rewarded with spectacular views.

Hacklebarney State Park

The land now occupied by Hacklebarney State Park was originally inhabited by Native Americans. In the 19th century the park was an iron ore mining site. Today Hacklebarney is a favorite spot for anglers, hikers, and picnickers. The park gets 100,000 visitors annually. The Black River (above) briskly cuts its way through the park, cascading around boulders in the hemlock-lined ravine.

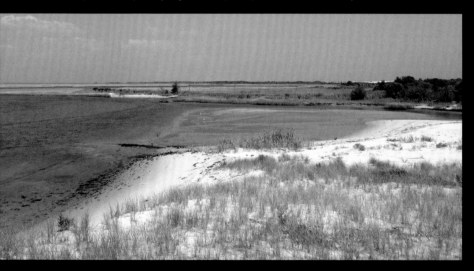

Island Beach State Park

Island Beach State Park is a narrow barrier island stretching for 10 miles between the Atlantic Ocean and the historic Barnegat Bay. Island Beach contains outstanding examples of plant communities such as primary dunes, thicket, freshwater wetlands, maritime forest, and tidal marshes with over 400 plants identified. Canoe and kayak tours are available.

Washington Crossing State Park

Sprawling across 3,575 acres of fields and woodlands, this park preserves the site where George Washington crossed the Delaware River at Johnson's Ferry and turned the tide of the Revolutionary War. The Vistor's Center has exhibits exploring the Continental Army's crossing and the battles of Trenton and Princeton during the "Ten Crucial Days," December 25, 1776–January 3, 1777. The park also offers nature trails, camping, fishing, and picnic facilities.

Monmouth Battlefield State Park
Monmouth Battlefield State Park, located on the border of Manalapan and Freehold Township, preserves the site of the Battle of Monmouth during the American Revolutionary War. The park encompasses miles of spectacular landscape, a restored farmhouse, and a visitor's center.

High Point State Park
The High Point Monument, built to honor war veterans, towers 220 feet over High Point State Park. High Point offers superb trails for hikers and skiers and quiet spots for campers and anglers.

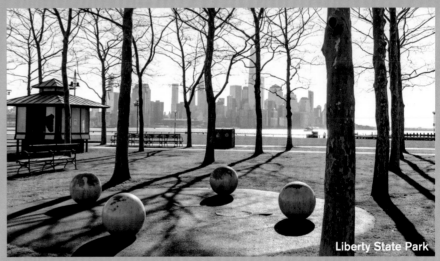

Liberty State Park

Other New Jersey State Parks
- Liberty State Park (Jersey City)
- Princeton Battlefield State Park (Princeton)
- Cheesequake State Park (Matawan)
- Parvin State Park (Pittsgrove)
- Swartswood State Park (Swartswood)
- Ringwood State Park (Ringwood)

NEW MEXICO

Living Desert Zoo and Gardens State Park
The Living Desert Zoo and Gardens State Park in Carlsbad, New Mexico, displays plants and animals of the Chihuahuan Desert in their native habitats. The gardens feature hundreds of cacti and succulents, including acacia, agave, cholla, ocotillo, prickly pear, small barrel cactus, saguaro, and yucca.

Elephant Butte Lake State Park
Elephant Butte Lake State Park is the largest state park in New Mexico and surrounds the state's largest reservoir. Elephant Butte Lake can accommodate watercraft of many styles and sizes: kayaks, Jet Skis, pontoons, sailboats, ski boats, cruisers, and houseboats. The park offers camping, fishing, boating, and sandy beaches.

City of Rocks State Park
City of Rocks State Park gets its name from the incredible volcanic rock formations found here. These rocks were formed about 34.9 million years ago. City of Rocks offers campsites, hiking trails, mountain biking, wildlife viewing, birding, stargazing, picnic areas, and a desert botanical garden.

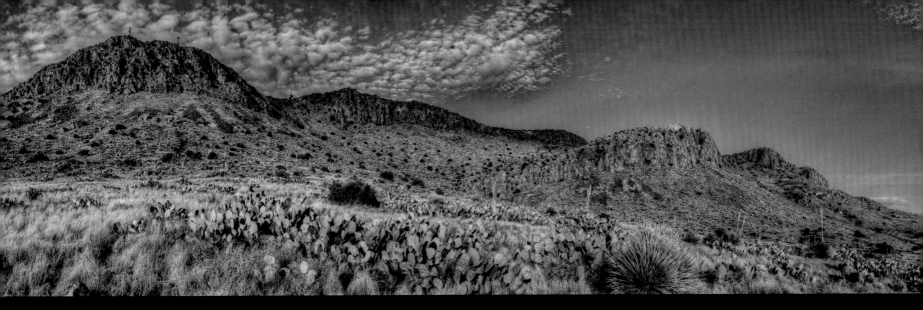

Rockhound State Park
Rockhound State Park is named for the abundance of minerals in the area, and visitors can search for quartz crystals, geodes, jasper, perlite, and many other minerals.

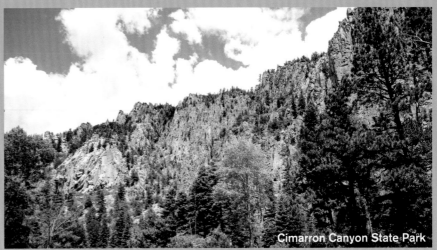

Cimarron Canyon State Park

Other New Mexico State Parks

- Eagle Nest Lake State Park (Eagle Nest)
- Brantley Lake State Park (Eddy)
- Oliver Lee Memorial State Park (Alamogordo)
- Pancho Villa State Park (Columbus)
- Bottomless Lakes State Park (Roswell)
- Cimarron Canyon State Park (Eagle Nest)

Bluewater Lake State Park
Bluewater Lake State Park, located 25 miles west of Grants, is set in a pinon-juniper tree landscape with views towards the Zuni Mountains. The park offers camping, hiking, birding, horseback riding, and fishing.

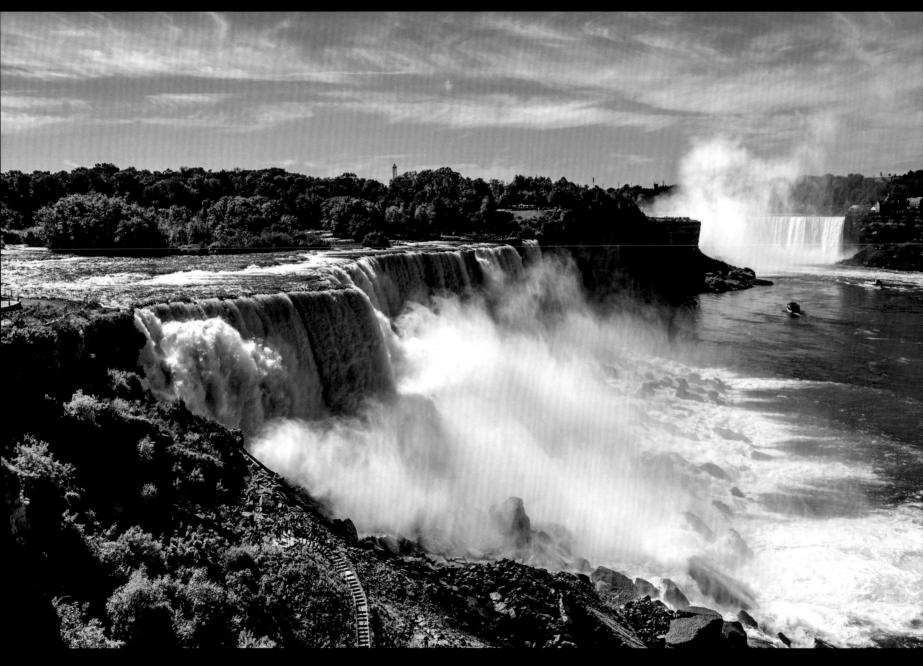

Niagara Falls State Park

Niagara Falls is the best-known group of waterfalls in North America and quite possibly the world. Tourists have flocked here for more than a century, to take in the overpowering sights and sounds of water in motion as it courses over ancient rock. Niagara Falls is where Lake Erie drains into the Niagara River, Lake Ontario, and beyond. It actually consists of three splendid waterfalls on the Niagara River: American Falls and Bridal Veil Falls in New York, and Horseshoe Falls in southeastern Ontario, Canada. More than six million cubic feet of water pour over these three falls every minute, making for the most powerful group of waterfalls in North America. Niagara Falls State Park offers spectacular views of the falls, as well as hiking and nature trails, fishing, a museum, a movie theater, a gift shop, picnic tables, and recreation programs.

Letchworth State Park

Located in Livingston and Wyoming counties is the over 14,000-acre Letchworth State Park. The park prominently features three large waterfalls–the Upper, Middle, and Lower Falls–on the Genesee River, which flows within a deep gorge that winds through the park. There are 66 miles of hiking trails, as well as trails for horseback riding, biking, snowmobiling, and cross-country skiing. Hot air ballooning is another memorable way to take in the scenic views of Letchworth State Park.

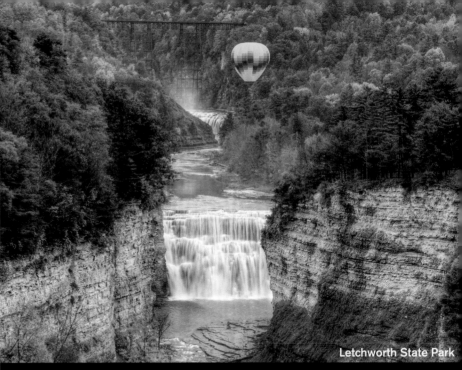

Letchworth State Park

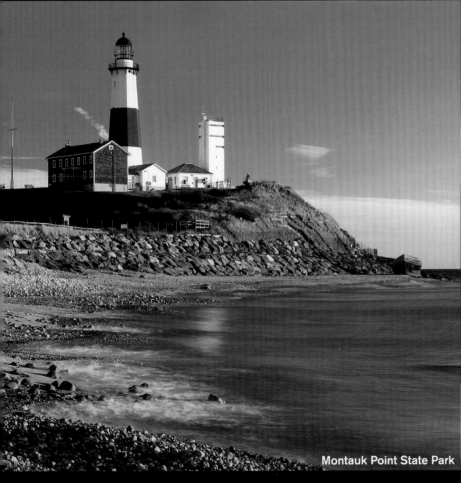

Montauk Point State Park

Montauk Point State Park

East of Fire Island, east of the Hamptons, and east of every other geographic point on Long Island is Montauk Point State Park. The 862-acre park is home to the Montauk Point Light (left). Built in 1797 by architect John McComb, the 78-foot tower at Montauk Point State Park rises from a grassy headland to overlook the gray-blue Atlantic. Given its location on tall bluffs above the surf line, Montauk Point is one of the most scenic lighthouses in North America. Visitors to this state park can see the famous lighthouse, hike or cross-country ski the nature trails, go fishing, or surf the waters.

Crown Point State Historic Site

Just off Route 9N/22 is Crown Point State Historic Site, where the ruins of two Colonial-era forts, St. Frederic and Crown Point, are preserved. They were occupied by a succession of French, British, and American soldiers during the French and Indian and Revolutionary wars. Both the British and the French claimed Crown Point in their struggle to dominate North America. Much later the Americans gained control of the location.

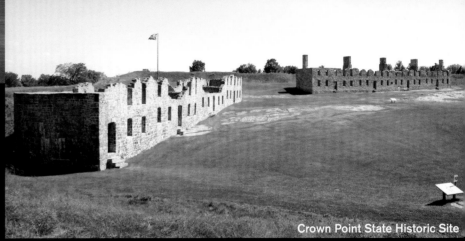

Crown Point State Historic Site

Allegany State Park
Allegany State Park's 65,000 acres are known for their primitive forested valleys, unglaciated landscape, fall leaves, and wildlife. The two developed areas, Red House and Quaker, make this the largest state park in New York's state park system. Both areas offer sand beaches, picnic areas, museums, hiking trails, and naturalist walks.

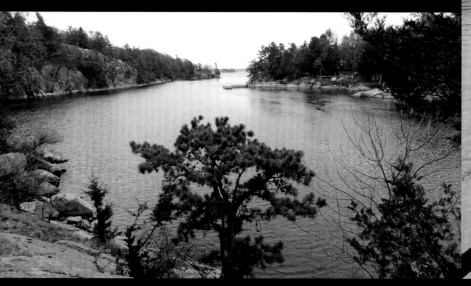

Wellesley Island State Park
Wellesley Island State Park is nestled along the banks of the St. Lawrence River. Popular activities here include swimming, hiking, hunting, fishing, cross-country skiing, and biking.

Green Lakes State Park
Green Lakes State Park's exceptional features are its two glacial lakes surrounded by upland forest. Both Round and Green Lakes are meromictic lakes, which means that there is no fall and spring mixing of surface and bottom waters. Another special feature of the park is an 18-hole golf course.

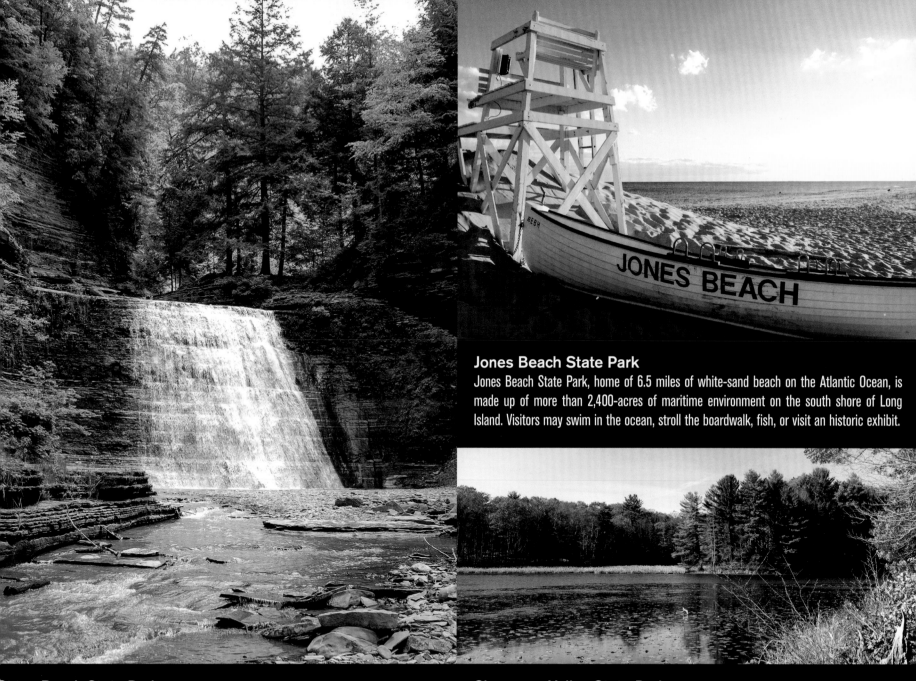

Jones Beach State Park

Jones Beach State Park, home of 6.5 miles of white-sand beach on the Atlantic Ocean, is made up of more than 2,400-acres of maritime environment on the south shore of Long Island. Visitors may swim in the ocean, stroll the boardwalk, fish, or visit an historic exhibit.

Stony Brook State Park

Stony Brook State Park features a rugged gorge in the rolling hills of western New York. Hikers can choose among three hiking trails. The park also offers a variety of playfields that include a tennis court, baseball field, volleyball court, basketball court, and playgrounds. Stony Brook State Park's beautiful gorge trail passes by three major waterfalls and flows into a stream-fed pool.

Chenango Valley State Park

Chenango Valley State Park is made up of two kettle lakes, Lily Lake and Chenango Lake. They were created when the last glacier retreated and left behind huge chunks of buried ice. Bird-watching, camping, and fishing are among the favorite activities at this park. This park near Binghamton also includes an 18-hole golf course.

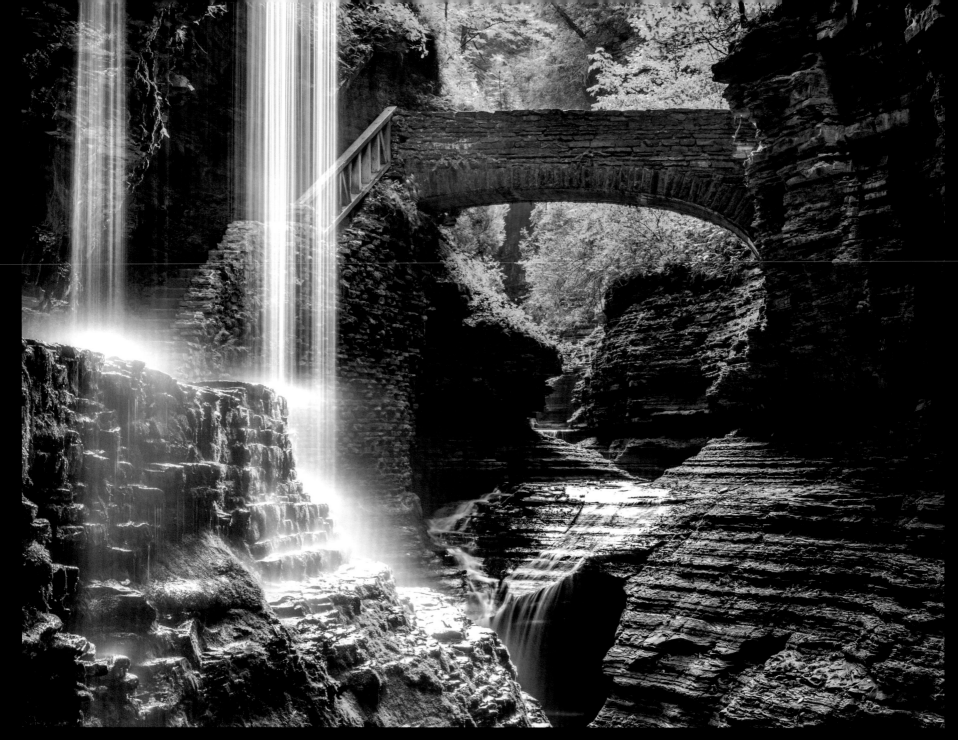

Watkins Glen State Park

The centerpiece of Watkins Glen State Park in central New York's Finger Lakes region is a 400-foot-deep narrow gorge cut through rock by a stream. The 778-acre park features three trails—open mid-May to early November—by which visitors can climb or descend the gorge.

Chimney Bluffs State Park

Chimney Bluffs State Park derives its name from the massive earthen spires that line the shores of Lake Ontario in Wolcott, New York. Although the pinnacles and cliffs have existed for thousands of years, they are constantly changing and further eroding.

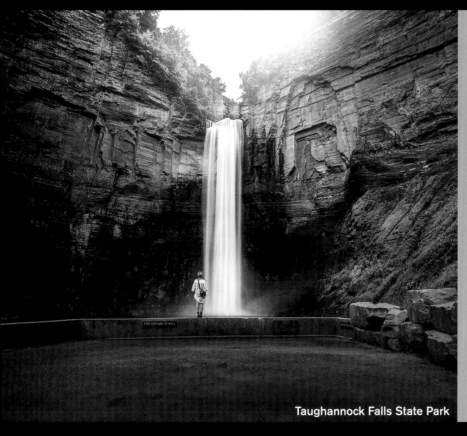

Taughannock Falls State Park

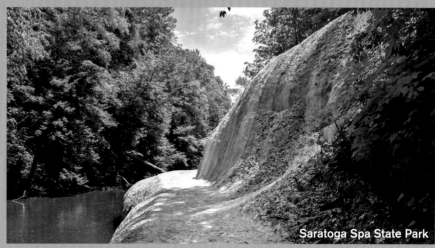

Saratoga Spa State Park

Other New York State Parks

- Bear Mountain State Park (Bear Mountain)
- Fillmore Glen State Park (Moravia)
- Taughannock Falls State Park (Trumansburg)
- Saratoga Spa State Park (Saratoga Springs)
- Lake Erie State Park (Brockton)
- Cayuga Lake State Park (Seneca Falls)

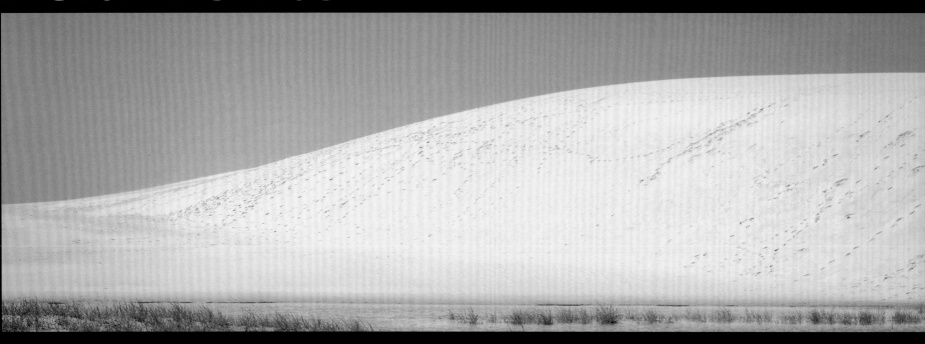

Jockey's Ridge State Park

Jockey's Ridge State Park features the tallest living sand dune in the eastern United States and is a prime location for kite flying, sightseeing, and sunsets, with a view arcing from the Atlantic Ocean to Roanoke Sound. Hang gliding lessons are also available. Jockey's Ridge State Park is the most visited park within North Carolina's state park system.

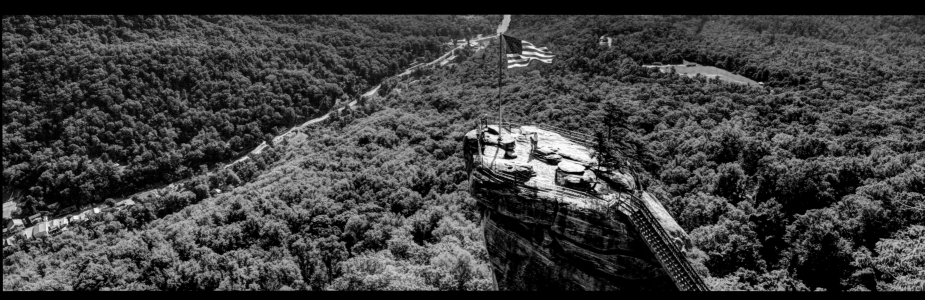

Chimney Rock State Park

Some of North Carolina's most dramatic mountain scenery is found at Chimney Rock State Park. It has six hiking trails for all skill levels, ranging from child-friendly nature explorations to moderately strenuous treks to the top of Chimney Rock Mountain and to the edge of Hickory Nut Falls. Chimney Rock (above) is a 315-foot granite monolith overlooking Hickory Nut Gorge and Lake Lure. The Rocky Broad River is a destination for trout anglers.

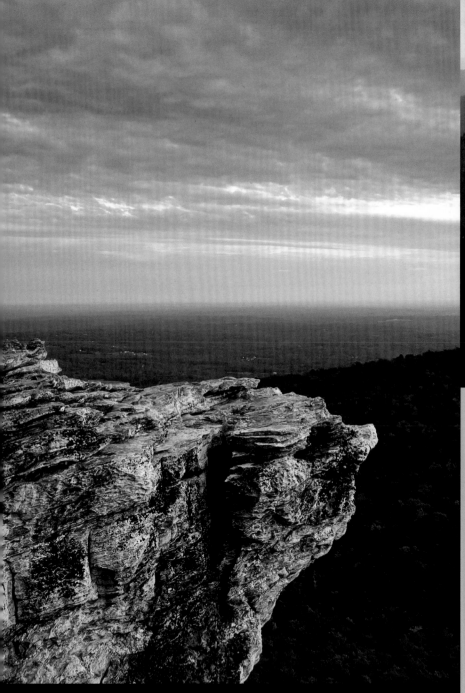

Mount Mitchell State Park

Mount Mitchell State Park was established in 1915 and became the first state park in North Carolina. The summit of Mount Mitchell reaches 6,684 feet making it the highest point east of the Mississippi River. In addition to Mount Mitchell itself, the park encompasses several other peaks which top out at over 6,000 feet in elevation, including Mount Hallback, Mount Craig (the second highest peak east of the Mississippi River), Big Tom, and Balsam Cone.

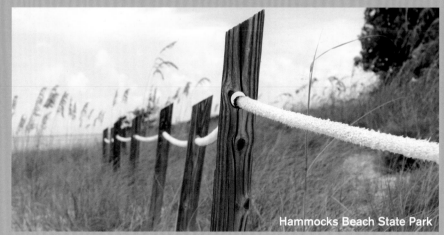

Hammocks Beach State Park

Other North Carolina State Parks

- Gorges State Park (Sapphire)
- Hammocks Beach State Park (Swansboro)
- Lake Waccamaw State Park (Lake Waccamaw)
- Pettigrew State Park (Creswell)
- Stone Mountain State Park (Roaring Gap)
- Eno River State Park (Durham)

Hanging Rock State Park

Hanging Rock State Park is located in the Sauratown Mountain Range, one of the most easterly mountain ranges in North Carolina. There are over 20 miles of trails for visitors to hike the numerous peaks and waterfalls, as well as rock climbing, swimming, canoeing, mountain biking, and camping.

Fort Abraham Lincoln State Park
A trip to this picturesque frontier fort and state park on the upper Missouri River will take you back to another century, to the time when this fort was the largest and most important on the Northern Plains. It was from this fort that General George A. Custer and the Seventh Cavalry rode off to meet their destiny at Little Bighorn.

Fort Ransom State Park

Fort Ransom State Park provides a wealth of outdoor activities, including educational programs, camping, fishing, picnicking, horseback riding, canoeing, cross-country skiing, hiking, birding, and nature photography. Amenities include an outdoor amphitheater, canoe landing, campsites, playground, picnic shelters, visitor center, and horse corrals. The park is also home to Sunne Farm, which demonstrates pioneer farming methods.

Icelandic State Park

Located on the shores of Lake Renwick (above), Icelandic State Park was established in 1964. The park features North Dakota's first dedicated state nature preserve, Gunlogson Nature Preserve. The 200-acre natural wooded area along the Tongue River is a sanctuary for plants, birds, and wildlife. Boating, swimming, and fishing are a few favorite summer activities, while snowshoeing and cross-country skiing are popular during the winter months.

Lake Sakakawea State Park

Lake Sakakawea (above) is known for its premier walleye, northern pike, and chinook salmon fishing. The park offers a full-service marina, boat ramps, hiking trails, and campsites.

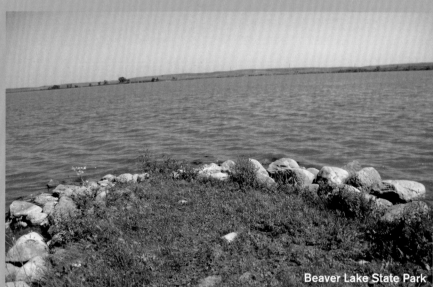

Beaver Lake State Park

Other North Dakota State Parks

- Beaver Lake State Park (Wishek)
- Lake Metigoshe State Park (Bottineau)
- Cross Ranch State Park (Center)
- Little Missouri State Park (Killdeer)
- Sully Creek State Park (Medora)

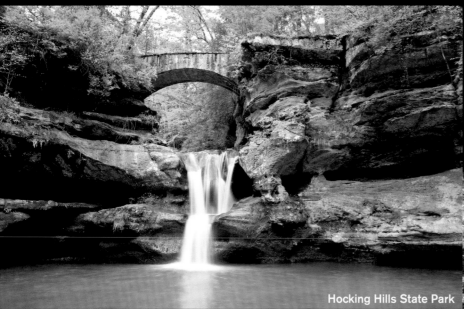

Hocking Hills State Park

Hocking Hills State Park

Located in southeastern Ohio, Hocking Hills State Park is one of the most popular parks in the state. It contains spectacular rock formations, waterfalls, caves, gorges, forests, and abundant wildlife. The park offers five hiking areas, each with multiple trails to accommodate different skill levels. Other popular activities include canoeing, ziplining, horseback riding, rock climbing, and stargazing. A variety of overnight accommodations are available, but popular facilities book far in advance.

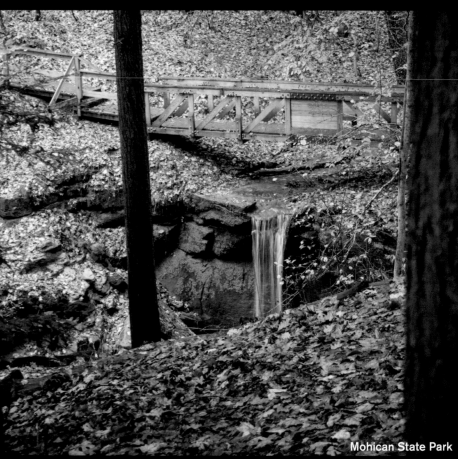

Mohican State Park

Mohican State Park

Mohican State Park and the adjacent state forest offer nature lovers plenty of unique landscapes to explore. The Mohican River, which flows through the park, is one of the best canoeing rivers in Ohio. Anglers will love fishing in Mohican's streams, Wolf Creek, and Pleasant Hill Lake. The park also offers ample opportunities for hiking, mountain biking, horseback riding, snowmobiling, swimming, and camping.

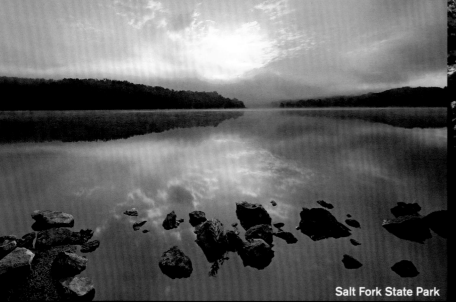

Salt Fork State Park

Salt Fork State Park

Salt Fork State Park in Guernsey County is the largest state park in Ohio with over 17,200 acres. The nearly 3,000-acre Salt Fork Lake located within the park is a major draw. The park offers a 2,500-foot swimming beach, two marinas, eight boat launch ramps, and a variety of rental boats. The park also includes an 18-hole golf course, archery range, dog park, nature center, campsites, and hiking trails.

John Bryan State Park

John Bryan State Park in western Ohio is one of the state's most scenic parks. The 752-acre park includes a stunning limestone gorge carved by the Little Miami River. A portion of the gorge is designated as a National Natural Landmark. Ten hiking trails traverse the park, as well as several trails for mountain bikers of all skill levels. Visitors can also canoe the Little Miami River, fish for bass, go rock climbing or rappelling, play a round of disc golf, or enjoy a picnic. Campsites are also available.

Barkcamp State Park

Eastern Ohio's Barkcamp State Park centers around the 117-acre Belmont Lake, which offers boating, fishing, and swimming. Over 140 campsites, some with equestrian facilities, are available. The campgrounds include an accessible 18-hole mini golf course, volleyball and basketball courts, and horseshoe pits.

Maumee Bay State Park

Tar Hollow State Park

Tar Hollow State Park and the adjacent state forest are nestled in the foothills of the Appalachian Plateau. The 604-acre park offers a range of moderate to difficult hiking trails that explore the hills, forests, and steep ravines. The 15-acre Pine Lake is perfect for canoes and row boats.

Other Ohio State Parks

- **Maumee Bay State Park (near Toledo)**
- **Kelleys Island State Park (Kelleys Island)**
- **Deer Creek State Park (near Mt. Sterling)**
- **Malabar Farm State Park (Richland County)**
- **Punderson State Park (Newbury)**
- **Geneva State Park (Geneva)**

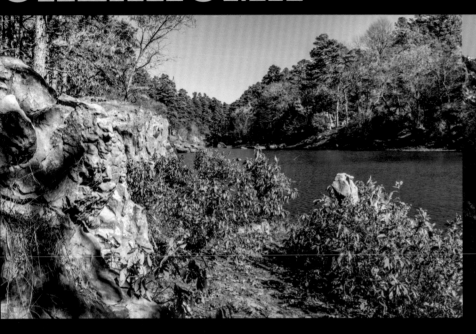

Robbers Cave State Park
Amazing cliffs just outside Wilburton draw climbers, rappelers, hikers, runners, and horseback riders to this scenic state park. Oklahoma criminal Belle Starr and famed outlaw Jesse James are said to have once hidden from their pursuers in Robbers Cave. The park and surrounding wildlife management area cover more than 8,000 acres.

Boiling Springs State Park
Though it's found on the central plains near Woodward, Boiling Springs–one of Oklahoma's seven original state parks–is anything but arid. There's a natural spring feeding water to the surface. "Boiling" is a bit misleading, as the water is actually quite cool. Make sure to spend some time at the informative, on-site interpretive center.

Natural Falls State Park
As the name of this Siloam Springs-area park suggests, tumbling water is the top attraction at Natural Falls. The 77-foot fall that gives the park its name is a wonder to see (and hear), which can be done from two up-close observation platforms. The surrounding woods are epic, too. Five unique yurts are among the many camping options.

Sequoia State Park

Believe it or not, there's a park in Oklahoma with 225 miles of shoreline. It's Sequoia, spanning the shores of Fort Gibson Lake and providing some of the best boating, fishing, and watersports in the Midwest. Its popularity for those and other activities keeps a 104-room lodge, 45 cottages, and numerous campsites hopping.

Lake Eufaula State Park

Lake Eufaula State Park is home to the largest man-made lake in Oklahoma and truly has something for everyone—from camping to hiking to wildlife viewing to an 18-hole golf course. The Arrowhead Area even has an airstrip for small private planes!

Beavers Bend State Park

With two different catch-and-release trophy areas, Beavers Bend State Park lures fishing enthusiasts from far and wide. It contains Broken Bow Lake and streams stocked with trout year-round, keeping its Lakeview Lodge bustling with guests.

Heavener Runestone State Park

A historical curiosity, the Heavener runestone is a 12-foot-tall slab of stone onto which eight letters have been carved. The carvings have been identified as Scandinavian runes. One theory suggests the stone is a Norse land claim dating back to the 8th century, left by Vikings traversing the Mississippi, Arkansas, and Poteau rivers. A visitor center at the 55-acre park on Poteau Mountain provides details.

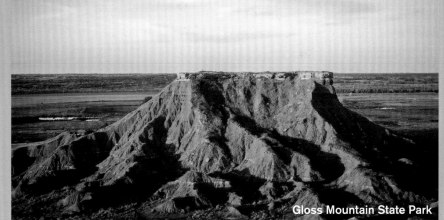

Gloss Mountain State Park

Other Oklahoma State Parks

- Alabaster Caverns State Park (near Freedom)
- Gloss Mountain State Park (near Fairview)
- Great Salt Plains State Park (near Jet)
- Lake Murray State Park (near Ardmore)
- Little Sahara State Park (near Waynoka)

Roman Nose State Park

One of Oklahoma's first state parks, Roman Nose (est. 1937) near Watonga was named after Cheyenne chief Henry Roman Nose. In addition to lakes, hiking trails, swimming pools, and an 18-hole golf course, the park rents teepees to summertime campers.

Cottonwood Canyon State Park

The newest (2013) and second-largest (8,000 acres) state park in Oregon, Cottonwood Canyon is a product of several purchases and land mergers over a span of decades. It offers a massive network of all-purpose trails, great fishing, and some amazing wildlife viewing. The largest known herd of California bighorn sheep roam the area between Wasco and Condon.

Beverly Beach State Park

Tucked between Depoe Bay and Newport on the Pacific, Beverly Beach is a little slice of heaven. There are campsites with tent areas and heated yurts for rent. The iconic Spencer Creek Bridge is one of the most photographed spots here, although crashing ocean waves and the park's majestic trees are not far behind.

Milo McIver State Park

Its proximity to Mount Hood in the northwest part of their state makes Milo McIver State Park a favorite among Oregonians. In fact, some of the best views of Mount Hood can be enjoyed from the park's new Memorial Viewpoint. The Clackamas River is popular for kayaking, canoeing, or lazily floating on inner tubes basked in nature's beauty.

The Cove Palisades State Park

A boater's and Jet Skier's paradise, the Lake Billy Chinook reservoir beckons at the confluence of the Deschutes, Metolius, and Crooked rivers just east of the Cascade Mountains. There's a short trail that leads to stunning views of the park. Boats can access The Island, a preserve that's technically off-limits but showcases Oregon's original high desert ecosystem.

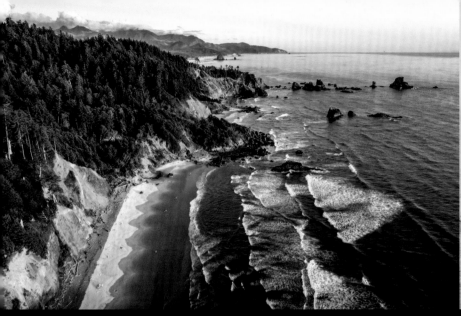

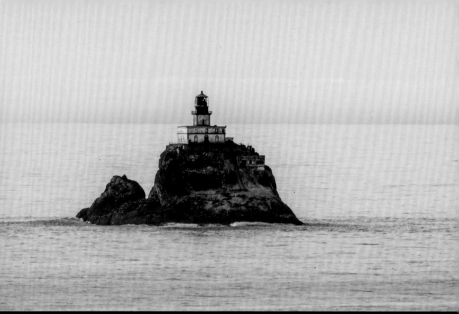

Ecola State Park

The park with the best views of the Pacific's Tillamook Rock Lighthouse is also famed for its two beautiful beaches and incredible hiking trails. The trails, through old-growth forest, meander along cliffs that overlook the ocean. Scenes from *The Goonies*, *Point Break*, *Twilight*, and *Kindergarten Cop*, among others, were shot at Ecola State Park.

(Above) The deactivated Tillamook Rock Lighthouse viewed from Ecola State Park

Cape Lookout State Park

Visitors will agree that Cape Lookout is aptly named once they see the views from this North Coast haven. Located on a sand spit between Netarts Bay and the ocean and easily accessed via 101, this popular park rents cabins nestled in the woods that overlook the Pacific. Yurts, tents, and deluxe cabins are also available for rent.

State Capitol State Park

Salem's State Capitol State Park is known for the State Capitol building, of course, along with green, pristine grounds that beg for a summer picnic. In 2019, however, the park introduced a "pop-up ranger" program that was a big hit with families. On summer Saturdays, patrons could produce their own art, learn about Oregon wildlife, and view several historic Oregon photos through a stereoscope.

Oswald West State Park

Oswald West has been called the most beautiful state park on Oregon's Pacific coast, thanks to Devils Cauldron's whipping waters, the majesty of Neahkahnie Mountain, and some of the best trails in the state. Its 2.5-mile Cape Falcon Trail provides perhaps the best view of the Pacific (above), along with a cutoff trail that overlooks beautiful Short Sand Beach (pictured below).

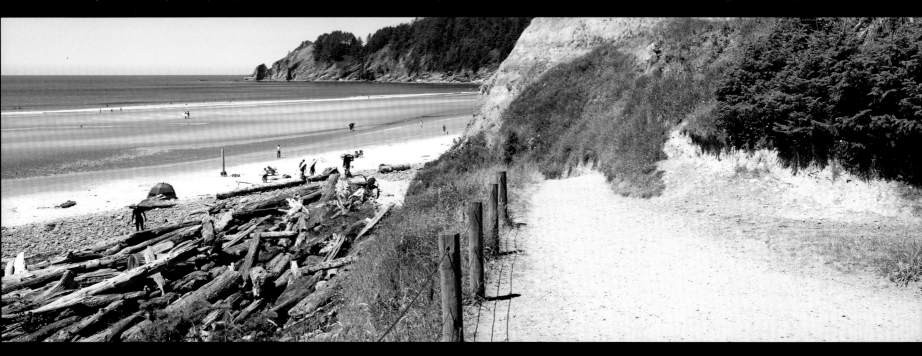

Silver Falls State Park

If you're going to hike one trail in Oregon, trek the Trail of Ten Falls loop in Silver Falls State Park. Its name says it all, and four of the 10 falls allow hikers to meander behind the falls for stunning photos. South Falls (pictured below) drops 177 feet and competes with the harder-to-access Double Falls (178 feet) for highest in the park.

Fort Stevens State Park

An active military outpost from 1863–1947 that's now listed on the National Register of Historic Places, Fort Stevens sits at the mouth of the Columbia River around what was the Three Fort Harbor Defense System. There's a military museum, oodles of sand, and—perhaps most photographed—the iconic remains of the *Peter Iredale* shipwreck of 1906 (above).

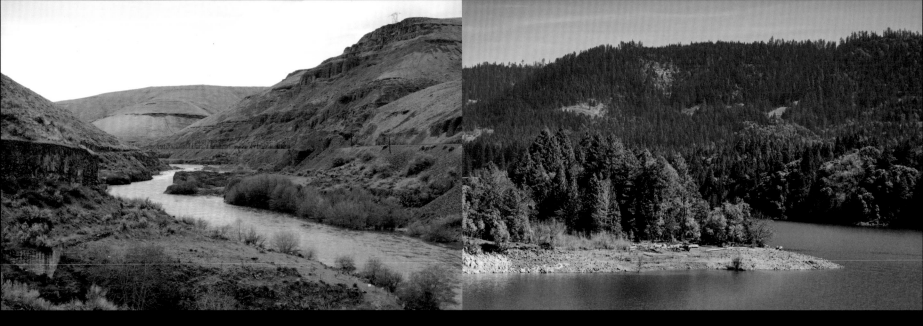

Deschutes River State Recreation Area

Deschutes River State Recreation Area sits at the confluence of the Deschutes and Columbia rivers in northern Oregon and has a 17-mile-long converted rail bed running through it. In addition to enticing visitors with its stunning views and great trails, it's one of 28 state parks in Oregon that offer year-round camping.

Valley of the Rogue State Recreation Area

Along the banks of the Rogue River and adjacent to Interstate 5 in the southern part of the state, Valley of the Rogue State Recreation Area is the most popular state park in Oregon. Its scenic trails and numerous recreation options drew 1.8 million day-use visitors in 2017.

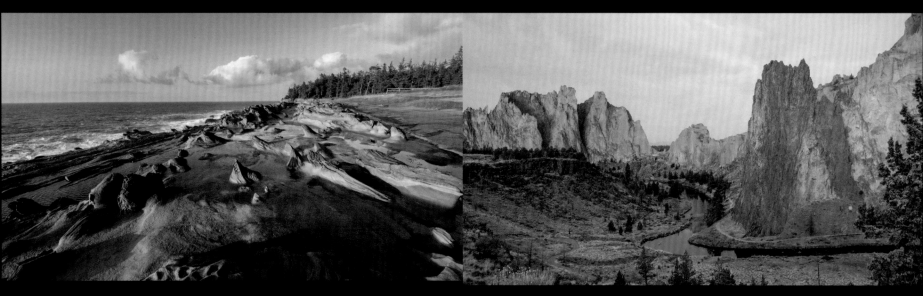

Shore Acres State Park

Shore Acres State Park is just south of Coos Bay, a quaint fishing village that produced distance running legend Steve Prefontaine. Its shores are nothing like those of Miami's South Beach, and for campers and outdoor enthusiasts that's probably a good thing!

Smith Rock State Park

Smith Rock State Park is widely considered the birthplace of modern American sport climbing. Located in central Oregon's high desert between Redmond and Terrebonne, the park's centerpiece is Smith Rock, whose cliff-face overlooks a bend in the Crooked River.

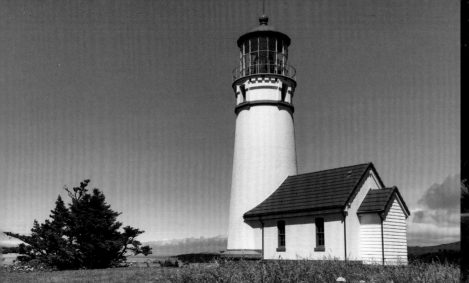

Cape Blanco State Park

Cape Blanco Light, first lit in 1870, is the calling card of Cape Blanco State Park on Oregon's southwest coast. In addition to learning about the lighthouse's history, visitors can check out a pioneer cemetery or the Hughes House, which is on the National Register of Historic Places.

Ukiah Dale-Forest State Scenic Corridor

Ukiah Dale-Forest State Scenic Corridor is a 14-mile scenic stretch in eastern Oregon that will take your breath away. There are seldom-used mountain trails and numerous camping options, but the MVPs here are the black bears, streams, and tiny hamlets along the way.

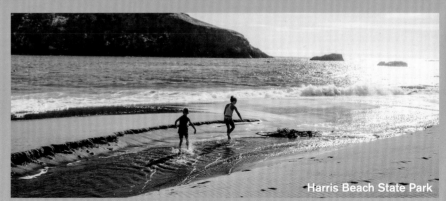

Harris Beach State Park

Sunset Bay State Park

Sunset Bay, just south of the Cape Arago Lighthouse on the Pacific Coast, is one of Oregon's most popular state parks. It's named for its magnificent sunsets, but guests will also enjoy views of the lighthouse and a "ghost forest," created by an earthquake some 1,200 years ago.

Other Oregon State Parks

- Harris Beach State Park (near Brookings)
- Wallowa Lake State Recreation Area (near Joseph)
- Jessie M. Honeyman Memorial State Park (near Florence)
- Jackson H. Kimball State Recreation Area (near Klamath Falls)
- Hug Point State Recreation Site (near Arch Cape)
- Cape Kiwanda State Natural Area (Pacific City)
- Willamette Mission State Park (near Salem)
- La Pine State Park (near Bend)

PENNSYLVANIA

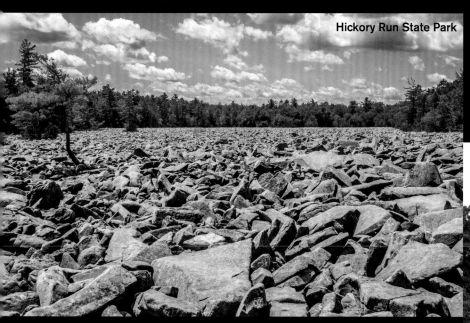

Hickory Run State Park

Hickory Run State Park

The large boulder field in Hickory Run State Park, located in the foothills of the Poconos, is listed as a National Natural Landmark. Guests can hop from boulder to boulder for 16 acres of the almost 16,000-acre park. There are also 44 miles of hiking trails and, in the warm weather months, a sand beach on swimmable Sand Spring Lake.

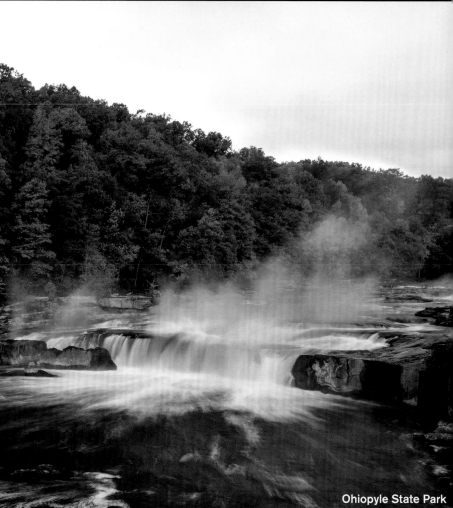

Ohiopyle State Park

Ohiopyle State Park

Some of the best (if not *the* best) rafting in the eastern United States, majestic waterfalls, and numerous hiking trails make Ohiopyle a well-known and oft-visited Pennsylvania gem. The Youghiogheny River provides the rapids that lure rafters from all over. In addition to the stunning waterfalls, there are rare natural waterslides that guests can ride.

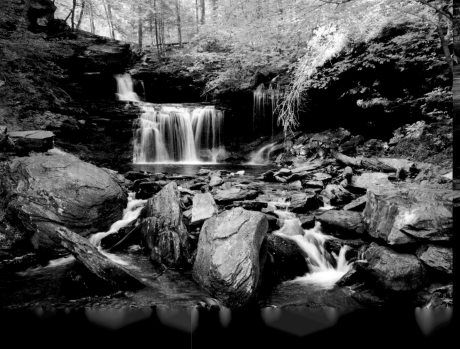

Ricketts Glen State Park

Ricketts Glen was on its way to becoming a national park in the 1930s before World War II came along. With those funds diverted to war causes, this park filled with two dozen waterfalls became a state park in 1944. Fishing, swimming, canoeing, and kayaking on Lake Jean are among the popular pastimes.

(Right) The Presque Isle Light was added to the National Register of Historic Places in 1983.

Presque Isle State Park

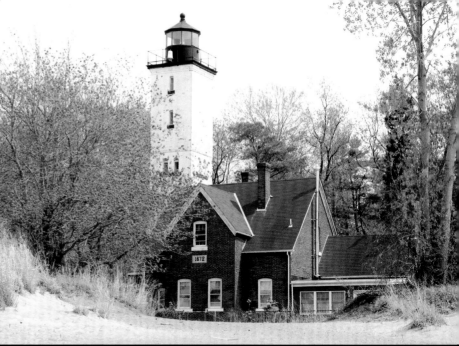

Presque Isle State Park

Its name is French for "almost an island," and the name fits. Presque Isle State Park is a peninsula jutting into Lake Erie about four miles west of the city of Erie. It contains 13 beaches and a marina—a great combination for those who love the water. A lighthouse, Presque Isle Light (above), began operation in 1873 and is still in use today.

Black Moshannon State Park

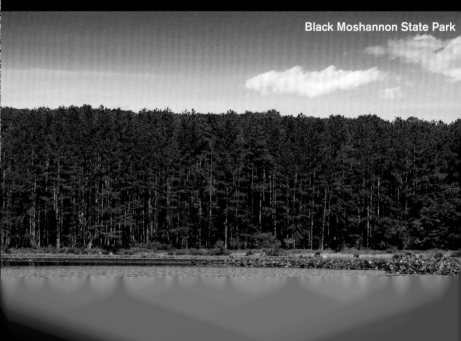

Black Moshannon State Park

Near Phillipsburg in the center of the state, this park touts "the largest reconstituted bog/wetland complex in Pennsylvania." A dam on Black Moshannon Creek formed the park's centerpiece, Black Moshannon Lake, which offers many of the recreational options within. More than 20 miles of trails are open to hikers, bikers, and cross-

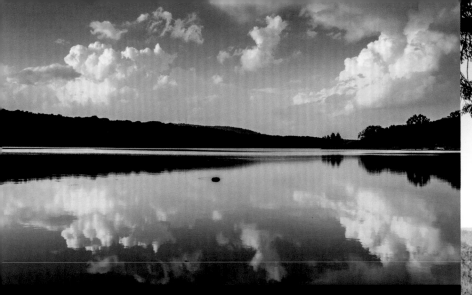

Gifford Pinchot State Park

Named after a Pennsylvania governor, conservationist, and first chief of the U.S. Forest Service, Gifford Pinchot State Park south of Harrisburg showcases farm fields, undeveloped wooded areas, and supreme bass fishing. Among the park's 12 interconnected trails is the famous Mason-Dixon Trail.

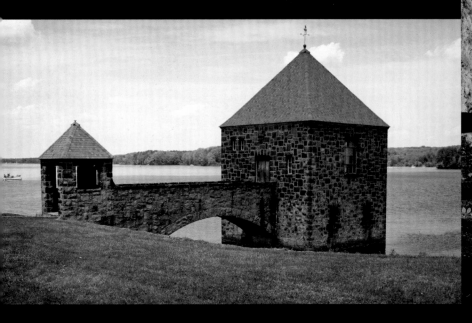

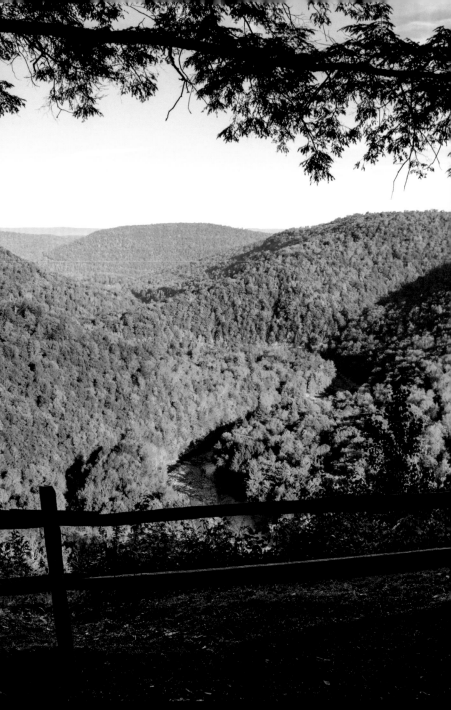

Pymatuning State Park

Bald eagles nest in stunning Pymatuning State Park, a portion of which stretches into neighboring Ohio. The northwest Pennsylvania park gets its name from a former chief of the Lenape tribe, its original inhabitants. At more than 21,000 acres, it's Pennsylvania's largest state park.

Worlds End State Park

Surrounded by the Loyalsock State Forest, Worlds End State Park in Sullivan County was originally settled by the Susquehanna before the sawmills took over. The park has rebounded beautifully, providing a one-of-a-kind setting for hiking, swimming, boating, and wildlife viewing.

Cook Forest State Park

This old-growth hemlock is one of several old-growth trees in northwest Pennsylvania's Cook Forest State Park. The evergreens here once grew so thick that the area was known as Black Forest. Hiking and biking trails abound, and two trails are open to horses. Fish bite in the Clarion River and in a stocked trout pond for the little ones.

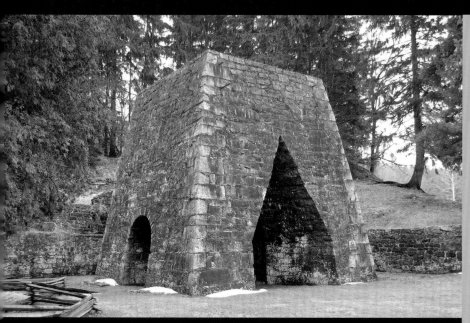

Colton Point State Park

Greenwood Furnace State Park

Greenwood Furnace State Park is a must-see for Pennsylvania history buffs. About 20 miles from State College, home to Penn State University, the park includes a ghost town (Greenwood) and the remains of an iron furnace that was once central to the area's economy. There are several hiking trails, and 320 acres of the park are open for hunting (in season, of course).

Other Pennsylvania State Parks

- Big Pocono State Park (Monroe)
- Archbald Pothole State Park (Archbald)
- Mont Alto State Park (Quincy Township)
- Colton Point State Park (Shippen Township)
- Delaware Canal State Park (between Easton and Bristol)

Beavertail State Park

Beavertail State Park, located on Conanicut Island in Narragansett Bay, Rhode Island, offers some of the most beautiful vistas along the New England coastline. The main attraction at this popular park is Beavertail Light. The first lighthouse was raised here in 1749. Four years later, it was destroyed by fire and rebuilt. The present tower was completed in 1856. It supports a flashing, white electric light visible about 20 miles out to sea. The assistant-keeper's house (completed in 1898) is maintained by the state of Rhode Island as a lighthouse museum. Beavertail State Park also offers ample sightseeing opportunities (from the car or on foot), hiking trails, the area's best saltwater fishing, and seasonal nature programs.

Colt State Park

Colt State Park is often referred to as the "gem" of the Rhode Island state parks system. The park occupies 464 acres in Bristol once owned by industrialist Samuel P. Colt. The entire western border of the park is an open panorama onto Narragansett Bay. Open year-round, Colt State Park offers several large playfields, six picnic groves containing over 400 picnic tables, a 55-foot observation tower, a public boat ramp, a historical museum, and its popular open-air Chapel-By-The-Sea. The park also has four miles of bike trails and is a stop on the East Bay Bike Path.

(Above) The scenic Beavertail Light occupies its own state park, Beavertail State Park, located near Jamestown, Rhode Island. During World War II, the park area was part of Fort Burnside, one of several coastal fortifications designed to protect Narragansett Bay.

Misquamicut State Beach

Misquamicut State Beach, near the western tip of the state, is enjoyed by locals and tourists alike. This stretch of sand is lined with family-friendly amusements and snack bars.

Fort Adams State Park

Situated at the mouth of Newport Harbor, this state park preserves Fort Adams, a large coastal fortification active from 1841–1965. Fort Adams State Park is famous for hosting Newport's annual jazz and folk festivals. Popular activities at the park include swimming, fishing, boating, soccer, rugby, and picnicking. Visitors can also tour Fort Adams and President's Eisenhower's "Summer White House."

(Above) Fort Adams State Park is home to the Eisenhower House, President Dwight D. Eisenhower's "Summer White House." The Fort Adams Trust offers guided tours.

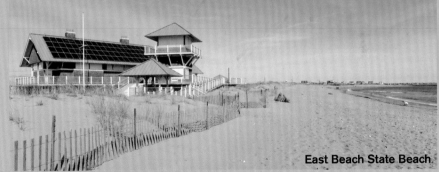

East Beach State Beach

Goddard Memorial State Park

Goddard Memorial State Park in Warwick, Rhode Island, offers a 9-hole golf course, an equestrian show area, miles of equestrian trails, picnic tables, game fields, and a performing arts center for weddings, concerts, and special events.

Rhode Island State Beaches

- **East Beach State Beach (Charlestown)**
- **Charlestown Breachway State Beach (Charlestown)**
- **East Matunuck Beach State Park (South Kingstown)**
- **Roger W. Wheeler State Beach (Narragansett)**
- **Salty Brine State Beach (Narragansett)**
- **Scarborough State Beach (Narragansett)**

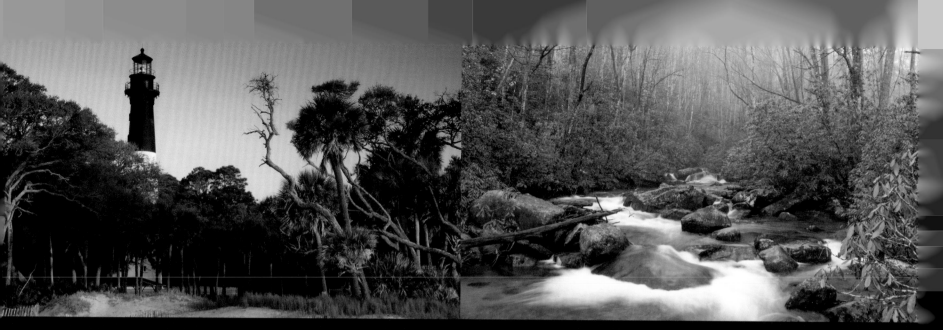

Hunting Island State Park

The most visited state park in South Carolina is famed for its 19th-century lighthouse, Hunting Island Light. Hunting Island, a barrier island, was stripped by the 1893 Sea Islands Hurricane but the lighthouse survived and is open year-round to the public. Loggerhead turtles and a wide variety of birdlife can be spotted here.

Jones Gap State Park

Near Marietta on South Carolina's northern border, Jones Gap varies in elevation between 1,000 and 3,000 feet and includes the headwaters of the Middle Saluda River. Iconic bridges, shallow lagoons, more than 60 species of mammal, and 600-some wildflower types keep visitors' cameras and cell phones fully engaged.

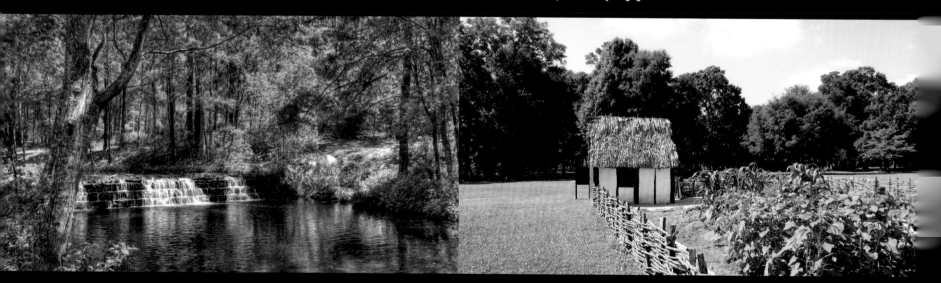

Sesquicentennial State Park

Right in the middle of Columbia, South Carolina's capital, is an almost 1,500-square-foot oasis from city life in the form of Sesquicentennial State Park. Locals call it "Sesqui," and they head there for picnics, hiking, overnight camping, and even the occasional Civil War reenactment.

Charles Towne Landing State Historic Site

The first permanent English settlement in the Carolinas is honored at this history-rich Charleston state park. A replica ship, hut, and garden like the ones used by the settlers who landed in 1670 are on display, along with cannons that can still be fired. Just don't hit the

Landsford Canal State Park

The ruins of the Landsford Canal give this park both its name and its appeal. There's an informative interpretive museum in the former lock keeper's house. From mid-May to mid-June, this hiker's delight in Chester County showcases one of the largest remaining stands of *Hymenocallis coronaria*, the Shoals spider-lily.

Paris Mountain State Park

Many of the structures in Paris Mountain State Park near Greenville appear on the National Register of Historic Places. The park's 1,540 beautiful acres include 13-acre Lake Placid, a popular swimming and fishing spot.

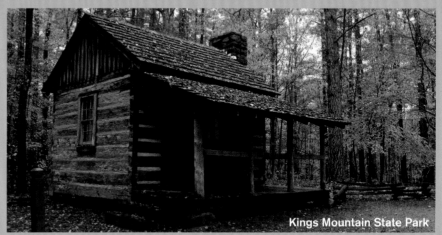

Kings Mountain State Park

Lake Hartwell State Park

Sure, there are hiking trails, a playground, and campsites at Lake Hartwell State Park near Fair Play. But make no mistake—there's one reason folks flock to its 14 miles of shoreline. Fishing. Boating is a close second, but the fishing off this park's shores is among the best in the southeast United States.

Other South Carolina State Parks

- Andrew Jackson State Park (near Lancaster)
- Kings Mountain State Park (near Blacksburg)
- Musgrove Mill State Historic Site (near Spartanburg)
- Poinsett State Park (near Wedgefield)

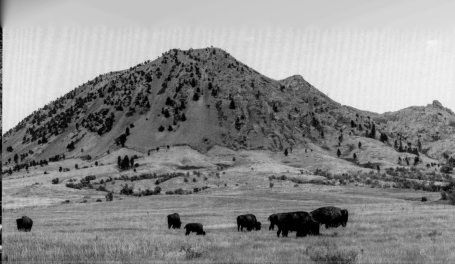

Roughlock Falls Nature Area

Roughlock Falls Nature Area, located in Spearfish Canyon, is one of the prettiest places in the Black Hills. The water feeding Roughlock Falls (above) flows into Spearfish Canyon from Little Spearfish Creek. Designated walking paths and hiking trails offer an excellent opportunity to explore the nature area. Visitors can enjoy bird-watching, fishing, wildlife viewing, and picnicking at this day-use park.

Bear Butte State Park

Mato Paha (Bear Mountain) is the Lakota name for this site. To the Cheyenne, it is known as Noahvose. The 1,200-foot mountain near Sturgis is sacred to many Native American tribes. Hikers may see colorful pieces of cloth or small bundles hanging from trees on the nearly two-mile Summit Trail—these prayer cloths and tobacco ties represent the prayers offered during worship. Bear Butte State Park advises visitors to leave these religious offerings undisturbed. The park in western South Dakota offers camping, hiking, horseback riding, fishing, and boating opportunities.

Palisades State Park

Palisades State Park in eastern South Dakota draws people from all over the country with its unique rock formations. Split Rock Creek, which flows through the park (and also through

(Left) Sioux quartzite formations in Palisades State Park vary from shelves several feet above the water to 50-foot vertical cliffs.

(Above) A truss bridge spanning Split Rock Creek within the park's borders is on the

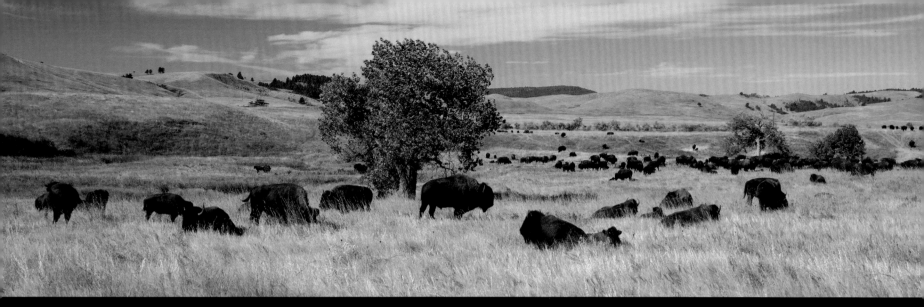

Custer State Park

Custer State Park is South Dakota's largest state park, encompassing 71,000 acres in the southern Black Hills. Wildlife abounds here. The park is home to one of the nation's largest free roaming bison herds, bighorn sheep, antelope, white-tailed and mule deer, burros, elk, coyote, prairie dogs, and a host of bird species. Traveling on Needles Highway and Wildlife Loop Road is a great way to see these animals. Custer State Park offers hiking, biking, swimming, fishing, rock climbing, canoeing, kayaking, horseback riding, historic sites, and guided nature tours. Its nine campground areas offer everything from primitive backcountry camping and camper cabins to luxurious lodge rooms.

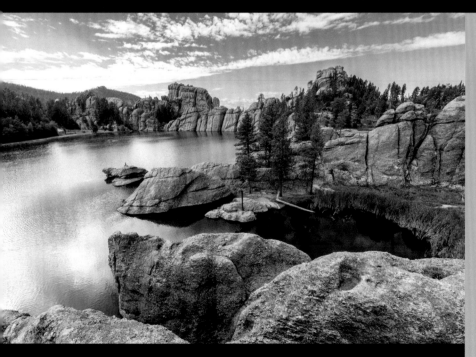

(Above) Located in Custer State Park, Sylvan Lake is the oldest reservoir in the Black Hills of South Dakota. Take time to swim, fish, hike, camp, or rock climb in the area.

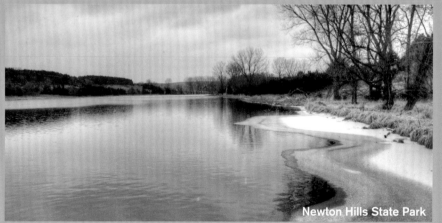

Newton Hills State Park

Other South Dakota State Parks

- Good Earth State Park at Blood Run (near Sioux Falls)
- Fort Sisseton Historic State Park (near Lake City)
- Oakwood Lakes State Park (Oakwood)
- Lake Herman State Park (Madison)
- Newton Hills State Park (Canton)

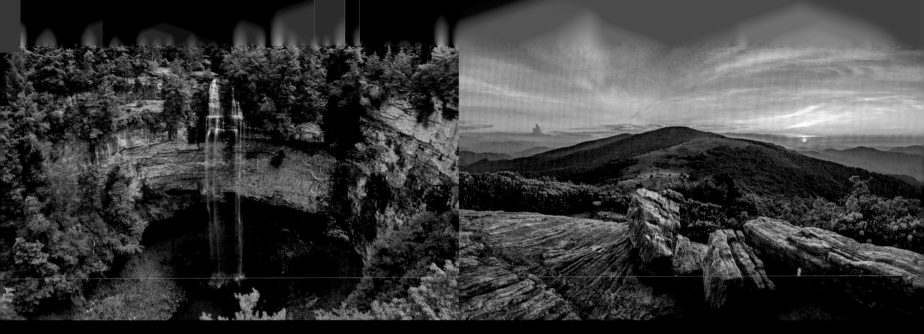

Fall Creek Falls State Park

The largest and most visited of Tennessee's state parks is overflowing, literally, with natural beauty. Its waterfalls, gorges, and streams provide more than enough entertainment for visitors, but there's plenty on top of that. Fall Creek Falls is a resort-style park, with extras like a zipline park and horseback riding on the Cumberland Plateau.

Roan Mountain State Park

Near the North Carolina border in the Blue Ridge of the Appalachian Mountains sits one of the most breathtaking state parks you'll see. Roan Mountain is a favorite for too many reasons to count, whether it's the wild rhododendrons with viewing areas, furnished cabins, authentic 1908 Appalachian settlement, or hiking trails divided by experience level.

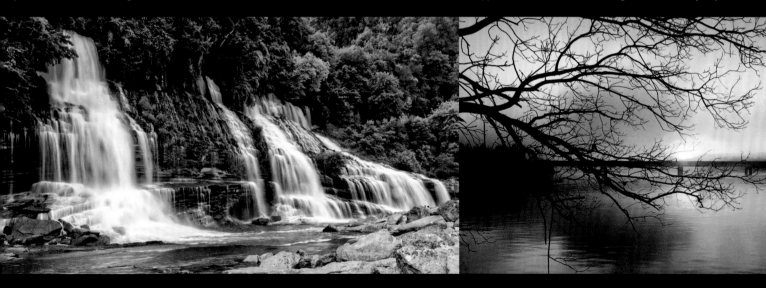

Rock Island State Park

A central-state favorite among Tennesseans, Rock Island State Park is renowned for its whitewater. Kayakers flock from all over the country to enjoy the rapids, but they're only a small slice of the beauty this park offers. Sandy beach, diverse hiking trails, and rich history in the form of a spring house and abandoned textile mill all make Rock Island worth the trip.

Tims Ford State Park

This 1,300-acre park surrounding the Tims Ford Reservoir is considered one of the most scenic in Tennessee. World-class bass fishing brings anglers from across the globe. Swimming is not allowed in the lake due to the high volume of traffic, but there's an Olympic-sized pool for those wanting to take a dip.

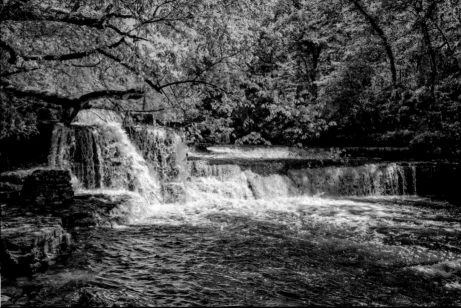

Montgomery Bell State Park

An old country church is one of the many camera-friendly spots awaiting visitors to middle Tennessee's Montgomery Bell State Park. The park's namesake built one of the state's top iron industries. These days, the park is home to fantastic fishing, swimming, and mountain biking.

Old Stone Fort State Park

Manchester's Old Stone Fort State Park, at the confluence of the Duck and Little Duck rivers, boasts Step Falls among its scenic points of interest. The park was once a ceremonial gathering place among Native Americans.

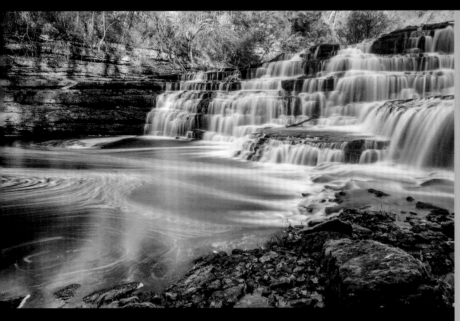

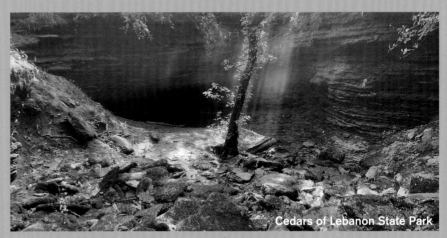

Cedars of Lebanon State Park

Burgess Falls State Park

A native butterfly garden and junior ranger day camps are among the family activities at Burgess Falls State Park. But it's the spectacular waterfalls that draw a crowd at this day-use-only park almost equidistant from Nashville, Knoxville, and Chattanooga in middle Tennessee.

Other Tennessee State Parks

- Big Ridge State Park (Maynardville)
- Cedars of Lebanon State Park (near Lebanon)
- Cummins Falls State Park (near Cookeville)
- Natchez Trace State Park (near Wildersville)
- Pickwick Landing State Park (Pickwick Dam)

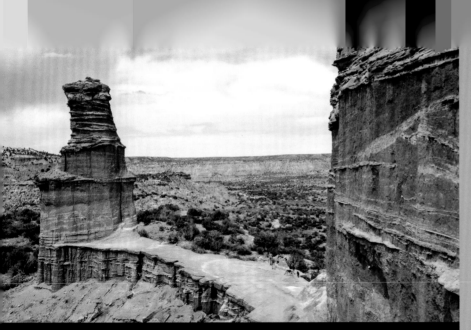

Junior Rangers

Texas Parks and Wildlife offers a free Junior Ranger youth explorer program for the youngsters in the family. At park headquarters or the ranger station, children can pick up a Junior Ranger Journal to fill out and take home, and can borrow (for the day) explorer packs that include binoculars, magnifying glass, an animal tracking key, and guides to what they might see.

Palo Duro Canyon State Park

The second-largest canyon in the U.S., Palo Duro Canyon is sometimes referred to as the Grand Canyon of Texas. It elicits similar "oohs" and "aahs" from first-time visitors as the original. The park is about 60 miles long and up to 20 miles wide in places. It reserves 1,500 acres for horseback riders, but there are spectacular trails for hikers and mountain bikers, too.

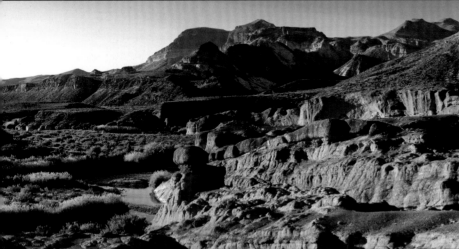

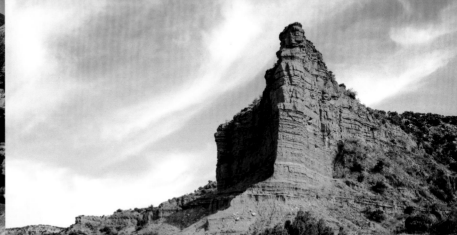

Big Bend Ranch State Park

Adjacent to Big Bend National Park, Big Bend Ranch is the largest state park in Texas at more than 300,000 acres. Its ecosystem is Chihuahuan desert, giving it rugged landscape replete with hoodoos and all kinds of wildlife. A dip in the Rio Grande provides perfect relief from the region's dry heat, and campers enjoy a night sky that seems to stretch forever.

Caprock Canyons State Park and Trailway

Just south of Palo Duro in the Texas Panhandle awaits a state park with nearly 90 miles of trails to explore, including the Trailway–a 64-mile hiking, biking, and equestrian trail that follows the abandoned Fort Worth and Denver Railroad line. Once you catch your breath, the Caprock Escarpment will take it away again with stunning sandstone cliffs.

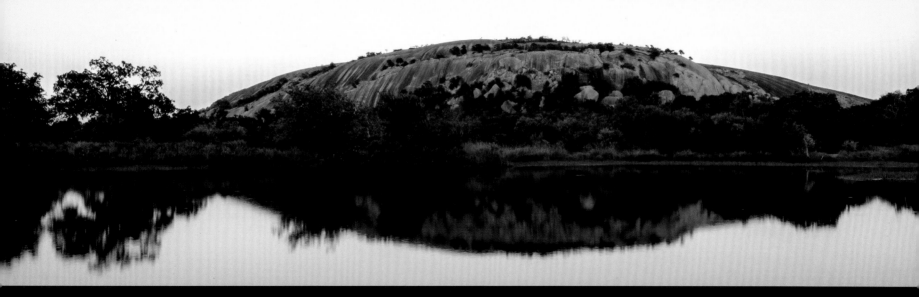

Enchanted Rocks State Natural Area

Rising some 425 feet above its surrounding terrain is a pink granite mountain in central Texas. Enchanted Rock is technically a pink, granite monadnock–the largest of its kind in the U.S. No matter what one calls it, the state park surrounding the National Natural Landmark has been ranked the best spot in Texas for camping.

Longhorn Cavern State Park

A limestone cave formed by an underground river that receded thousands of years ago, Longhorn Cavern has a rich and ancient history. Ice age animals, Native Americans, pioneer settlers, Confederate soldiers, bootleggers, and outlaws all called this central Texas area home at one time. Tours are available.

Lost Maples State Natural Area

Bigtooth maple trees are called "lost" in this central Texas natural area not because you can't find them, but rather because they don't usually grow in the region. Leftover from the cooler, wetter climate of the last ice age, they provide a perfect canopy for hikers and campers who visit.

Inks Lake State Park

Along Inks Lake and the Colorado River, this state park is a unique combination of rocky hills, rugged terrain, and beautiful blue water. Rock-surrounded Devils Waterhole, a small extension of Inks Lake, offers a canoe tour and is open for swimming (at one's own risk, as there's no lifeguard). There are seven miles of hiking trails.

Seminole Canyon State Park and Historic Site

One might expect to find a place called Seminole Canyon State Park and Historic Site in Florida. Instead, you'll find it along the Rio Grande on Texas's southwest border. While the views of the river are stunning, the Native American pictographs on one of the oldest cave dwellings in America—Fate Bell Shelter—might top them all.

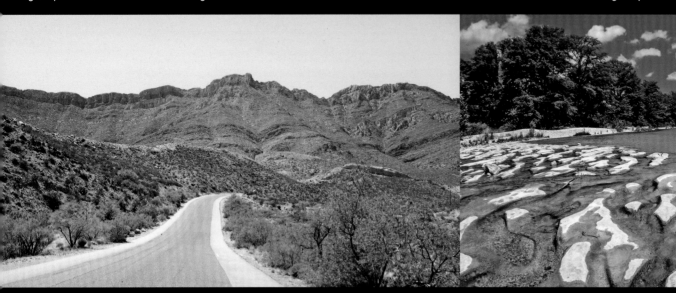

Franklin Mountains State Park

Franklin Mountains State Park, at 24,000-plus acres, is the biggest urban park in America lying completely within city limits (El Paso). The Franklin Mountains are the largest sustained range in Texas, with a peak elevation of 7,192 feet. Hikers and campers can enjoy the park year-round

Garner State Park

Garner State Park along the Frio River offers many of the same activities found in a lot of parks—fishing, camping, hiking, and even a mini golf course. However, it's the dances held nightly during spring and summer with an old-fashioned juke box that help set this place apart

Dinosaur Valley State Park

No, you won't see an actual dinosaur in Glen Rose's Dinosaur Valley State Park. You can, however, see imprints of dinosaur tracks left millions of years ago if the Paluxy River is low enough. That's why the park is also a National Natural Landmark.

Guadalupe River State Park

With four miles of river running through Guadalupe River State Park, the popular pastimes here include tubing, canoeing, kayaking, swimming, and fishing. For landlubbers, trails are open to hikers, horseback riders, and mountain bikers.

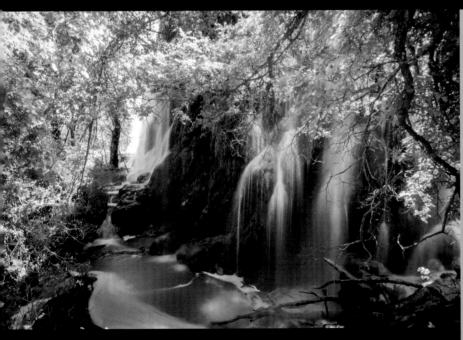

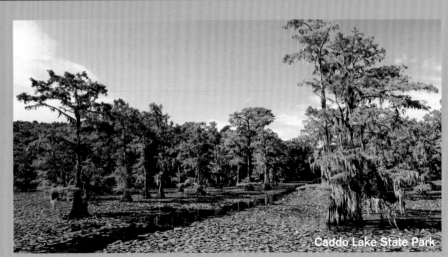

Caddo Lake State Park

Other Texas State Parks

- Caddo Lake State Park (Karnack)
- Davis Mountains State Park (Fort Davis)
- Monahans Sandhills State Park (Monahans)
- Pendernales Falls State Park (near Johnson City)
- Village Creek State Park (Lumberton)

Colorado Bend State Park

Sixty-five-foot Gorman Falls (pictured above) is the hands-down highlight of Colorado Bend State Park in the Hill Country region of Texas. But there are also caves, a travertine creek, and magnificent foliage to enjoy on hikes here.

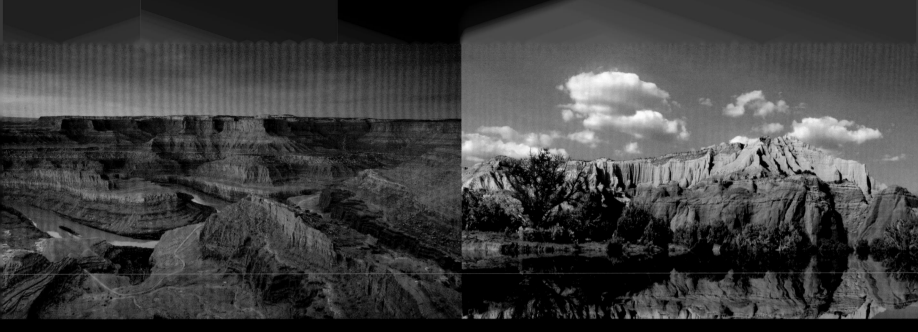

Dead Horse Point State Park

Not far from uber-popular Arches National Park there's a state park that's quieter and—if you can believe it—perhaps even more scenic. Dead Horse Point is a spectacular, 2,000-foot-high headland that overlooks the northern eye-candy of Canyonlands. The three-mile Rim Trail provides some of the most breathtaking views in the Southwest.

Kodachrome Basin State Park

Just east of the more famous and more populated Bryce Canyon, Kodachrome Basin—named not by Paul Simon but by members of a 1949 *National Geographic* expedition—features unique "sand pipes" formed by solidified ancient hot springs and geysers. Its elevation makes it cooler than many Utah hot spots and the night sky here is known as one of the best.

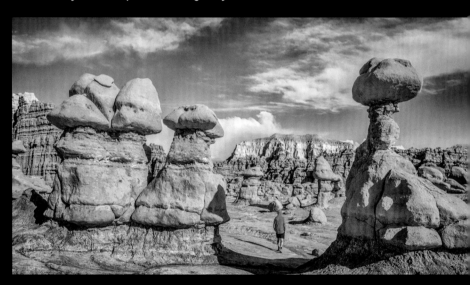

Edge of the Cedars State Park and Museum

This fascinating state park showcases the life of native peoples from A.D. 825 to 1125. Visitors can descend a ladder to enter a 1,000-year-old kiva and view other ruins, petroglyphs, and relics from ancestral Puebloan, Hopi, Ute, and Navajo people. The park's name comes from its location between the desert and the Manti-La Sal National Forest.

Goblin Valley State Park

It takes some doing for a Utah park's odd geologic structures to stand out above the rest, but the hoodoos at Goblin Valley do just that. Thousands of the mushroom-shaped wonders are clustered in a valley on the edge of the San Rafael Swell. The park's campsites are quite popular, so book early, or consider some of the free ones just outside the park.

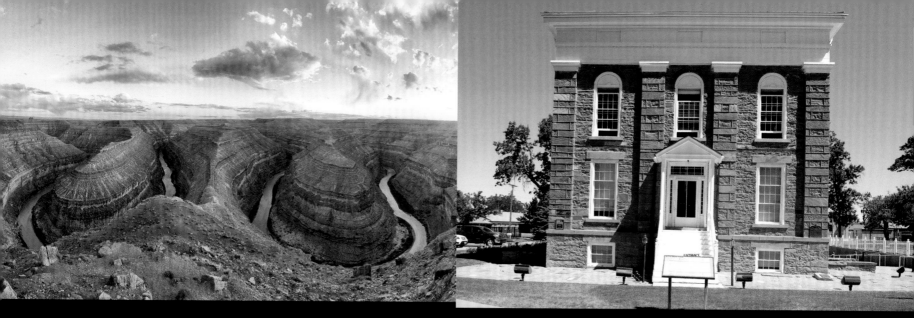

Goosenecks State Park

Near Mexican Hat, Goosenecks State Park showcases layer after layer of ancient geologic history, largely formed by the winding nature of the San Juan River. The park's facilities are primitive but its views and location–just north of Monument Valley and west of Valley of the Gods–are unparalleled.

Utah Territorial Statehouse

The Utah Territorial Statehouse, one of the four heritage parks that founded the state's parks system, is park and museum all in one. Built in the 1850s, it's the state's oldest government building.

Escalante Petrified Forest State Park

The multicolored wood of petrified trees drew visitors to this area just north of Escalante before Escalante Petrified Forest State Park was established in 1976. A visitor center was added in 1991 that contains fossilized dinosaur bones from the Upper Jurassic Period.

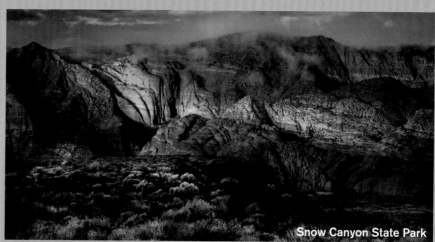

Snow Canyon State Park

Other Utah State Parks

- This Is the Place Heritage Park (Salt Lake City)
- Camp Floyd State Park Museum (Fairfield)
- Snow Canyon State Park (Washington)
- Green River State Park (Emery)

Grand Isle State Park

Grand Isle is the largest island around picturesque Lake Champlain and the perfect spot for a summer picnic or campout. Swimming, boating, canoeing, and kayaking are popular pastimes for state park visitors during the warm-weather months. The views of the lake are worth the trip.

Kingsland Bay State Park

There are few better spots to look for Champy, the sea monster who, according to folklore, lives in Lake Champlain. That's because if you don't spot him, you can always rent a canoe, kayak, or boat, hang out on the beach, play horseshoes, or go for a swim. Fifty acres are designated as the Kingsland Bay Natural Area.

Mount Philo State Park

Near Burlington, Mount Philo State Park offers access to scenic Lake Champlain for all kinds of water recreation, along with plenty to do on the land. The trails here are great hiking grounds—especially popular during peak tree-color season in the fall. Trek up to a

Elmore State Park

Elmore State Park, on Lake Elmore in northern Vermont, is a much smaller alternative to Lake Champlain for options like camping, swimming, fishing, or a day at the beach. There's also great bird-watching and wildlife viewing. Hiking options include the Fire Tower Trail, which

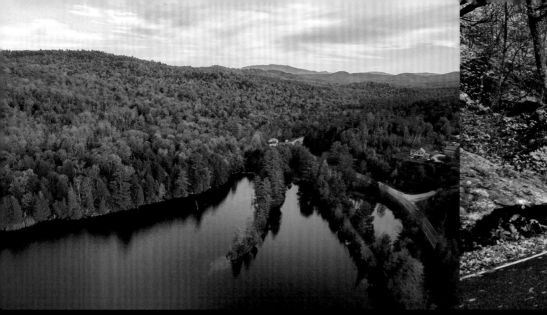

Ricker State Park

Ricker State Park is one of seven state parks found in Groton State Forest. Developed in the 1930s by the Civilian Conservation Corps, it allows access to 95-acre Ricker Pond for all sorts of water activities, along with snowshoeing and cross-country skiing during the winter.

Smugglers' Notch State Park

Route 108 winds through Smugglers' Notch State Park near Stowe, Vermont. Situated in the Green Mountains, the park offers hiking trails, tent and trailer campsites, and plenty of breathtaking scenery.

Burton Island State Park

A colorful sign in Burton Island State Park points to several other locations, but visitors to the island park have every reason to be content right where they are. Accessible only by boat near the Canadian border, it's a beautiful spot to picnic, hike, fish, swim, or boat.

Button Bay State Park

Other Vermont State Parks

- Button Bay State Park (Ferrisburgh)
- Half Moon Pond State Park (Hubbardton)
- Mt. Ascutney State Park (near Windsor)
- Stillwater State Park (Groton)

Grayson Highlands State Park

Proximity to Virginia's two highest mountains, Mount Rogers and Whitetop Mountain, and its epic hiking trails make Grayson Highlands a must-visit park for those on the eastern seaboard. Scenic horse trails and hikes leading to waterfalls and overlooks abound. There's plenty of camping, and the Appalachian Trail is accessible year-round.

First Landing State Park

This Virginia Beach/Chesapeake Bay gem was Virginia's first planned state park and has a spot on the National Register of Historic Places. It's also the state's most popular, hosting more than a million visitors every year. It's no wonder, given its unique bald cypress swamps, lagoons, maritime forest, wildlife, and birds, along with a host of outdoor recreational offerings.

Hungry Mother State Park

Named for the legend of a young child who could only utter the words "hungry mother" in an effort to help rescuers find his mom, this western Virginia state park is a fave among campers, boaters, and hikers. Its trails offer amazing views, and its Hemlock Haven was the

Pocahontas State Park

Chesterfield's Pocahontas State Park, not far from the state capital of Richmond, spans almost 800 acres of trails, streams, lakes, and foliage. Performers at its amphitheater captivate audiences much like 64 miles of trails hold the attention of active visitors.

York River State Park

A long fishing pier, boat ramp, rich marine and plant life, fresh water and salt water, and 30-plus miles of hiking, biking, and equestrian trails draw loads of visitors to York River State Park on the south bank of the York River. There's evidence of Native American habitation some 3,000 years ago. The park is listed on the National Register of Historic Places.

Chippokes Plantation State Park

Chippokes Plantation State Park showcases one of the oldest continually farmed communities in the country–a working farm since 1619. The park has an Olympic-sized swimming pool, plenty of hiking and camping, and access to the Historic James River.

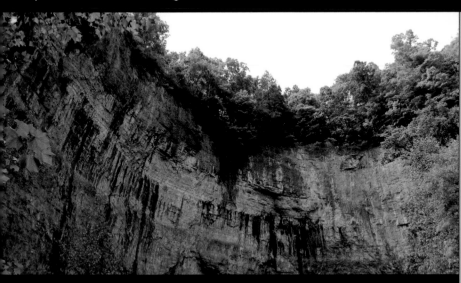

Natural Tunnel State Park

Natural Tunnel was carved through a limestone ridge over thousands of years. Some 200 feet wide, up to 80 feet high, and running more than 850 feet long through the Appalachian Mountains, trains can go through it. Natural Tunnel State Park visitors will enjoy a swimming pool with a 100-foot slide, the Wilderness Road historic area, and a chairlift that operates seasonally.

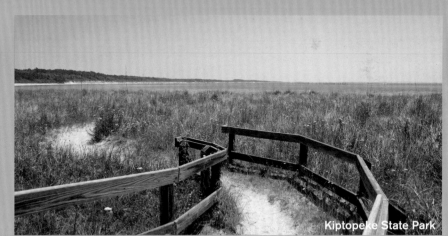

Kiptopeke State Park

Other Virginia State Parks

- **High Bridge Trail State Park (near Farmville)**
- **Kiptopeke State Park (near Cape Charles)**
- **Smith Mountain Lake State Park (Huddleston)**
- **Twin Lakes State Park (near Green Bay)**

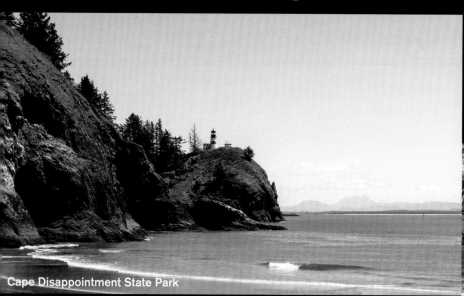

Cape Disappointment State Park

Cape Disappointment State Park

Perhaps the least-aptly named spot in the country, Cape Disappointment thrills both history buffs and hikers. For the former, two lighthouses—one the oldest working lighthouse on the west coast (1856)—stand tall on the cape that got its name when an English ship missed its mark and could not find the Columbia River in 1788. For the latter, eight miles of trails take guests past stunning shoreline to secluded coves.

Flaming Geyser State Park

Flaming Geyser State Park

This park was named (and once known) for two geysers, one of which spewed a massive flame for much of the 20th century due to an underground methane gas pocket. That flame no longer burns, though the geysers can still be viewed on a short hike. These days, Flaming Geyser State Park is a hot destination for hikers, boaters, tubers, and—in the fall—hopeful chinook anglers.

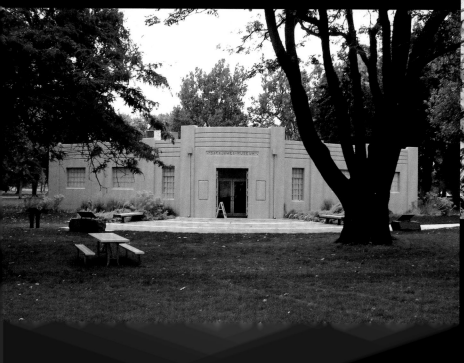

Sacajawea State Park

Sacajawea State Park, which lies along the 367-mile Northwest Discovery Water Trail in Pasco, celebrates the life of the savvy Lemhi Shoshone woman who helped Lewis and Clark trek from Missouri to the Pacific Ocean. There's an interpretive center and ancient artifacts for those interested in the history of the place, and a single campsite that's only

Sun Lakes-Dry Falls State Park

The Missoula Floods some 15,000 years ago gave this area a waterfall that was once several times the size of Niagara Falls. Now it's a bone-dry cliff measuring 400 feet high and 3.5 miles wide that overlooks a desert oasis at Sun Lakes-Dry Falls in central Washington. Hikers will enjoy the views, and the park also offers golf, swimming, boating, and fishing.

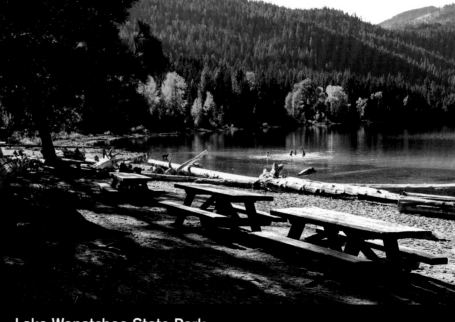

Lake Wenatchee State Park

Lake Wenatchee State Park is divided into north shore and south shore areas and is a freshwater playground for fishing, boating, waterskiing, whitewater kayaking, and numerous winter activities, too. Views of the nearby Cascade mountain range are stunning. There are two different campgrounds in the park.

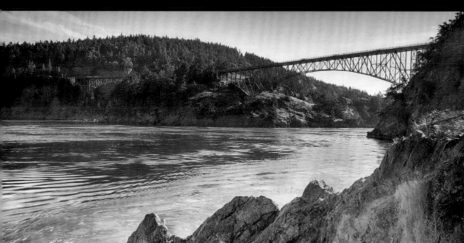

Deception Pass State Park

Deception Pass, the strait separating Whidbey and Fidalgo islands in northwest Washington, boasts one of the state's most visited parks. It hosts about two million visitors each year, many to enjoy its beaches, tidepools, and variety of trails. Within its bounds are 10 different islands and several miles of the Pacific Northwest Trail, including the Highway 20 bridge, along with numerous spots that have appeared as Hollywood film settings.

Lime Kiln Point State Park

Located on the jagged west coast of San Juan Island, this 36-acre day-use park is often referred to as "Whale Watch Park." It's one of the best spots on Earth to view wild orcas from land. Lime Kiln Lighthouse (above), still operational, is worth a tour (and a few photos). And while lime kilns no longer burn on the grounds, one has been restored so visitors can take a look.

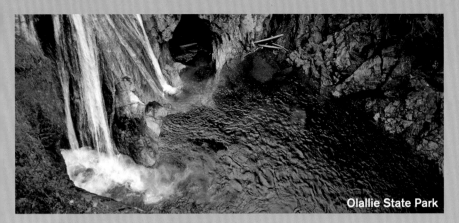
Olallie State Park

Going for the Gold

Washington State Parks was a finalist in the National Recreation and Park Association Gold Medal Awards program in 2017 and 2019. The program "honors communities in the U.S. that demonstrate excellence in parks and recreation through long-range planning, resource management, volunteerism, environmental stewardship, program development, professional development and agency recognition." Washington State Parks manages 124 state parks, 13 interpretive centers, 770 historic structures, a variety of heritage sites, and 500 miles of long-distance trail. With more than 37 million visitors annually, the state's parks contribute an economic impact of $1.4 billion.

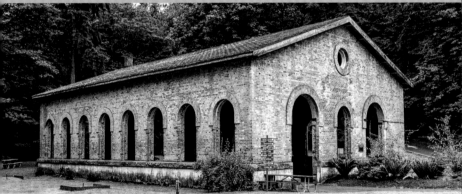

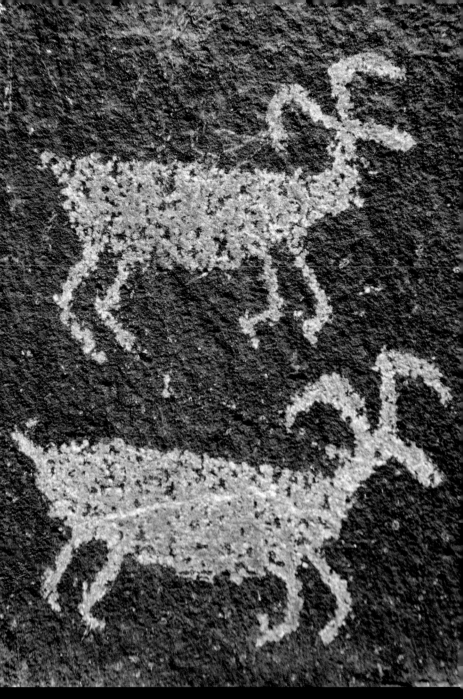

Manchester State Park

Once called Fort Middle Point, this area was built on the Kitsap Peninsula, across Puget Sound from Seattle, to protect that body of water and the Bremerton Naval Shipyard in the early 20th century. Manchester State Park is now home to walks along a winding shoreline, picnics in an abandoned torpedo warehouse, and camera-worthy views in all directions.

Gingko Petrified Forest State Park

This eastern Washington state park contains one of the country's most diverse assortments of petrified wood—more than 50 species, including the park's namesake gingko. The Wanapum people who greeted Lewis and Clark once lived on the grounds. Several well-preserved petroglyphs are on display at the park and its interpretive center.

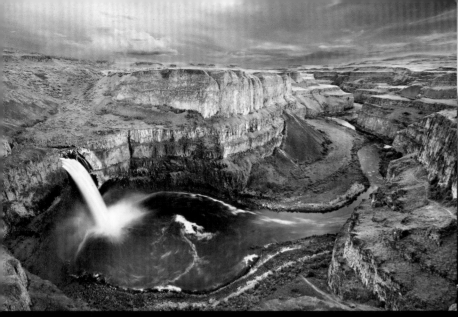

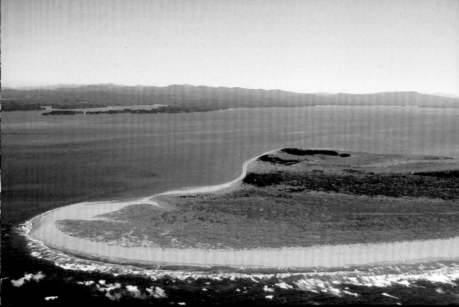

Palouse Falls State Park

The 198-foot Palouse Falls waterfall gives this park in the southeast corner of Washington its name and its signature. Interpretive signs outline its history, both geological and cultural. The trail to the falls overlook is short and manageable. Camping in the park is tent-only.

Leadbetter Point State Park

On the northern tip of the Long Beach Peninsula beckons Leadbetter Point State Park, a public recreation area and nature preserve. Martha Jordan Birding Trail takes visitors through a trumpeter swan wintering ground. Clamming is among the popular beach activities.

Birch Bay State Park

Birch Bay State Park, north of Bellingham and just a few miles south of Canada, is one fantastic spot to soak in a sunset. It's also a great place to see two mountain ranges (Canadian Gulf and Cascade), harvest hard-shell clams, camp, or picnic on a bench by the shore.

Mount Spokane State Park

Mount Spokane State Park, 23 miles from Spokane in the Selkirk Mountains, has year-round activities for just about everyone. The largest of Washington's state parks (at about 13,000 acres) offers a ski and snowboard park in the winter and one of the most extensive trail systems for warmer-weather runners and hikers.

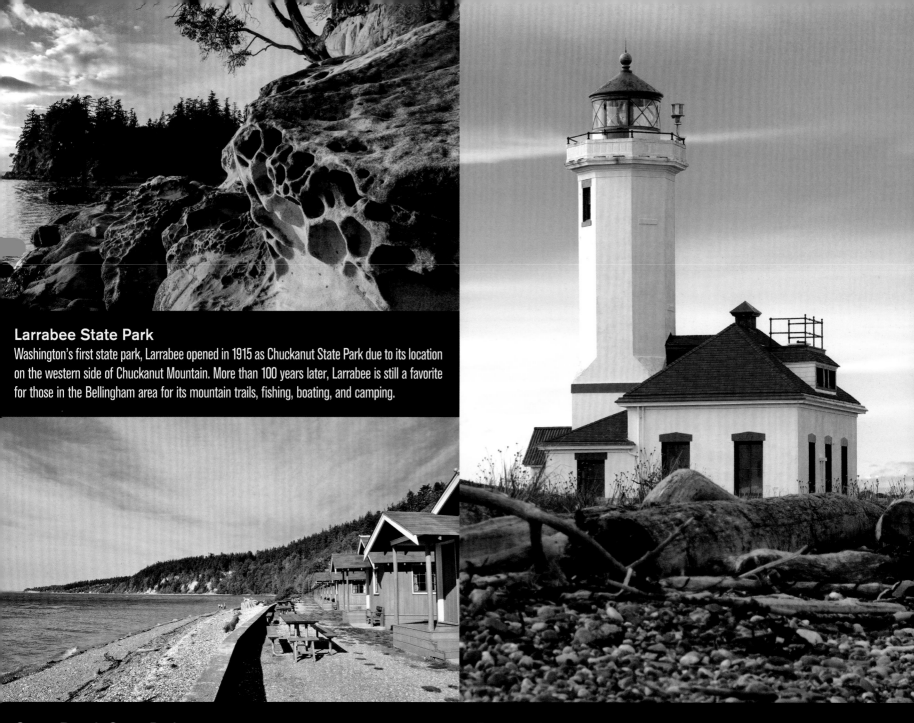

Larrabee State Park

Washington's first state park, Larrabee opened in 1915 as Chuckanut State Park due to its location on the western side of Chuckanut Mountain. More than 100 years later, Larrabee is still a favorite for those in the Bellingham area for its mountain trails, fishing, boating, and camping.

Cama Beach State Park

Beachfront cabins make Cama Beach State Park an overnight favorite on the southwest shore of Camano Island. The park's Center for Wooden Boats offers free, family-friendly programs during the summer, helping turn first-time visitors into regulars.

Fort Worden Historical State Park

Point Wilson Lighthouse (above) adds a touch of extra class—and history—to Fort Worden Historical State Park along Puget Sound's Admiralty Inlet. Fort Worden was an active U.S. Army base for the first half of the 20th century, a history celebrated and preserved by the park.

Crawford State Park Heritage Site

One of the longest natural limestone caves in Washington, Gardner Cove (above) is preserved at Crawford State Park Heritage Site on the U.S.-Canada border. The park offers cave tours seasonally, giving visitors a close look at stalactites, stalagmites, and rimstone pools.

Peshastin Pinnacles State Park

Rock climbers and hikers love Peshastin Pinnacles State Park, three miles northwest of Cashmere in central Washington. Its unique sandstone slabs and spires are also fascinating for those who prefer to photograph nature rather than climb it. The wildlife viewing is terrific here, too.

Olmstead Place State Park

Olmstead Place State Park, in Kittitas County, is listed on the National Register of Historic Places. The 217-acre park preserves a working pioneer farm. Visitors can tour the farm and learn about its history. There's also nearby hiking and fishing for the outdoor lovers.

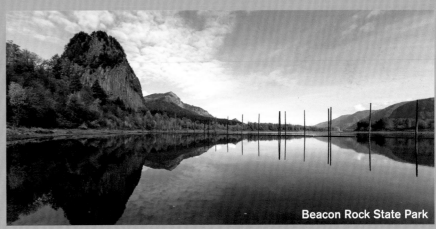

Beacon Rock State Park

Other Washington State Parks

- Beacon Rock State Park (near Washougal)
- Fields Spring State Park (near Anatone)
- Olallie State Park (near North Bend)
- Riverside State Park (near Spokane)
- Wallace Falls State Park (near Gold Bar)

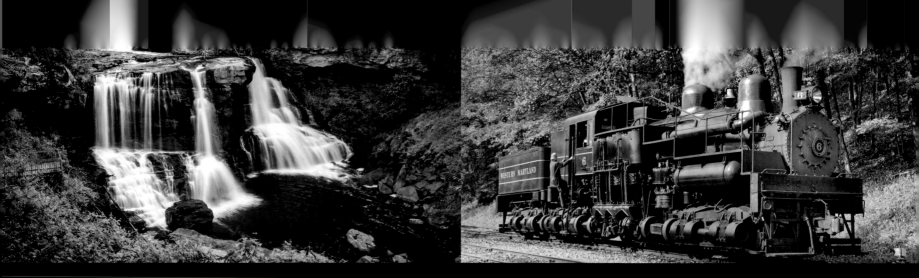

Blackwater Falls State Park

Located in the Allegheny Mountains, this park is named for the falls of the Blackwater River, whose amber-colored waters plunge 57–63 feet (depending on how it's measured) before winding through an eight-mile-long gorge. The water is tinted by tannic acid from fallen hemlock and red spruce needles. The park includes several short trails ranging from easy to difficult. Accommodations include campgrounds with 65 tent and trailer sites (30 of which include an electric hookup), 26 cabins (10 of which are pet-friendly), and 54 motel-style rooms at the lodge.

Cass Scenic Railroad State Park

Cass Scenic Railroad State Park gives visitors the opportunity to travel back in time when steam-driven locomotives were an essential part of everyday life. Cass was founded in 1901 by the West Virginia Pulp and Paper Company and built as a company town. The railroad was used to haul lumber to the mill at Cass. Now, tourists can take the train from historic downtown to the overlook at Bald Knob (the third-highest point in West Virginia). It's a 4.5-hour round-trip ride. Visitors to this park can check out the Company Store, eat at the Last Run Restaurant, and stay overnight at one of the restored company houses.

Coopers Rock State Forest

Located near Morgantown, Coopers Rock State Forest has something for everyone—camping, fishing, hunting, rock climbing, picnicking, geocaching, and more than 50 miles of hiking and biking trails to explore. The park is probably best known for its many scenic views.

Holly River State Park

Holly River State Park is West Virginia's second largest state park with over 8,100 acres. The park is located in a narrow valley in the Mountain Lakes region, surrounded by densely forested mountains. Holly River offers hiking, swimming, fishing, tennis, camping, cabins, picnic shelters, a restaurant

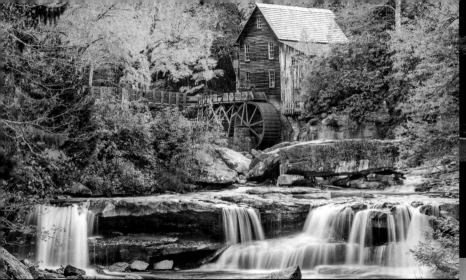

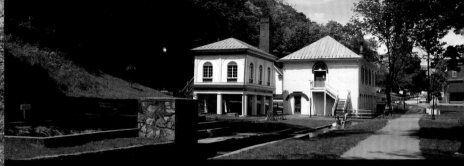

Berkeley Springs State Park
Located in the center of historic Berkeley Springs, Berkeley Springs State Park is known for its warm mineral spring water, which maintains a constant temperature of 74.3 degrees. Two facilities operated by the State of West Virginia offer spa treatments to the public.

Babcock State Park
Visitors to Babcock State Park in Clifftop, West Virginia, can hike, camp, fish, and rent watercraft, as one might expect at a state park. They can also visit a working mill, the Glade Creek Grist Mill, which pays tribute to West Virginia's past—and they can even buy corn meal and flour made at the mill! While the mill is one of the most photographed spots in the park (and the state), Babcock has much more to offer. Its 4,127 acres are filled with rhododendron-lined trails, mountain vistas, and rock-strewn streams.

Hawks Nest State Park
Hawks Nest State Park encompasses 276 acres bordering a rugged section of the New River Gorge National River. Visitors can ride the aerial tramway 876 feet from Hawks Nest Lodge to the marina at base of the New River Gorge. The park also features a museum, lodging, scenic dining, jetboat rides, and hiking trails.

Cacapon Resort State Park
Situated in West Virginia's eastern panhandle, the 6,000-acre Cacapon Resort State Park offers lake activities, golfing, vacation cabins, and hiking opportunities. Its proximity to the Baltimore–Washington metropolitan area makes this park a popular getaway.

Other West Virginia State Parks
- Tomlinson Run State Park (New Manchester)
- Twin Falls Resort State Park (Mullens)
- Lost River State Park (Mathias)
- Chief Logan State Park (Logan)
- Audra State Park (Buckhannon)

Lakeshore State Park

Who says you need to leave the city to enjoy nature's wonders? Lakeshore State Park in Milwaukee is a mecca for runners and walkers, offers both beachfront and prairie land, and has a marina for boaters. There are views of a lighthouse and, of course, the downtown skyline.

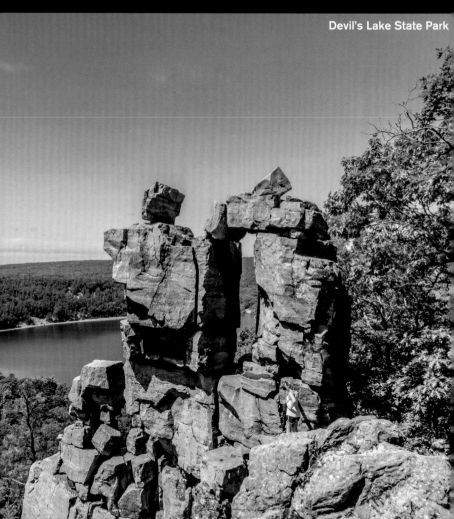

Devil's Lake State Park

Lakeshore State Park

Devil's Lake State Park

An easy drive from Madison, Devil's Lake is Wisconsin's largest state park and one of its most popular. It's known for the 500-foot-high quartzite bluffs that overlook the 360-acre lake. Some 29 miles of gorgeous trails await hikers. There are several campsites, and those who prefer water can swim, boat, fish, and even dive.

Rock Island State Park

It takes two ferry rides to get to this park off the tip of Door County, but the payoff is well worth the effort. Visitors can enjoy the stunning views and trails, ascend Wisconsin's oldest lighthouse (on a five-mile perimeter loop hike), camp in seclusion along the lakeshore, or

Interstate Park

Wisconsin and Minnesota share a border and a (usually) friendly rivalry, but their shared St. Croix River has produced one of the most breathtaking state parks in the Midwest. Interstate, Wisconsin's first state park (established 1900), showcases ancient rock with glacial potholes and the western terminus of the Ice Age Trail.

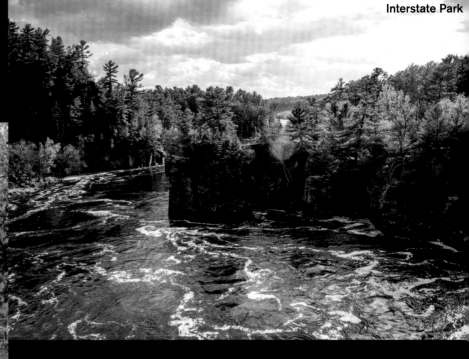

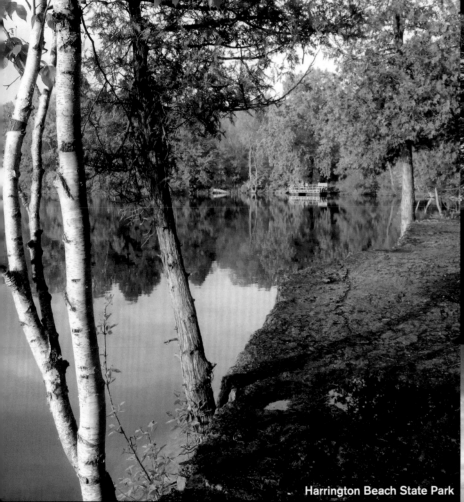

Harrington Beach State Park

A mile-long beach, access to both Lake Michigan and an inland lake, campgrounds, hiking, wildlife, and bird-watching areas are among the many reasons outdoor lovers visit Harrington Beach State Park, which is a 30 minute drive from Sheboygan. Quarry Lake was part of the Stonehaven mining community and is surrounded by a 1.5-mile-long trail.

Harrington Beach State Park

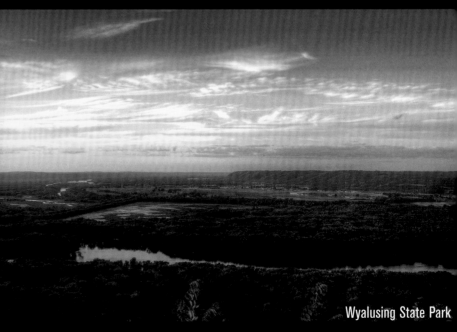

Wyalusing State Park

Wyalusing State Park south of Prairie du Chien gives guests spectacular views of the Mississippi and Wisconsin rivers, which meet there. Prehistoric Native American mounds are scattered across 500-foot bluffs that, on a clear day, provide views for miles and miles. This 2,700-acre park also offers campsites, 14 miles of hiking trails, a canoe trail, kayak and canoe rentals, fishing, bird-watching, and picnicking sites near scenic overlooks.

Wyalusing State Park

Newport State Park

Wisconsin's only wilderness-designated park, Newport State Park sits at the tip of the Door Peninsula in northern Lake Michigan. There are 11 miles of Lake Michigan shoreline accessible in the park, but at nighttime make sure to fix your eyes upward. This area boasts some of the best stargazing anywhere.

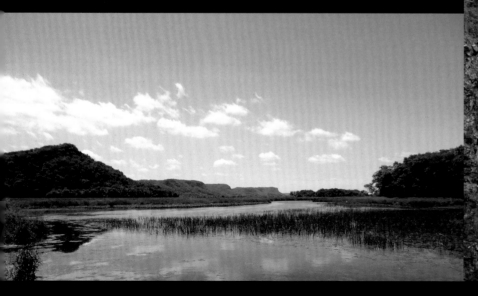

Perrot State Park

At the confluence of the Trempealeau and Mississippi rivers, Perrot State Park protects two state natural areas: Brady's Bluff Prairie and Trempealeau Mountain. Bluffs reaching 500 feet skyward provide some of the best photo ops in the western part of the state.

Copper Falls State Park

Way up in the northern part of the state, Copper Falls State Park enchants visitors with several waterfalls, 17 miles of trails (including part of the North Country National Scenic Trail), a 24-site campground, and some killer trout fishing. Native Americans and European settlers once mined

Aztalan State Park

Mounds and stockades near the Crawfish River are a testament to an ancient Native American tribe that abandoned this area of south-central Wisconsin around A.D. 1200. In addition to the history, the river provides excellent kayaking, canoeing, and fishing at this day-use park (no camping).

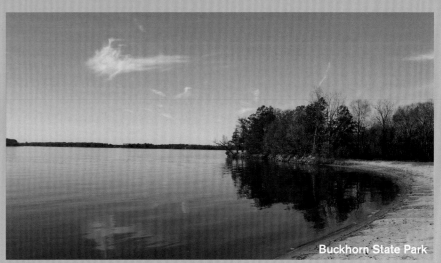

Buckhorn State Park

Mirror Lake State Park

Mirror Lake State Park is an idyllic spot to camp on any vacation to Wisconsin Dells. Panfish, bass, and walleye can be caught but speedboats cannot–the narrow lake is a no-wake zone. There's a beach with great views of the 50-foot sandstone surrounding the water.

Other Wisconsin State Parks

- Buckhorn State Park (Juneau)
- Council Grounds State Park (Lincoln)
- Governor Dodge State Park (near Dodgeville)
- Heritage Hill State Historical Park (Brown)
- Willow River State Park (St. Croix)

Buffalo Bill State Park

Named after one of the Wild West's most colorful characters, "Buffalo" Bill Cody, this state park near Cody—a city he founded—is a magical combination of history and recreation. Surrounding the reservoir formed by the Buffalo Bill Dam, it's a favorite spot for camping, fishing, hiking, picnicking, and boating in the shadow of the Absaroka Mountains.

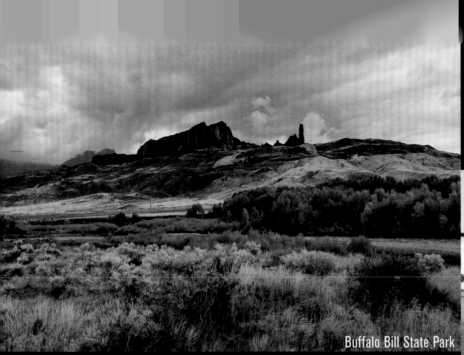

Buffalo Bill State Park

Curt Gowdy State Park

Named after the famed sportscaster who hailed from Wyoming and served for many years as the voice of the Boston Red Sox, Curt Gowdy State Park between Laramie and Cheyenne has a couple of distinct calling cards. One is its Hynds Lodge, which is on the National Register of Historic Places. Another is a hidden waterfall at the west end of Crow Creek Trail.

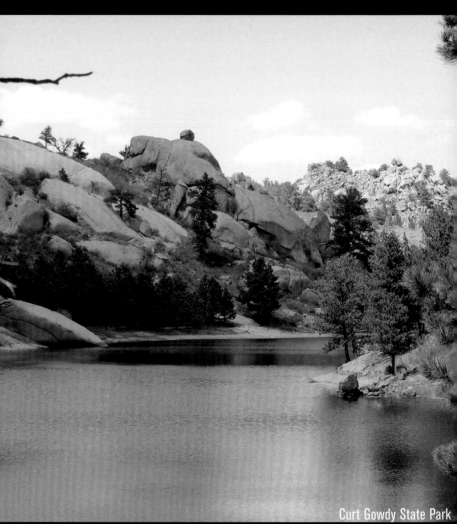

Curt Gowdy State Park

Bear River State Park

Every August, the Bear River Rendezvous Festival in Bear River State Park celebrates life in the hunting and trapping days of the 1800s. If you can't make it then, though, there are year-round opportunities to view bison and elk in their native habitat just outside of

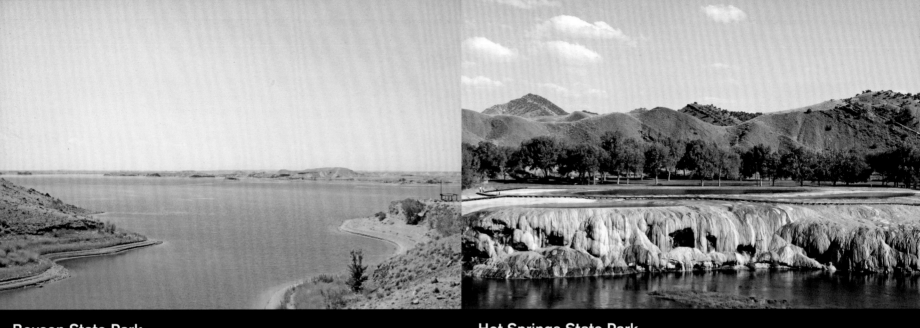

Boysen State Park

Wyoming's largest state park at 35,000-plus acres, this gem surrounds the Boysen Reservoir and offers several campgrounds and boat launches, along with a private marina. There are also interesting geological formations, along with terrific walleye, sauger, perch, and trout fishing.

Hot Springs State Park

A public recreation area in the aptly-named town of Thermopolis, Hot Springs State Park showcases the world's largest mineral hot spring. The water maintains a steady temp of 135 degrees Fahrenheit, but is cooled to a therapeutic 104 degrees at the park's State Bath House for free-of-charge enjoyment. This park also contains an ancient petroglyph site, Legend Rock.

Sinks Canyon State Park

Human activity at Sinks Canyon near Lander dates back thousands of years, and yet the geology here might be even more interesting than the history. The Popo Agie River flows into "Sinks," a mysterious underground canyon, and reappears a quarter-mile downstream. Dye tests indicate that the water takes more than two hours to reappear, and more water emerges than enters.

Guernsey State Park

Nature has done a dazzling job creating photo ops at Guernsey State Park, a public recreation area built around a reservoir on the North Platte River. The Civilian Conservation Corps, who created the recreational facilities here in the 1930s, left several buildings that helped the area gain National Historic Landmark status.

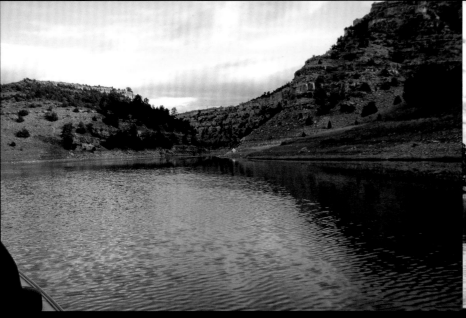

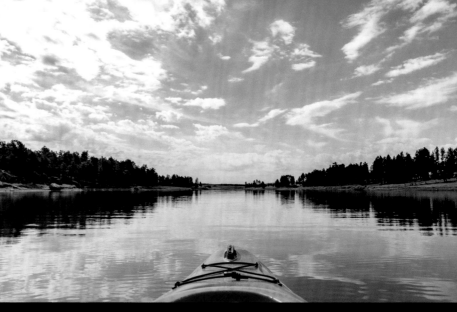

Glendo State Park

Mountain bikers love Glendo State Park in eastern Wyoming, thanks to 45 miles of mountain bike trails. There's also great hiking and camping, and state record-setting fish have been caught here. Native American Tipi rings and cultural artifacts can still be found in the park.

Keyhole State Park

Some of the state's largest fish on record have been caught in the reservoir at Keyhole State Park. There are also several campgrounds in the park, which is located on the western edge of the Black Hills between Sundance and Moorcroft.

Ames Monument

Wyoming State Historic Sites

- Ames Monument (near Laramie)
- Historic Governor's Mansion (Cheyenne)
- Legend Rock State Archaeological Site (near Thermopolis)
- Register Cliff (near Guernsey)

Hawk Springs State Recreation Area

Hawk Springs State Recreation Area, in the southeast corner of the state, is a favorite Wyoming spot for boaters, campers, and bird-watchers. Hawk Springs is home to a rookery dedicated to great blue heron, but you'll need a boat to get to it.

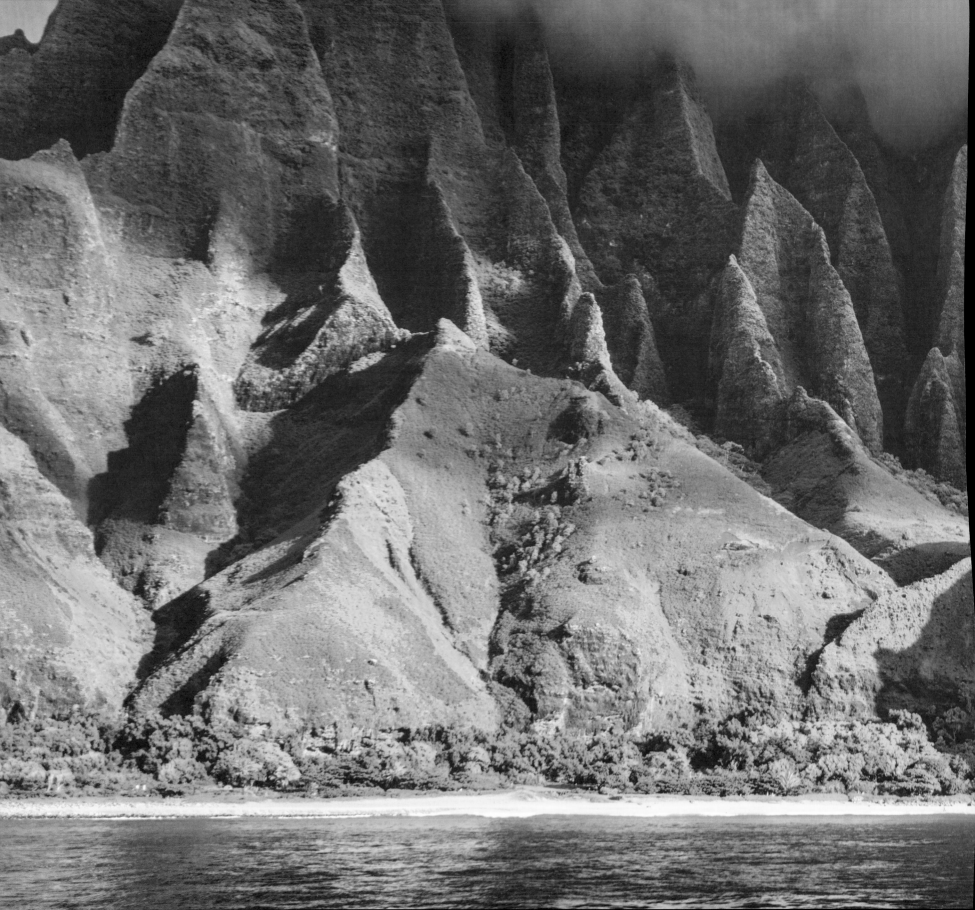